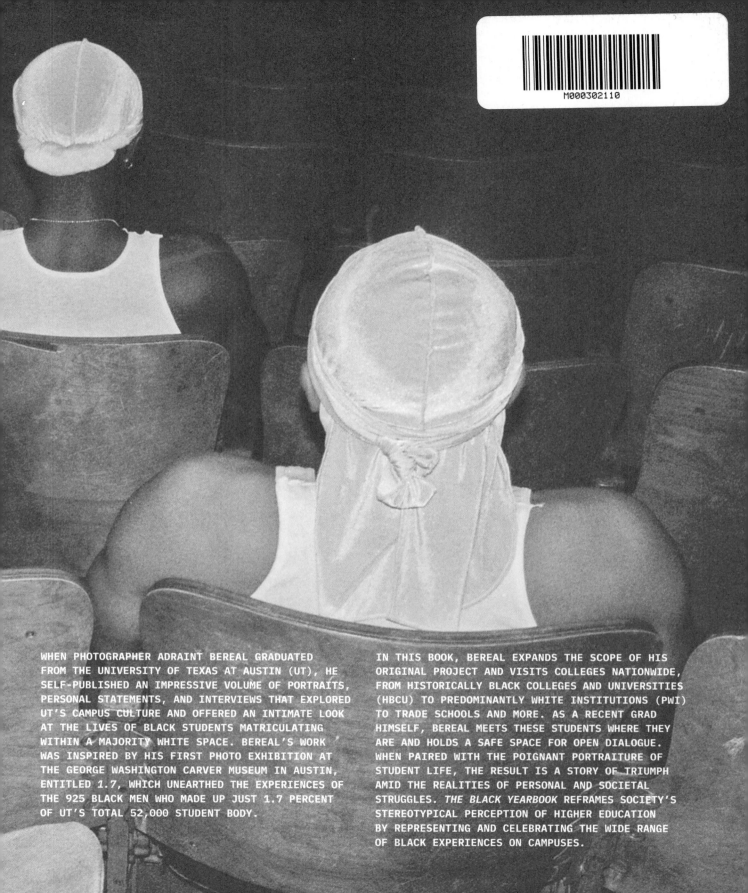

M000302110

WHEN PHOTOGRAPHER ADRAINT BEREAL GRADUATED
FROM THE UNIVERSITY OF TEXAS AT AUSTIN (UT), HE
SELF-PUBLISHED AN IMPRESSIVE VOLUME OF PORTRAITS,
PERSONAL STATEMENTS, AND INTERVIEWS THAT EXPLORED
UT'S CAMPUS CULTURE AND OFFERED AN INTIMATE LOOK
AT THE LIVES OF BLACK STUDENTS MATRICULATING
WITHIN A MAJORITY WHITE SPACE. BEREAL'S WORK
WAS INSPIRED BY HIS FIRST PHOTO EXHIBITION AT
THE GEORGE WASHINGTON CARVER MUSEUM IN AUSTIN,
ENTITLED 1.7, WHICH UNEARTHED THE EXPERIENCES OF
THE 925 BLACK MEN WHO MADE UP JUST 1.7 PERCENT
OF UT'S TOTAL 52,000 STUDENT BODY.

IN THIS BOOK, BEREAL EXPANDS THE SCOPE OF HIS
ORIGINAL PROJECT AND VISITS COLLEGES NATIONWIDE,
FROM HISTORICALLY BLACK COLLEGES AND UNIVERSITIES
(HBCU) TO PREDOMINANTLY WHITE INSTITUTIONS (PWI)
TO TRADE SCHOOLS AND MORE. AS A RECENT GRAD
HIMSELF, BEREAL MEETS THESE STUDENTS WHERE THEY
ARE AND HOLDS A SAFE SPACE FOR OPEN DIALOGUE.
WHEN PAIRED WITH THE POIGNANT PORTRAITURE OF
STUDENT LIFE, THE RESULT IS A STORY OF TRIUMPH
AMID THE REALITIES OF PERSONAL AND SOCIETAL
STRUGGLES. THE BLACK YEARBOOK REFRAMES SOCIETY'S
STEREOTYPICAL PERCEPTION OF HIGHER EDUCATION
BY REPRESENTING AND CELEBRATING THE WIDE RANGE
OF BLACK EXPERIENCES ON CAMPUSES.

The Black Yearbook

Adraint Khadafhi Bereal

The Black Yearbook

Adraint Khadafhi Bereal

4c

4 COLOR BOOKS
An imprint of TEN SPEED PRESS
California | New York

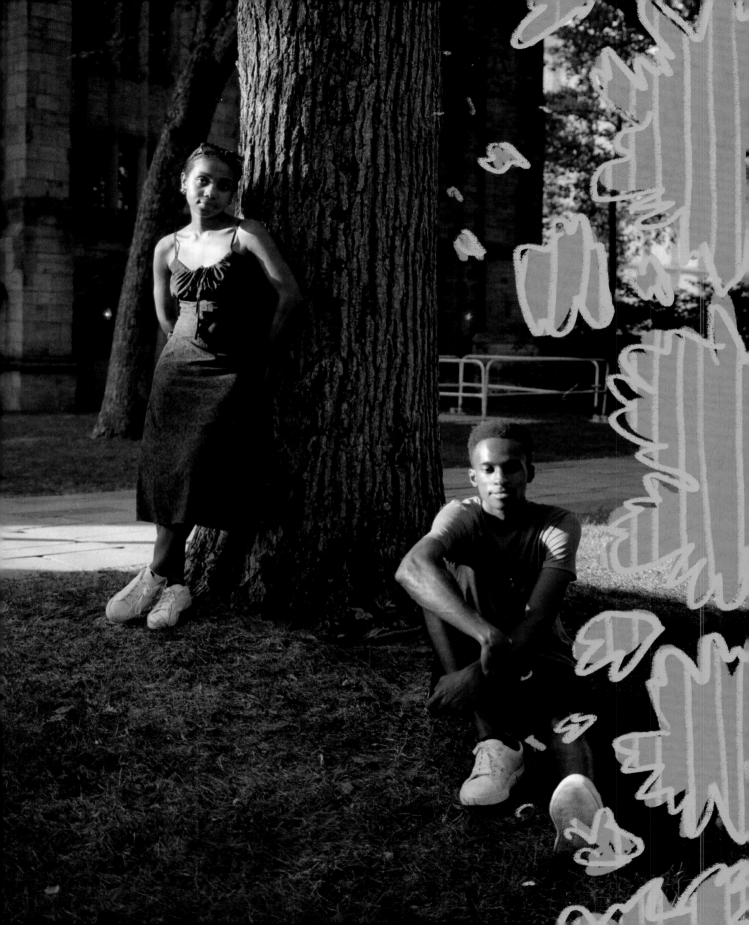

For those who dare look up.
Thank you, Iya, for teaching me kindness.

TABLE OF CONTENTS

TABLE OF CONTENTS

KIESE LAYMON

WRITER, AUTHOR, PROFESSOR

LONG DIVISION (2013)

How to Slowly Kill Yourself and Others in America (2013)

HEAVY: AN AMERICAN MEMOIR (2018)

MACARTHUR GENIUS GRANT

Foreword by Kiese Laymon

We often call books that blur categories "genre-bending," but what do we call work that bends our actual memory of what happened, or our imagination of what is happening? This is what Adraint Bereal has made here, in supposed elite college space, a space many of us believed to be beyond our imagination—and after surviving it, a place our memory often smudges because it longs to survive free of the wrong kind of weight.

I've read the book four times and felt gutted forty-four times by what Bereal has managed to do with our experiences and imaginations as students on these campuses. In the wildest, and really sorta shameful turn, Bereal forced me to sit with what it means to be conceived and raised on a historically Black university in Mississippi, then move on to attend a southern white liberal arts college, then a Midwest progressive liberal arts college, then a Big Ten university, then a tiny so-called prestigious college on the east coast, before ultimately moving back to teach in Houston, Texas.

These institutions are home to me. And home is sick. More than anything, *The Black Yearbook* will show us the importance of photography in our desire to piece together meaning in this intentionally harsh, anti-Black place.

I have never felt more honored and awed by an exploration of what we make of ourselves in spite of these institutions and their deficiencies. Colors, shapes, and textures matter. We are colors, shapes, and textures. We deserve art that honors our artful existences. Those of us who survived these places will find a new blue kind of love in this here place.

We are so lucky Bereal loves us. This is *The Black Yearbook*.

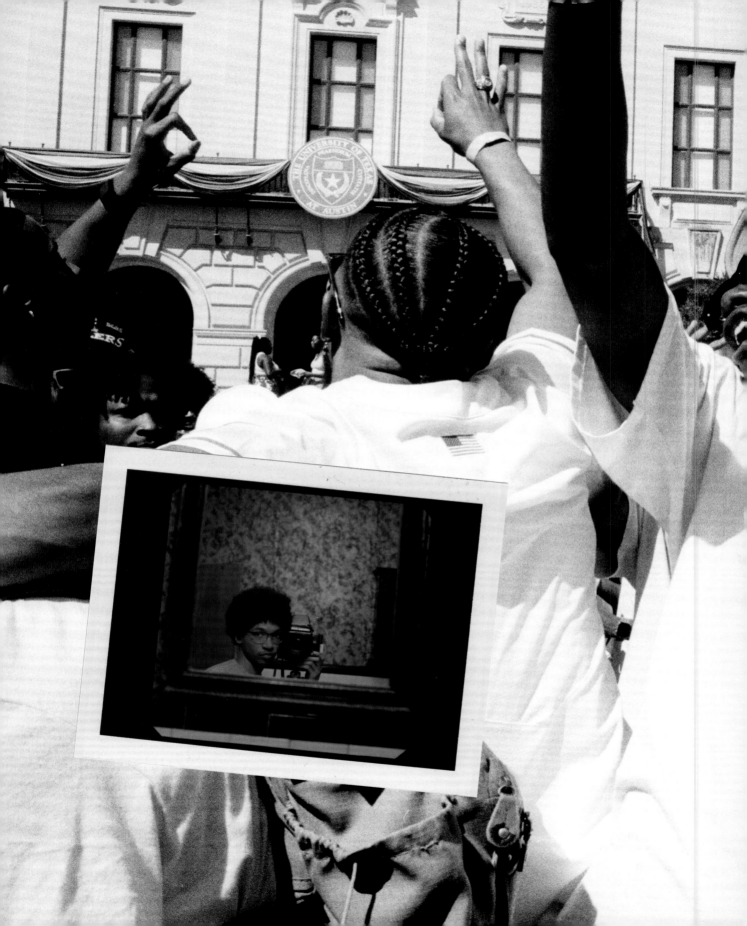

We are proud of what you have accomplished
this far in the journey of life, but we hope
you don't think that you can settle for
what you've done as the ultimate
accomplishment. Not only are we proud of
what you have done so far, we expect you
to reach higher and achieve greater success.
Now, with you being the leader, we want
you to understand that the road of life
gets hard, and not everyone wants to see
you succeed and do well. Keep in mind
that you are not alone, and not only do
we want you to do better and go farther,
we demand it.

If you get tired, take a break;
If you get hungry, nourish the body;
And as you journey, in all thy getting,
get understanding.

- Tyr

Introduction

"We are proud of what you have accomplished this far in the journey of life, but we hope you don't think that you can settle for what you have done as the ultimate accomplishment. Not only are we proud of what you have done so far, we expect you to reach higher and achieve greater success. Now, with you being the leader, we want you to understand that the road of life gets hard, and not everyone wants to see you succeed and do well. Keep in mind that you are not alone, and not only do we want you to do better and go farther, we demand it. If you get tired, take a break; if you get hungry, nourish the body; and as you journey, in all thy getting, get understanding." This is what Iya, my grandpa, said to me when I graduated from college.

As a first-generation college graduate raised between Waco, Texas, and Hattiesburg, Mississippi, I had no expectations of what college was supposed to be. At the University of Texas at Austin (UT Austin), I enrolled in an advanced

photography course even though I had never studied photography under a professor before.

The class was thesis based, so each student was tasked with choosing a topic and working from there. I initially wanted to explore the relationship between Black men and femininity, but I realized there were too many nuances to communicate in one semester. Then, as I looked deeper into the campus demographics, I discovered that in the fall semester of 2017, only 925 Black men were enrolled at UT Austin. My fellow Black peers and I already knew the number was low, but it was jarring to see the true number. You could fit all of UT Austin's Black men in the school's events auditorium and still have seats left over. In my time on campus, the Black student population would remain at less than 5 percent, making up a small cluster on a campus of about 50,000 students. I decided to spend the following two years taking photographs and interviewing these Black students about their experiences. The resulting work became the catalyst for what you will read and see here.

Since the founding of the oldest university in the country, Harvard University in 1636, college has always been considered an exclusive space for the rich and powerful. Over 385 years later, this threshold of entry has expanded, but things have remained the same just as much as they have changed. I traveled to schools from coast to coast for four months, connecting with these students and learning about their most personal moments in college. Being Black is the only thing I had in common with them. We were strangers, and yet we were able to create this safe space of curiosity, learning, and growth for each other. Accompanying these conversations and narratives are analog film portraits of the students and their environments. These images are meant to take away the brochure depiction of Black students and give back truth to our existence. "Such is the power of the photograph, of the image, that it can give back and take away, that it can bind," said the late bell hooks in her essay "In Our Glory" about her relationship to an image of her father. This book binds us in time, but we will continue to grow and evolve beyond these pages.

So, whoever you are as you begin your journey, "In all thy getting, get understanding."

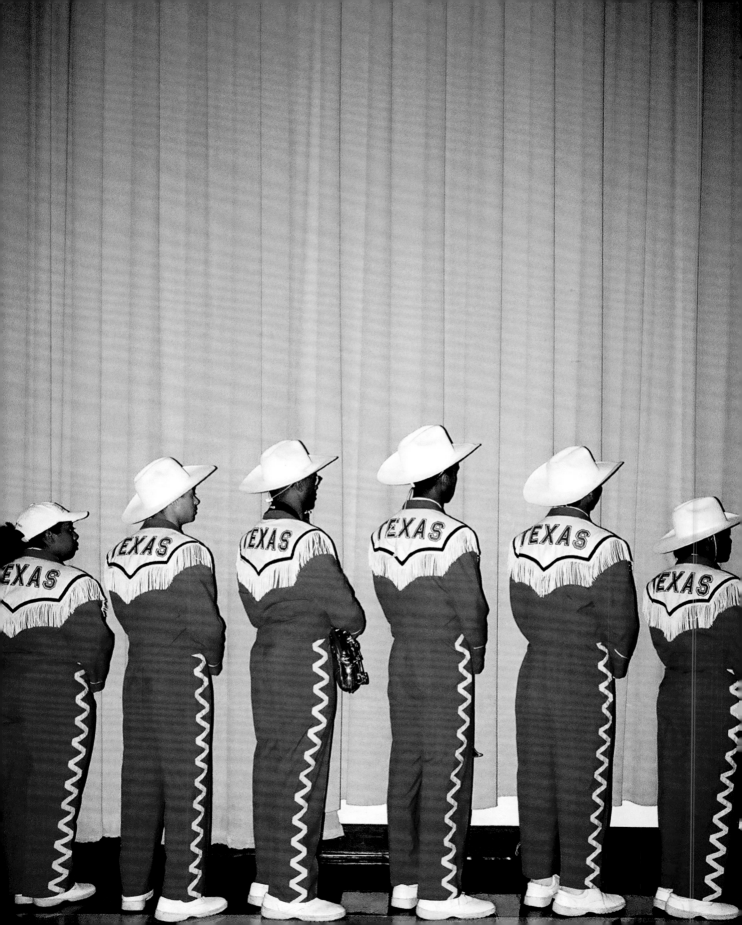

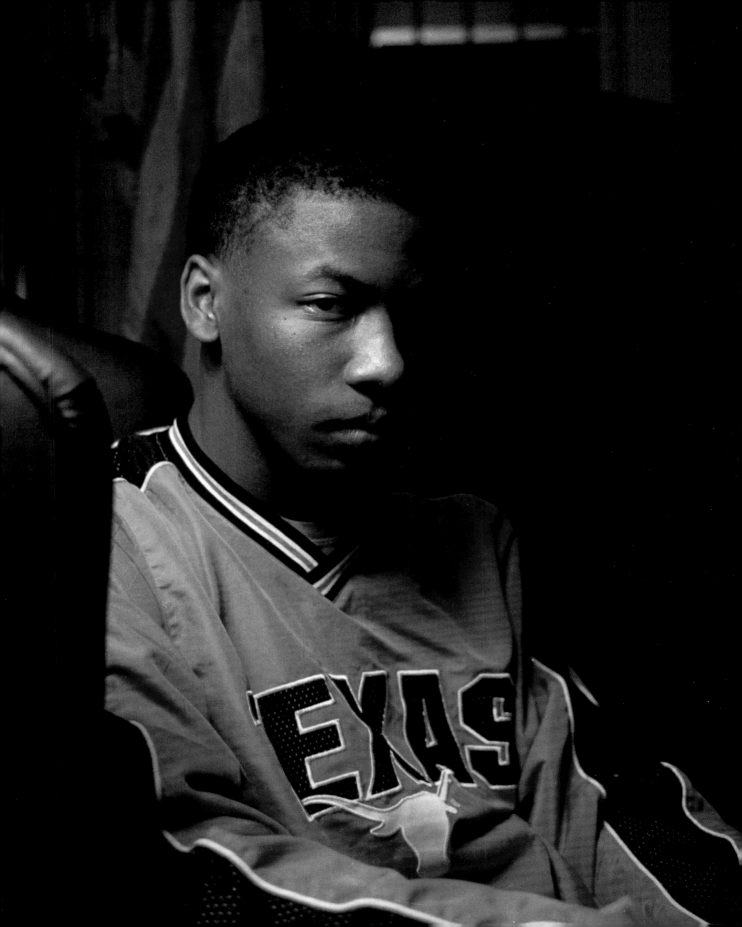

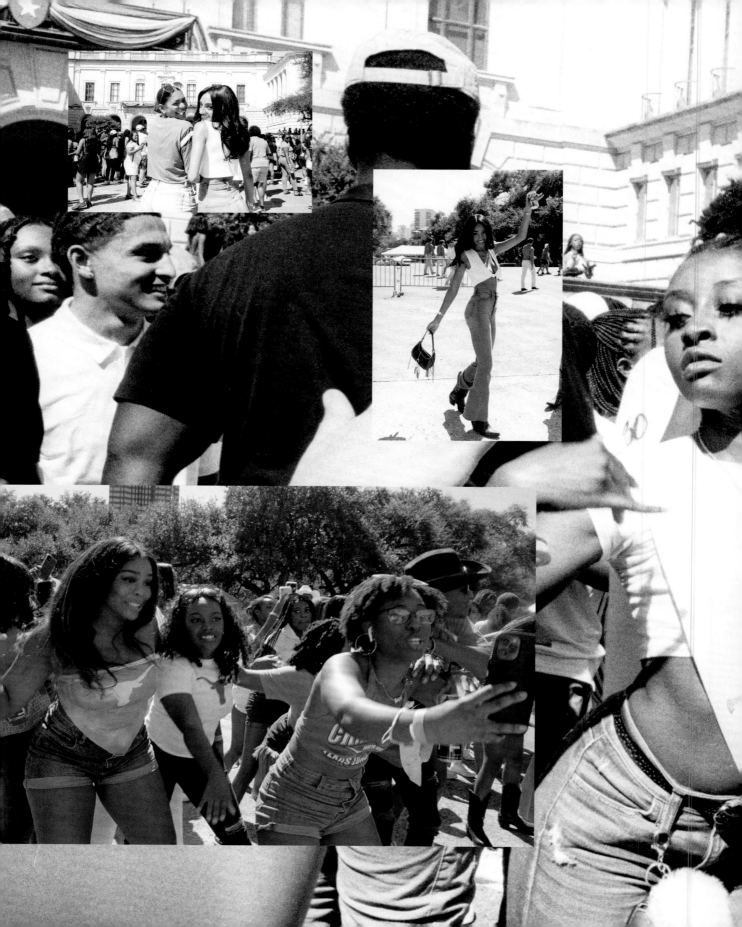

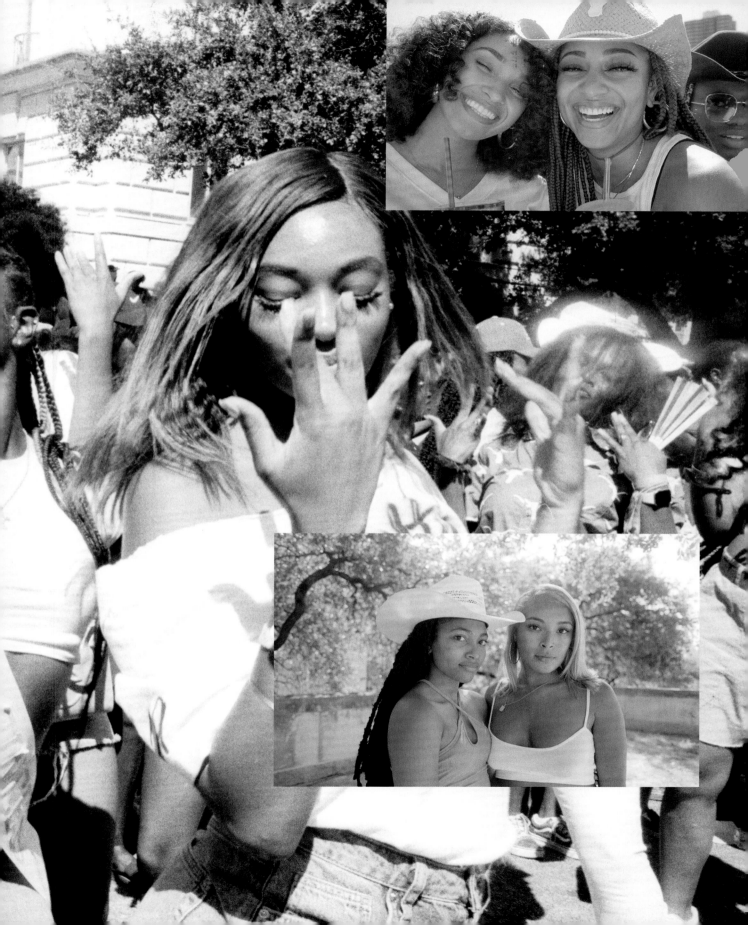

Predominantly White Institutions (PWI)

While visiting some public and private predominantly white institutions, I learned that many students share similar sentiments about fitting in, feeling accepted, dealing with the available academic offerings, navigating social hierarchies, and more. As for racism on these campuses, every student's experience with it is unique. For some, racism is blatant and presents itself as hearing the "n-word" shouted while casually walking to class. For others, it is more covert and masquerades as microaggressions that aggravate just enough to get under the their skin, but never enough to warrant repercussions. These are the examples that come up when we talk about the experiences of Black students.

To set aside my own biases and personal experiences, I decided to lead many of these interviews with a simple introduction, yet I consistently found myself on the topic of racism. In a lot of ways, I was trying to avoid talking about it, but then you would not be talking about the Black experience. It's deeply ingrained in the way

Black people move through the world, and how others perceive us. It was important for me to not unwrite the pain endured by these students. I didn't want these stories to be passed off as either small moments of "adversity" or "joy." Both exist, but one word alone is not all encompassing of a life. After all, maybe the refusal to reconcile with racism is why there is so much pain in proximity to collegiate narratives. If these students can bravely confront their reality, the people around them should be able to do so as well.

The racial conflicts that the students face at predominantly white institutions lack resolve. Very rarely did these students see anything dramatically change in the duration of experiencing these hardships, and some legacy students found themselves still fighting the same battles their parents did when they were on campus. When we look back at historical roadblocks, the racist uproar in response to cases such as *Sweatt v. Painter* and *Brown v. Board of Education* is treated like an obsolete issue of the past. The pictures may be in black and white, but the lived experience is in color. The voices of hatred belong to real people. There are Black people alive today who still have the images of pitchforks and various objects being hurled their way while simply trying to pursue an education. Ruby Bridges is still alive today. A wound cannot heal if it is not treated as such, and as I've seen it, we will continue to revisit this narrative until Black students feel safe and free from racism.

Another main concern that kept coming up in conversation was the five-mile radius surrounding these schools: often a façade of curated businesses that only cater to the type of student body, alumni, and tourists that the institution supports and prefers to be associated with. For example, when in New Haven visiting Yale, you can stop for a slice of Bar's famous mashed potato pizza, but not without passing by a Lululemon filled with people buying leggings for $100. There is an intentional recipe that goes into the fabrication of an "inviting" and "accessible" campus. These stores influence a cult-like culture on campus by creating an unspoken uniform for the student body. While many students still wear what they feel most comfortable in, they recognize the pressure to buy something to fit in. These businesses also accelerate economic tourism, which then accelerates the rate of gentrification and displaces residents.

And when it comes to the Ivy Leagues, you never know who might be sitting next to you. Many students recalled their first moments encountering peers with well-known family names and wealth that opens doors they didn't even know existed. There was a universal acknowledgment that Ivy League students with legacy backgrounds might receive opportunities above others that were more qualified, undermining the notion that hard work will be rewarded. For Black students that need to provide for themselves, "hard work" as a simple solution is a farce. Students are encouraged to join a number of student organizations and acquire student leadership roles in order to increase their chances of success but that road inevitably leads to burnout. You can't pull yourself up by the bootstraps if you don't have any boots to begin with.

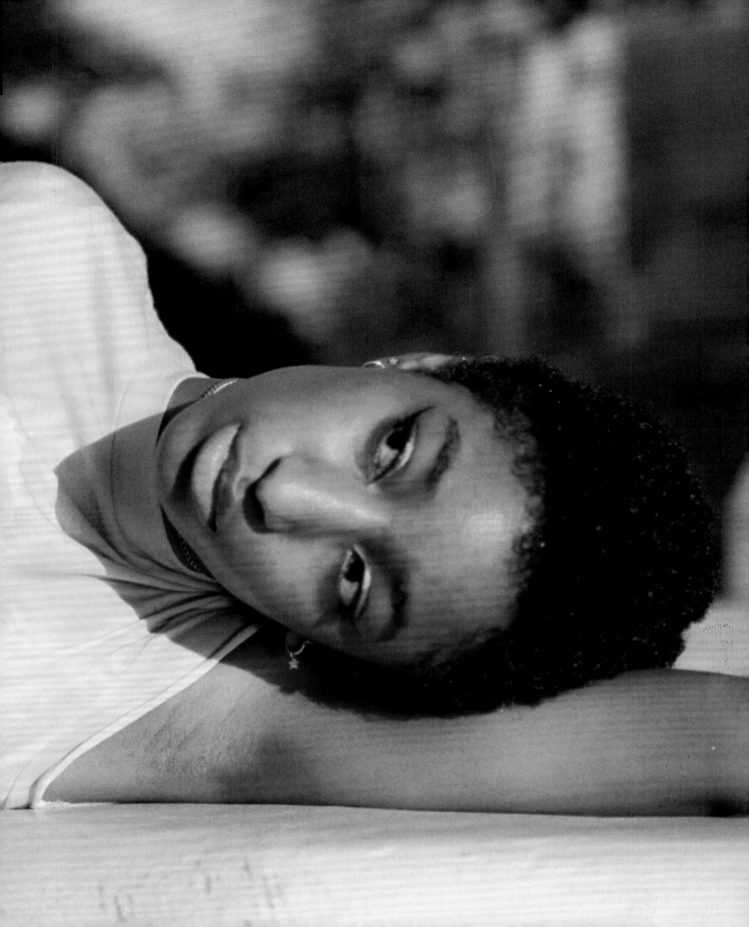

PILAR LEE
UNIVERSITY OF SOUTHERN CALIFORNIA (USC)

MAJOR	JOURNALISM
CLASS	2023

ADRAINT

How did you end up at USC? What was your process for getting here? Were there other schools you were looking at?

PILAR

Late sophomore year, my dad and I just started touring schools. For some reason, my dad is a huge USC football fan. I say "for some reason" because he did not go to USC. Literally, he has no connection, he just *really* loves their football team. So, he was like, "Oh, we should check out USC." And everyone growing up had always told me, "Oh my God, you're such a California girl. You seem *so LA*." When we toured here, I fell in love. As soon as I arrived on campus, I just felt at home. I had toured other schools in the South; none of them were really hitting for me.

ADRAINT

Wow. So you knew this was your spot? What did it look like trying to find community here?

PILAR

Yeah. I come from an acting background, but my junior year of high school, I took a broadcast journalism class and hosted the morning show. I loved it, and that really prompted me to study journalism as a field. USC has one of the top journalism schools in the country with a 3 percent acceptance rate. So when I got in, I was like, "Oh yeah, I did that. *I did that*."

To answer your question about how I found community, there was an Admitted Student Day. So, we all came and there was a Black informational session where you meet the Black faculty and other current Black students. I found out that there is a special interest community floor called Somerville—it was a Black floor. That was the best decision outside of choosing USC. I'm just a naturally outgoing person, and everyone here is so friendly and so easy to get to know or talk to. When it came to classes or other situations, I would always know at least one person and would get to know more people from there.

ADRAINT

That sounds really fun. I know some campuses have living quarters designated by personal interests, so it's great y'all were able to have something so specific to being Black. What's your favorite event on campus?

PILAR

My favorite event definitely has to be the Welcome Back concert. My freshman year, Ama Lou opened and then YBN Cordae performed. I only knew "RNP" because this was right after that song came out, but then I heard the rest of his performance and I fell in love. Welcome Back has this great energy, and everyone goes hard. During COVID, it was online, which was upsetting because it was Chloe x Halle? I love Chloe x Halle, so I'm mad that it wasn't in person, and I'm kind of getting nervous that they're not going to tour again.

And then there's GearFest, put on by the BSA's Cre-Ex, which is a group that organizes these experiences to celebrate Black creatives and artists. Brent Faiyaz performed my freshman year, and this was right before Brent really popped off, so that was super cool. Mereba headlined in 2021, and that was her last performance before she announced she was pregnant! We also had a bunch of student performers. GearFest encourages more students to perform because we want to highlight you, we want you to show up and show out with all of these profes-sional performers. They do fashion shows as well! I modeled in it my freshman year, and it was the most fun thing ever to look out into the crowd and see all my friends.

JAYDALYN "JAYDA" POLK
UNIVERSITY OF SOUTHERN CALIFORNIA (USC)

MAJOR	ENGLISH
CLASS	2024

ADRAINT

You're from Mississippi. How did you end up at USC? What did your parents think?

JAYDA

My parents were pretty supportive because my dad came to USC as a transfer. I'm from an all-Black school, so I knew that I wanted to go to a PWI. That may sound crazy, but I had experiences with HBCUs, we used to do band camps with HBCUs, and most of our teachers were HBCU-educated. I'm not going to speak for *the* HBCU experience, but a lot of HBCU culture was already on my campus, and I experienced a lot of that firsthand. I also had to think about my family and what we could afford, so I decided to go to a PWI. I had never really lived around a lot of white people, so I'm not going to lie to you, my first couple weeks were rough.

ADRAINT

Do your parents check in with you pretty often?

JAYDA

I talk to them every day! My dad was targeted on campus a lot when he was here. He actually sued the school and won because USC DPS [Department of Public Safety] assaulted him. That's one of the reasons why I was kind of scared I wasn't going to get into USC. Even though he's a legacy—and you know the legacy thing with colleges? It's easier for you to get in. I didn't put him down as a legacy because he was scared that they were going to hold it against me that he sued them. My dad and mom always check in on me because they know how it can get really rough here being a Black person.

ADRAINT

I imagine so, especially with your dad's personal experience weighing on you. How does that impact the way you look at USC today?

JAYDA

Besides that, I think the biggest thing is the diversity of mindsets. Conversations that you can have with people here are just so amazing and thought provoking. This past Thanksgiving, I went to a church sister's home. I was listening to her daughter and some of their friends talk, and it was amazing. They were talking about politics and how to solve homelessness in Los Angeles. Whenever you talk to somebody on campus, it's not just going to be negative responses to community issues and people saying, "You can't do that." That was the biggest culture shock to me, but it was something that I appreciated. I came here expecting no racism at all. I knew there was going to be racism, but not to the extent of Mississippi, where they just look at you like they can't believe you're free.

ADRAINT

Right.

JAYDA

But here . . . they have a lot of microaggressions like, "Oh wow. Look at the way you talk, and your hair is like that." I've also experienced a lot of racism from *minorities* here lately. It's happened to a lot of Black students on campus. Especially at the little marketplace, whenever we go in there, they always seem to think that we're going to steal something. That's one thing that really shocked me because at least in Mississippi there's a little more solidarity.

ADRAINT

I wish that was how it was . . .

JAYDA

I don't know how it is in actual LA, but in this USC community, that's what I've experienced. California's leftist and more open-minded, so people that are racist try to go along with that. That's how their racism gets hidden. It's kind of like, "Well I'm open-minded, but I'm just curious . . ."

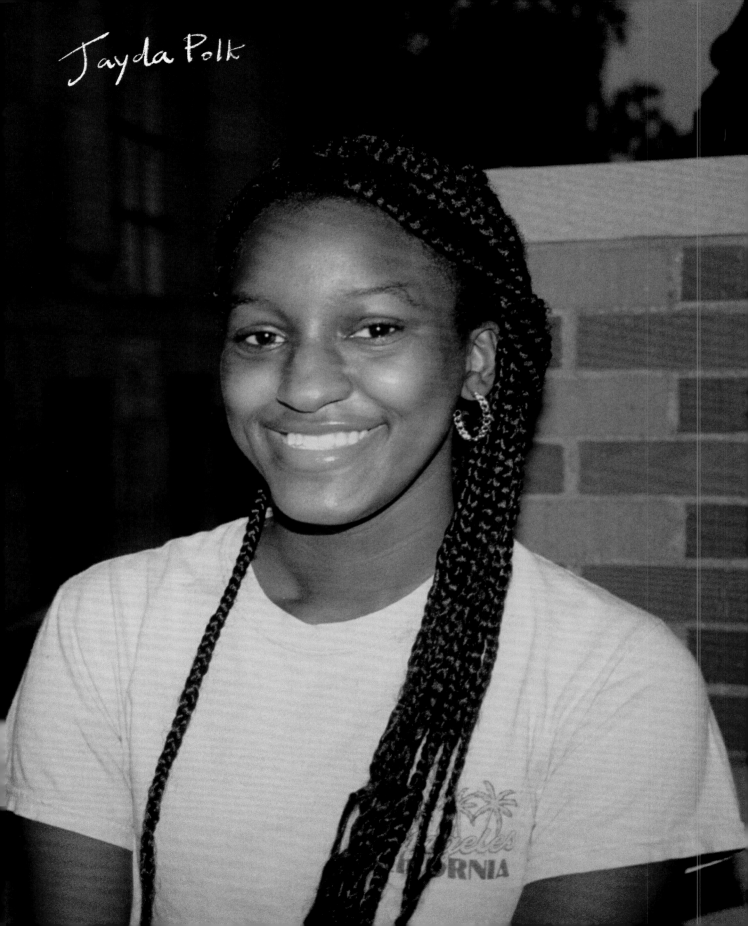

Jayda Polk

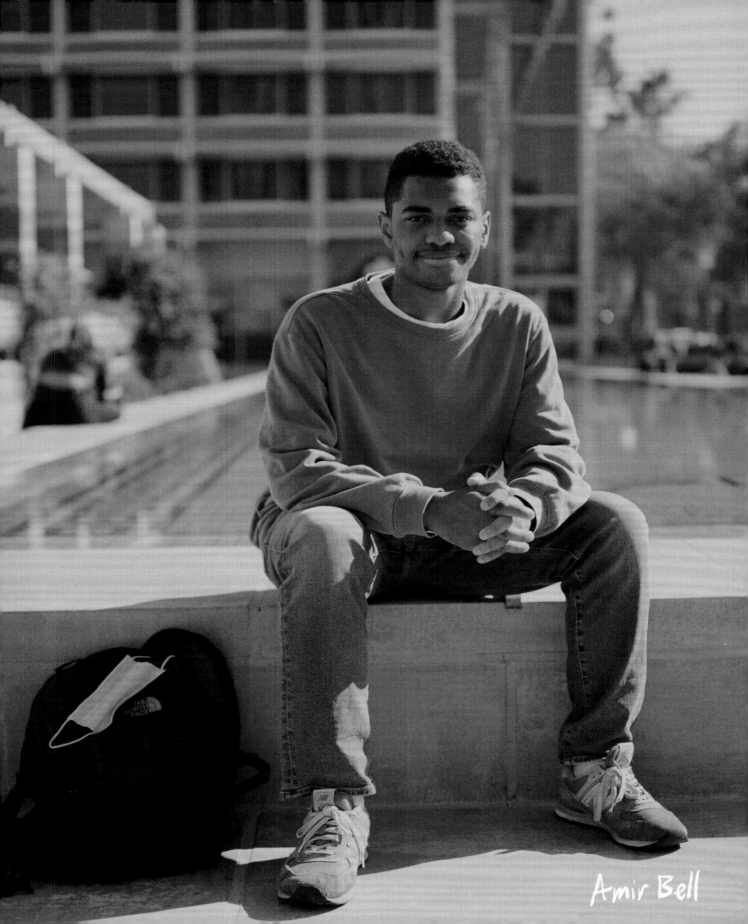

Amir Bell

AMIR BELL
UNIVERSITY OF SOUTHERN CALIFORNIA (USC)

MAJOR	BUSINESS ADMINISTRATION
CLASS	2023

ADRAINT

AMIR

How did you end up at USC? What was your first semester like?

I'm originally from Atlanta. I'm a transfer student from Lehigh University, a really small school in Pennsylvania. I transferred in the summer of 2020, and I've been loving my experience out here so far. I think one of the biggest things for me was I wanted to get out the South and get as far away from my parents as possible. USC is a fun campus with a large amount of student life, and there's so much to do in Los Angeles! I still feel like I'm doing something new every day. Now that I have my car, it has just opened a whole new world of possibilities of stuff that I can do in the city.

My first semester here online wasn't the best, but I still lived in an apartment near campus, so 99 percent of the people I interacted with were USC students. It was weird because I grew up in an upper-middle-class environment—Buckhead, Georgia, is probably the richest community in the whole state—but when I came to USC, it was a whole different thing. Kids casually say, "Oh, I'm taking a weekend trip to Cabo," and Cabo is something that my parents would have to save up for! Sometimes people would say microaggressions and not understand why it was wrong; so you have to educate them. But I did meet a lot of cool people from different cultures and different environments.

ADRAINT We are in what used to be a very predominantly Black neighborhood and schools have the tendency to be key in occupying spaces and areas. Do you know if USC does any work with surrounding communities?

AMIR I have mixed opinions on the organizations that do work because I want to feel safe on campus, so I'm happy about the little DPS [Department of Public Safety] bubble, but I also don't want it to become a situation where USC is kind of overtaking the whole community.

ADRAINT As students, we want to be safe, but when campuses expand so deep into residential communities that have a different definition of what safety looks like, this creates a lot of tension. If I'm living in the area and I've always lived there, my family has always lived there . . . and now DPS is patrolling in our area, I would feel uncomfortable and surveilled. Where does DPS's jurisdiction begin and end? I always remind my fellow students: "You're here temporarily; they're here forever." You could come on this campus, completely disrupt the surrounding area within your four years, and leave without any repercussions. That's where I began to look at institutions of this size and of this power almost as colonizers. These are institutions for learning, but how can they better support surrounding areas?

AMIR That's the biggest thing for me too. We are visitors in their space. With USC students, there's a large sense of entitlement and this tendency to be in a bubble-like environment. We should be more respectful and cognizant of the world around us.

ON THE BACKLASH FROM VOCALIZING
AND DEFENDING IDENTITY IN WHITE SPACES

—JEPHTHA PREMPEH

MAJOR: NON-GOVERNMENTAL
ORGANIZATIONS AND SOCIAL CHANGE

CLASS OF 2022

UNIVERSITY OF SOUTHERN
CALIFORNIA (USC)

I've always been very vocal about social issues and being a queer Black person—a poor person in rich spaces. I have to vocalize that a lot if I want to survive, or if I want to not surrender myself. A couple months in, I could feel that the friends I was making were short-circuiting when I tried to have these conversations, or when I tried to point things out. What helped me was coming from a PWI, I'd already been dealing with rich white kids and feeling that way. But because there were so many more people here, it was easier for me to find my own way, and just have some fun, and not let all these heavy things weigh me down.

By the time I was in college and having these conversations about social issues, I would begin to break it down, but then it would become this fight because I'm telling people, "Leave that perspective behind, and if you're not going to get it, then eventually that might be the end of our friendship." My conditioning to always meet someone there and hand hold them through those things resulted in me saying less and speaking up less in the long term. Not because I didn't want to have the conflict, but because I didn't want to have to walk them through and make sense of the conflict. That started to get frustrating, so it put me in a really rough position with friends.

People don't know how to talk about social issues with me, and I guess that's why they hate it when I try to have these conversations. In freshman year, my friends distanced themselves from me, and I went a while without knowing this was going on. I kept thinking, "Oh, what did I do? Maybe I'm a bully and maybe *I'm* not self-aware of how I'm treating people." But that's what taught me the breadth between our two perspectives, and our understandings of the world, and how hard it would ever be to bridge that.

What I notice about Black people is that they're going to call you out, but that's just what it means to *share space*. I villainized myself for it; meanwhile, people just had their own ideas about me, and no one had the courage, respect, or trust to talk about it. That colored the whole way I approached friendship throughout the rest of college and really defined my relationship to USC. I came here so open-minded and prepared for this type of environment, but I didn't know I could still get caught up in this position. I kept thinking, "There's going to be a way to just have the regular college experience despite how conscious I may be or despite the conflict. There's a way for me to survive this and still have a good time like everyone else." At the end of the day, I was not always afforded that.

its all been surreal and im still learning. Opportunities are still coming so im thankful

ON RECOGNIZING AND DEALING WITH BURNOUT

—EZI OGBULI

Coming into USC, I was pre-med like a lot of people I knew. Straight out of high school, I wanted to do neuroscience, go to medical school, become a doctor. I'm Nigerian. My parents are immigrants. There's always that fear of uncertainty and wanting me to succeed, so it's easier to go down those more structured paths to become a doctor, to become a lawyer. Freshman year, being in the classes meant to weed out underclassmen wanting to go into STEM [Science, Technology, Engineering, and Mathematics], I've never felt so much like I didn't belong in a space. When I changed my major to what it is now, Global Studies, I realized that there was an alternative pathway that I could take. I didn't have to follow a script, and my mental health did a whole 180. I felt more confident and engaged, and I had fun.

But the thing I did not realize about USC, just in terms of workload and expectations of students, is that they sell you the college experience: that you'll be able to take eighteen units, be the head of three clubs, go out every day with friends. They really sell that to you. But when you do it, when you attempt it, it can kill you pretty much. It's a lot of responsibilities to juggle. With an institution like USC, it is very competitive and you want to do well, you want to succeed. It's almost like that's all I think about now when I try to do things for myself. I used to love reading when I was younger. Now, the thought of reading a book, I can only associate it with school. And because of that, it doesn't bring me joy anymore. I could go out to get food with my friend, but that paper, that paper, I have to do that paper.

Especially as Black students on campus, we can't afford to be average. We have to be above average at every point in time. That adds to this stress and pressure to constantly be on and constantly feel like you can't have time for yourself. There is this collective sense of burnout, crawling your way along to finish or at least try to finish before the end of the semester.

It's all been surreal, and I'm still learning. Opportunities are still coming, so I'm thankful. I'm grateful. Overall, my USC experience has been a roller coaster, but it's been one for the books so I can't complain about that. It's had high points and low points, but I really value the people that I've met along the way who I know I can still reach out to and have a conversation with when a semester is really rough. I found community. Everything that I've done up until this point, aside from the stress and everything, is still valuable and worthwhile. I will cherish everything even after I leave the university, because it's been an experience—especially now that I'm an upperclassman and have people coming to me, asking me for advice, or looking up to me. COVID, of course, discombobulated who is upperclassmen and who is not because we're all lost at this point. Now that we're back on campus and I'm able to guide people in a better direction or share the lessons that I've learned through my experience, I hope that eases the burden that they may have to bear moving forward. That has made everything worth it.

UNIVERSITY OF SOUTHERN CALIFORNIA (USC)

CLASS OF 2022

MAJOR: GLOBAL STUDIES

ON THE PRESSURE TO PERFORM AND FEELING INADEQUATE IN THE FACE OF PRIVILEGE

—UKAIRO UKAIRO

MAJOR: CINEMATOGRAPHY & FILM/VIDEO PRODUCTION, MFA

FIRST YEAR

UNIVERSITY OF SOUTHERN CALIFORNIA (USC)

I would say USC has been what I expected. It has disappointments—what I expected—and it has excitement—also what I expected. Some professors will name-drop at USC and these are people they actually have relationships with. When I'm standing or sitting next to them, I just feel like they're my peer, because you still see the same hunger and desire to create stuff, to make money, or to be okay. But when you hear that, what it does to you . . . regardless, there's *a thirst.*

It's cool when you see professors or people who are still working hard even though they have all these accolades and connections. Hearing those names makes you feel like, "Okay, well, maybe that can be me one day," and it makes it realistic, but it doesn't tell you how to get there. When you get to hear them speak to their wins, it changes how you see the world because now you're in the room where it happens, in a sense. Unfortunately, for every room where it happens, there's an inner room, there's an inner caucus that you may not be allowed to get into for whatever reason. Most of those reasons I've learned are out of your control.

One of the biggest reasons why someone like me doesn't have access to fame is because I'm an immigrant, because I'm an international student. I'm not saying I would be the greatest Ukairo that there ever was if I was an American citizen, but I know that there are places that I want to go that I can't legally go. So, there's that layer for me. And then there's what my uncle and his friend call "the genetics lottery of being born white." The system knows how to perpetuate itself. If the people in the cockpit don't want to do anything about it because they can't, or won't, or don't know how to and I am the passenger, what the fuck am I supposed to do?

Sometimes power, access, and privilege just works the same way human relationships work. It's like survival of the fittest, but quiet and blind. All it would take for white people or people in power—it could be Black people too—to create equity and access is a level of intentionality. You quickly learn when you get to USC—and I think it's the gift of being at USC—that if there's an industry you're interested in, try and go to the elite's version of it. I encourage everyone because there were a lot of things that I didn't feel were possible. I feel I'm in the sauce right now. This is the first time I feel, "I'm a filmmaker."

There's a line between bleeding in public and being vulnerable. I hope I'm being vulnerable now in sharing.

Chase Leito

BIANCA SIMONS
UNIVERSITY OF CHICAGO

MAJOR	LAW, LETTERS, AND SOCIETY & GLOBAL STUDIES
CLASS	2022

ADRAINT

What's been your experience in Chicago?

BIANCA

My parents never went to college, so it was always drilled into my head: "Be successful at doing *something*." I went to a pretty good private high school that had a program with UChicago, so I got in. I didn't even know about the school much! It was just like, "What's a good school that isn't expensive?" And my Jamaican mother was like, "My God, what about Harvard and Yale and whatever?" I'm just like, "I hate Harvard, and who the hell's going to New Haven?"

Two weeks before the deadline, I decided to go to UChicago. Being from a predominantly white environment, coming here was an easy switch since I'd been through it for four years. I was even on the rowing team, so I was in the trenches with the white people. It's definitely different.

When you're from the South, racism is more overt. What you see is what you get. Being here, especially in the light of Black Lives Matter, everyone wants to scream, "I'm so left." That's been the hardest thing about being Black here is that you think you find people that are on your wavelength and then all of a sudden, they say something problematic and you start to see a pattern. You gaslight yourself to believe these people are different, but it's just the same old, same old. Schools will say, "We want diversity. We want more people." So you think they're going to invest in you, and they really don't. You can put Black people anywhere, but what does diversity and inclusivity even mean if you're just sticking them here and not giving them anything to do with that?

ADRAINT

Right. What about how class and economic status impact these dynamics? Class is one thing that I think is yet to be acknowledged among Ivies and schools that are perceived as Ivies.

BIANCA

They try to put the poor Black people in one way and the rich Black people in another way. It seems like the rich Black people are in fraternities and sororities. Everyone else gathers in OBS [Organization of Black Students] and ACSA [African and Caribbean Student Association]. They try to clump poor and middle-class Black people into the same thing to sell an image and a homogeneous perception of being Black and poor.

That's been the main thing that separates the Black community here. We try to bridge that gap to some degree, but we need to acknowledge that rich Black people do not have the same lives as poor Black people. The rich international students do not have the same lives as the people here. I come from a racist environment, so what hurts me the most is when Black people say stuff. That's not something I'm used to, coming from a private school where all the scholarship kids stuck together.

ADRAINT

I imagine the disparity in class also impacts social lives as well. What's the social environment like? Jumping from hyper-Black environments to non-Black environments?

BIANCA

We were just having a discussion with our board today about it. We had a party for ACSA and OBS on Friday. The problem is finding space to have these events. We never really have space to do something like that. That's a problem: having to raise money to rent white spaces to host Black events since we don't have our own spaces to any degree. If we have parties, we have to rent out of fraternities—white fraternities. Black people do not have the space to gather. We don't have a Black Student Alliance building because the administration doesn't believe in cultural spaces. So, finding space is one of our greatest problems. We're always trying to garner support, and that's something I work with in student government as well. We try our best, and we have great events, but how can we give Black people a space for themselves?

ADRAINT

You've been exposed to a lot of various Black experiences in a condensed period of time, I imagine that's shaped how you understand what it means to *be* Black. Not everyone opens themselves up to the multitude of Blackness. So, what's been the highlight of all of this for you? If there is one. What have you gained?

BIANCA

Meeting the Black women. The girls and the gays. I don't know what else is better. But what does my school give me? Depression. We have some of the worst wellness facilities out of, like, any top-tier university. I honestly think Black people might be happier in some top-tier universities compared to us. For a medium-sized university, you'd think they'd care about us a little bit more! UChicago's college advertising is so focused on diversity, but they really are not.

I had this perception of racism that was very one-dimensional. I also had a perception of Blackness that was to a certain extent one-dimensional. A lot of what I believe has been challenged because of the large sum of people that I'm encountering. Everyone in the Black community is so different, and I'm constantly learning what Blackness is and what it means. Even how we talk to people and the vocabulary that we're using when we're talking about each other is interesting.

ADRAINT

Vocabulary and language are really important. Language is something that divided a lot of people at UT when I was there. I feel like that kind of contributed to whether or not you got to be a part of a certain something or didn't get to be a part of a certain something. It created a bubble within a bubble within another bubble. I had friends who opted for more white spaces because they felt more comfortable there, socially.

BIANCA

My mother always says, "You are the people that you sur-round yourself with." I normally never say Florida is part of the South, but to some degree it very much is the South in terms of cultural expectations. Joining all these groups, being around people here that are gender nonconforming, and using pro-nouns was different.

ADRAINT

The dissonance from one community to another can be jarring. It was for me.

BIANCA

We're shaped both by what is and what *isn't* here. If we had more spaces, once again, we could curate our own expe-riences and not have to borrow spaces that are owned by other foundations. I do believe that we would have more creativity of thought, be more comfortable with what we have, and feel more grounded. Not having that space leaves a sense of unease.

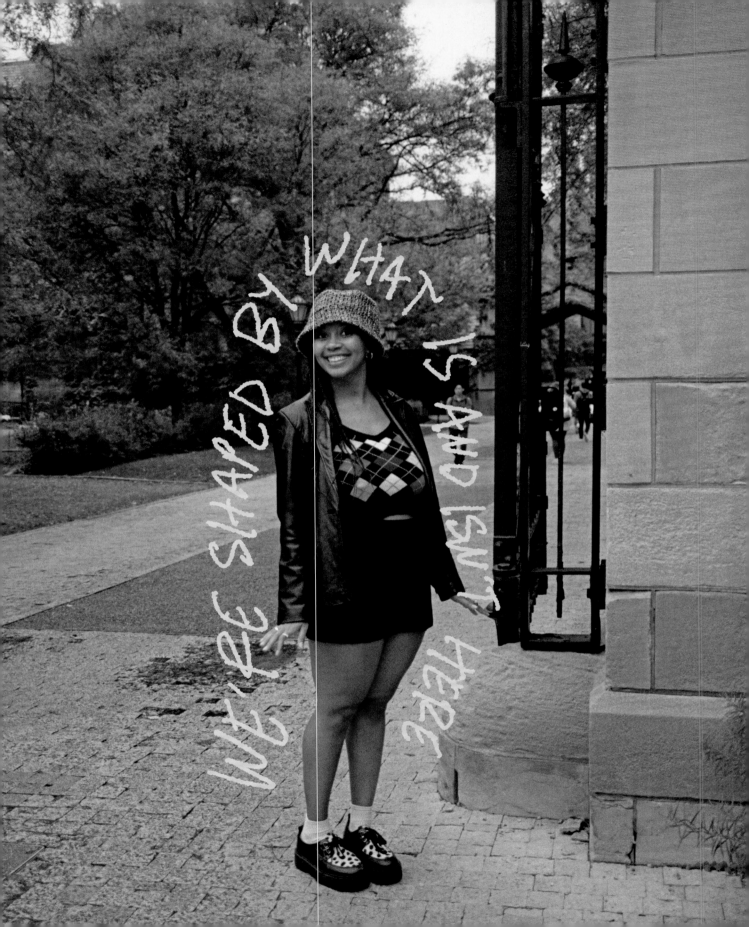

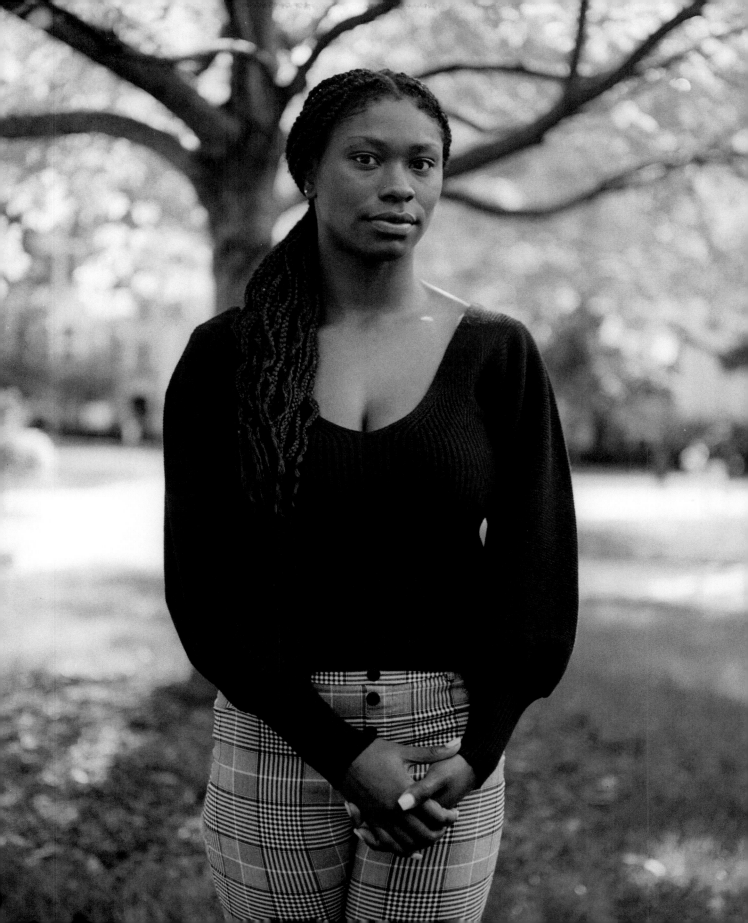

ON EXPERIENCING ANTI-BLACKNESS AMONG OTHER MINORITY GROUPS AS A FIRST-YEAR MEDICAL STUDENT

—TECORA TURNER

MAJOR: PRITZKER SCHOOL OF MEDICINE, MD CANDIDATE

FIRST YEAR

UNIVERSITY OF CHICAGO

One time there was a lecture we had during our speaker series that made a bunch of us uncomfortable. We have a group chat where we talk about everything, and somebody texts, "Did that woman really just say that?" And we're like, "Yeah, she really just said she thought she was Black."

She was supposed to be an expert in an entirely different subject, but she pressed on to say, "Oh, I just really love Black people—my bridesmaids were Black!" Weird comments like, "Yeah, I really love studying Black people. I really like doing my research on Black people," but not saying she likes taking care of Black patients or helping Black people.

When she finally gets midway through her lecture after talking about Black people the whole time, she shares that she shifted to study her own demographic after her mother contracted a disease that disproportionately affects those within her own community. She said she resonates more with Black people, but that personal experience led to her decision to shift to studying her own culture. By the end of the lecture, we're all feeling some type of way.

I raise my hand and asked, "How do you feel about anti-Blackness in your own community given that you resonate so heavily with Black people?" She deflected and even went as far as to say, "Yeah, there's prejudice in the Black community as well." And I was like, "That doesn't have the implications that you think it does, one. And two, it doesn't have the same intent, or it doesn't have the same power." Her response was that she hires a lot of Black people on her team and sometimes a patient will come in and they'll be like, "Oh, wow. *They're* here?" so she helps with those interactions.

That response was problematic, so we all let our thoughts be known in the survey after class. Following that, a message was sent out that basically said we could petition to replace the lecturer and find a better provider to lecture on that subject matter. This started disagreements with other students who were nitpicking the use of the word "replace" rather than actually critiquing the problematic content of the lecture.

I realized then maybe not everybody is here for the reason that I'm here. I came here for the social justice piece. I came here to take care of all patients regardless of their race or ethnicity, but especially Black women. For a lot of people, especially with this class, this is the first time that they have been around this many Black people in the higher education space making up a large proportion of the class.

I was talking to our chapter's SNMA (Student National Medical Association) president, and he said, "You just have to take it with a grain of salt." He was saying sometimes equity feels like inequality to people who have never been oppressed.

There were a lot of reasons why I chose to come here, but it was mainly because Pritzker [School of Medicine] was one of the only schools I interviewed at that had women and minorities in leadership positions. There's a larger percentage of underrepresented minorities at this school than at any of the other schools that I was applying to.

In my interview for Pritzker, a pro-
fessor and dean of multicultural
affairs came on the call and liter-
ally said, "If you do not care about
Black patients, if you're not going
to take care of Black patients, if
you don't care about minorities,
if you don't care about social jus-
tice, this is not the school for you."

And I appreciated that so much because
I felt everyone that is coming here
is here for the same reason. We are
for social justice. We are here for
these Black patients, and I came
here very specifically to take care
of Black patients. And so, it's just
really nice and I can't wait. I'm
interested in OB-GYN, and I want to
take care of women, minority women.
My ultimate goal, if I still continue
to go the OB-GYN route, would be to
open a reproductive health clinic for
minority women, and all the doctors
will be minority providers.

DAYO ADEOYE
UNIVERSITY OF CHICAGO

MAJOR	LAW, LETTERS, AND SOCIETY & RELIGIOUS STUDIES
CLASS	2022

DAYO

My name is Dayo Adeoye, but my government name is Adetokunbo Adedayo Adeoye.

ADRAINT

Oh, that's a beautiful name. You said you grew up in the suburbs of Chicago. What was that like? How did that come about to be?

DAYO

I'm from Marysville, Ohio, but I originally grew up in a suburb of Chicago. My parents are Nigerian immigrants, and that's all I'd ever known. My family lives in a very rural, very white, very conservative town, so coming to UChicago felt like this was the most Black people and culture I'd ever been around. It was comforting to know that I can go down the street to get hair products instead of forty minutes away. Having Nigerians around again was really nice. I felt *found*.

ADRAINT

What's your story of finding yourself? What did that look like?

DAYO

First year was very, very, very tough for me. The transition was not in going from white rural to white urban, but going from rural public school to this institution where so many people went to private school. It seemed like they were on another academic level, and that really got to me. I was very depressed; what got me through it was the campus counseling services. My first counselor was this white man, and honestly, I got worse after talking to him each and every session. He finally recommended I do group therapy led by a Black woman therapist. And, oh my God! I credit a lot of my success to her because she helped change how I think; she reframed every-thing. The group therapy became a literal group for me, so I felt very seen, very welcome, very comforted.

ADRAINT

Got you. What was your experience like with the Black community here at Chicago? How would you paint a picture of it to someone else, the landscape of individuals?

DAYO

They're very great and very beautiful, but also very different. The landscape of Black people here at Chicago is very diverse to the greatest extent. We come from every socioeconomic background and every interest—I've never met two Black people that were exactly the same. There are a lot of cliques within the Black community on campus, but as a whole, in the aggregate, very wonderful and supportive people.

ADRAINT

Is there anything else that you think would be important to add about your time at Chicago or like, "I want this to be known in my writing," or anything like that?

DAYO

I want to emphasize the position of being Black at Chicago because I'm very happy, and I'm getting a good education. But being Black at Chicago also means being Black in the South Side of Chicago and knowing that just one bus stop away is a completely different reality. And then also having to square what you're going to do about that, how you're going to relate to other people. That's what defines our community because, at the end of the day, you realize how everyone who works in the dining halls is Black and everyone who's at the front desk is Black, and *they're* as much a part of the Black community here at Chicago as the students.

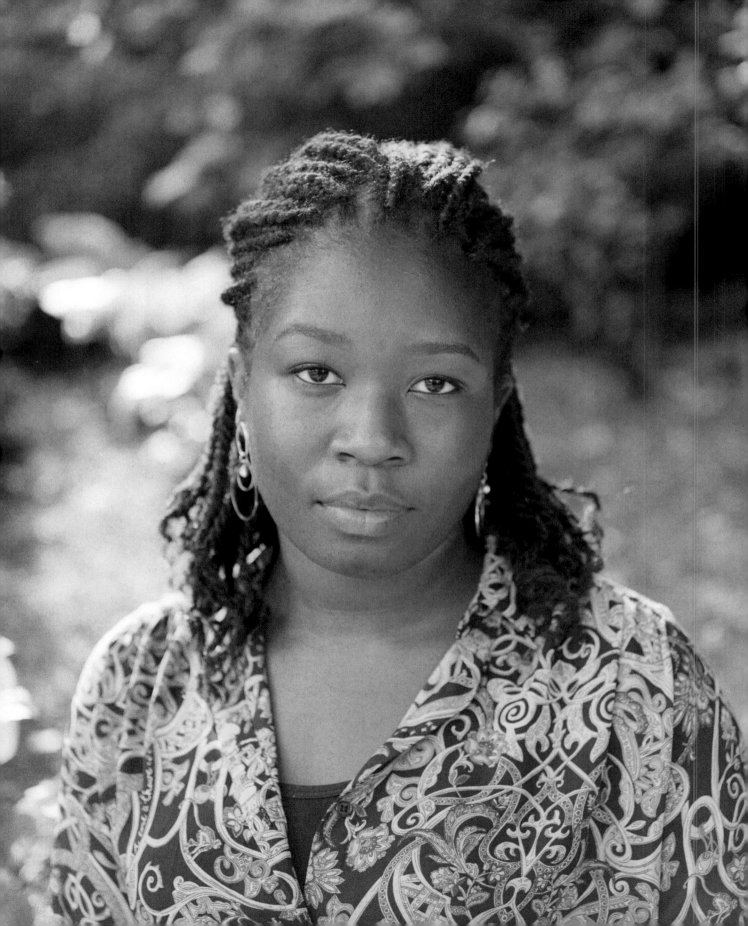

Zaria El-Fil

ZARIA EL-FIL
UNIVERSITY OF CHICAGO

MAJOR	US HISTORY (PRE-1900), PHD STUDENT
CLASS	FIRST-YEAR

ADRAINT
What's been your general experience with campus or classes so far? Have you enjoyed it?

ZARIA
It has been a really hard adjustment for classes because I come from a Black Studies background. The university's framework is very European, so they say things matter-of-factly like we're all supposed to know about European thinkers and European theorists. That's not my frame of reference.

So, I felt a little bit of impostor syndrome—but not too much because I did get into Yale, Northwestern, Berkeley, and Rutgers, so I'm clearly doing something right! But it is hard coming into a very white department with people who are thinking about white frames of reference or thought. That's been the biggest adjustment so far, and I don't even know what I'm going to do about that still.

ADRAINT
You had a lot of really great prospects. What led you to pick Chicago?

ZARIA
UChicago hasn't successfully recruited a Black PhD student for their history program in the last two years. So, they were heavily recruiting me. It made me feel wanted, and it made me feel like they would support me when I came here. I needed to be in a space where I felt like people were invested in me finishing and saw me as more than a number.

When I was still deciding, one of the faculty members put me in contact with another person who was still deciding because he wanted me to help recruit her. And I'm like, "But you're also recruiting me." So, what is this, a diversity thing?

ADRAINT
How you gon' ask me to do something and you're not paying me for it?

ZARIA

Exactly. That's something I'm going to have to come up against a lot. My mentor, a Black woman, was just hired last year. I was asking her for time, and she says they have her working all types of diversity things because there were no other women of color in the department. She said, "They're also going to ask these things of you too."

It's just a matter of what are their priorities, right? Their excuse to me was that they're usually competing with Yale since all of the students they accept usually also get into Yale, but that just means try harder to recruit! Make sure you're paying these Black students who are interested in coming, and make sure you have the programming to help them adjust to your programs. Literally, all it takes is active recruiting.

ADRAINT

Hearing about your recruitment process highlights how higher education has been completely gamified. So many of these schools are not really concerned with our academic advancement. How have you been able to find community on campus so far? Has that been difficult? In undergrad at UT Austin, you had not only your sorority and academic peers, but more tight-knit relationships you spent years building.

ZARIA

Hanging out with people outside the department has been really helpful, so people from the English department and the med school students, but other than them, it's just me and Gabriel [a fellow PhD student] really. I met a few Latinx folks who have been really kind and also come from a class-marginalized background, and that's nice. Uniting around class has been important to me in the absence of any racial solidarity. I think that graduate school can be very exploitative, but we normalize it because we're all going through it. It also inspired me to *be more* than the ivory tower and to do more than just my studies, which I feel like I wouldn't have gotten at Yale. I do nineteenth-century US South slavery, but I also look at surveillance and the formation of the modern police state. As part of my degree, I'm working on a project about the moral justification for slavery through religion: Christianity, slavery, and how Christianity was used to secure slavery as an institution.

ON STARTING THE BLACK CONVOCATION AT UNIVERSITY OF CHICAGO

—DINAH CLOTTEY

MAJOR: SOCIOLOGY

CLASS OF 2022

UNIVERSITY OF CHICAGO

In my sophomore year here, I started a Black Convocation. Coming in freshman year, I thought Black Convocation was something that all predominantly white institutions did as a welcoming ceremony for incoming Black students to celebrate the fact that we're all here.

When I realized it was not a thing, I made it a thing. I had to jump through so many hoops to get permission from the administration, but we got it done. I would say that is definitely one of my biggest accomplishments. That first inaugural Black Convocation is probably one of my best memories from being here at the university. We held it at one of the big chapels on campus, and I was amazed by the amount of students that showed up (both undergraduate and graduate), alumni, faculty, and some family members. That year, we had a student government president who I believe was the first Black female president in a number of years at the University of Chicago.

I remember seeing how moved everybody was, and I was like, "Man, this is how we, need to do it. Start the year off with a bang, and let people know that community is here." Because finding that can be one of the hardest parts about navigating predominantly white spaces. So, let's have an event where all of us can get together at the beginning of the year. If we don't do it soon enough, it can feel like it's too late.

It changed the tone and let other students from other multicultural organizations, not just Black students, know that there are big things they can do to make an impact on campus. The event gained the university's attention because ain't nothing like gathering a bunch of Black people in one space to get people looking. The Black Convocation, and specifically getting the university to be invested in that sort of event, started to open doors. I'm hoping that it will continue to open doors for anything that Black students need in the future.

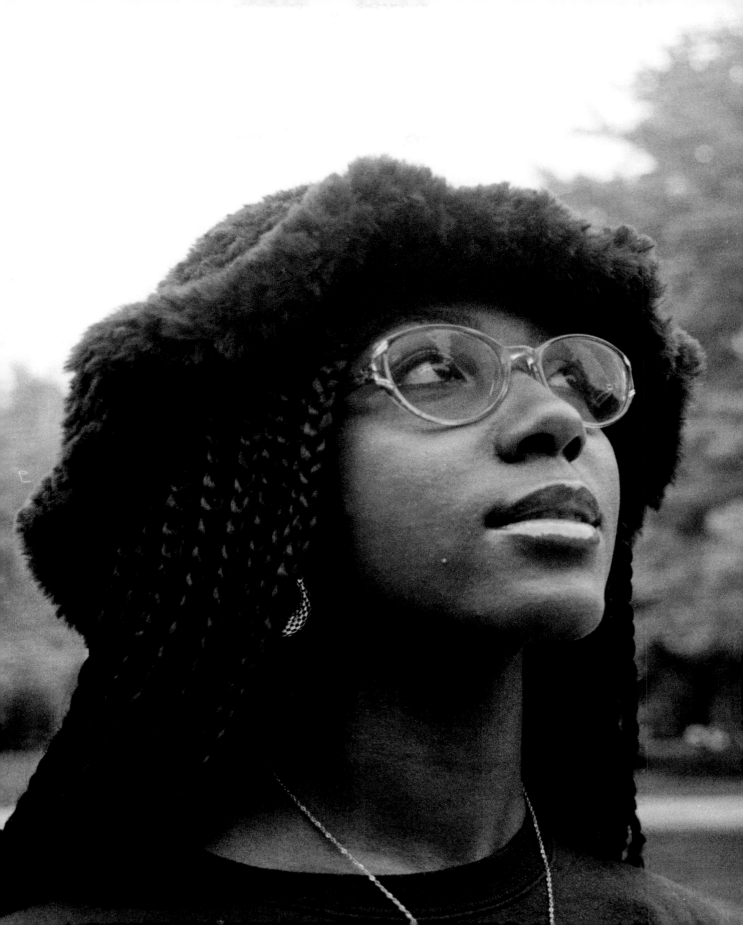

CAMILLA OAKLAND
CHICAGO STATE UNIVERSITY

MAJOR	NURSING
CLASS	2023

ADRAINT What made you come to Chicago State, Milla?

CAMILLA Well, I wanted to stay close to home. Then, the price point? Great. This school is really diverse—we all melt together. If you were to walk around campus on a normal day, you'll see it's mainly Black students like an HBCU. It's also a four-year institution where I don't have to go through a hassle of finding nursing programs.

ADRAINT How would you describe Chicago State to someone that doesn't go to school here?

CAMILLA It's a hidden gem. A lot of people don't know about it. The JDC, the Jacoby Dickens Center, is a $47 million facility. People don't know that because they think that our school is a community college, and it's not; we just have a lot of commuter students, so it paints that idea in other people's heads. We have a lot of students with potential here. Our CMAT [Communications, Media Arts, and Theatre] department is filled with pure talent, and they pour into their students. If you listen to Power 92, we actually have an alum named Hot Rod on the radio station. The department even works with the people at BET!

We have everything here—Student Government Association, Greek life, residence halls, sports, and all of that. People only see it for its past. The current student body is working to change some of the past misconceptions about our school. We're no longer in danger of closing, and the students are involved on campus. It's time to just reshape our image.

ADRAINT

Right. Also, didn't Kanye West go to school here?

CAMILLA

Yes, his mom taught English. I always hear good things about her. Kanye donated tickets to us for his *DONDA* listening party—he really didn't have to do that. While we were at the concert, there was an English major sitting behind us, and he said that Kanye's mom rallied for him to graduate.

ADRAINT

What has your time been like at Chicago State so far?

CAMILLA

I really evolved into who I am now over quarantine. I wasn't shy before, but I wasn't where I am now, where I can go up to anyone and start a conversation. I've met a lot of people at this school—people that would be in my wedding! One of my good friends, Kayla, I randomly met her when I was going to see my advisor. She sat down next to me, and we just started talking.

It's important to remember that going to college is your own experience. What other people are doing should not influence you. You should always be true to yourself. Some people drop out of school because they feel like it isn't in their plans, but everyone's timeline isn't like that. I used to think about this a lot. People have different trade skills, and I don't have any big skills that I can make money off of, but I learned that it's their journey and not mine.

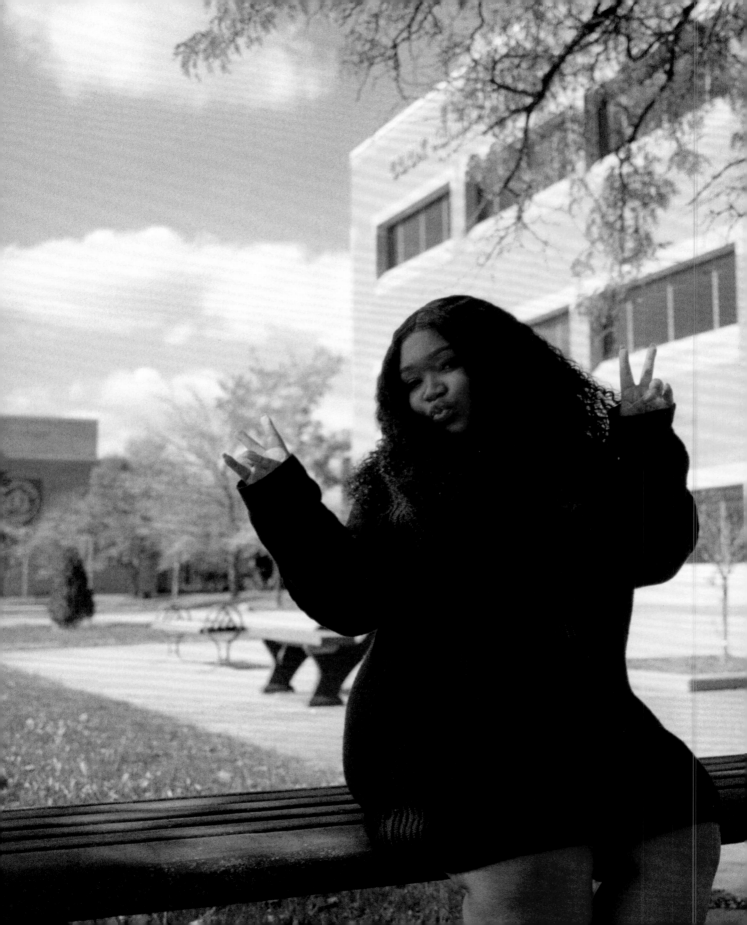

We have everything here. People only see it for its past. The student body is working to change some of the past misconceptions about our school. We're no longer in danger of closing and students are involved on campus. It's time to just reshape our image.

— C. Oakland

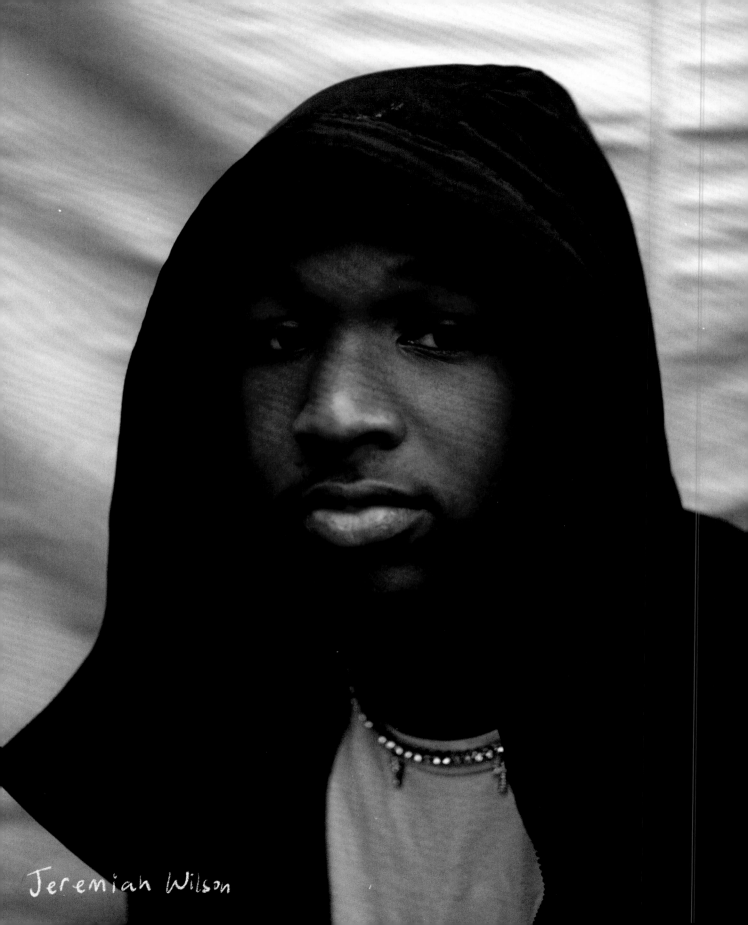

Jeremiah Wilson

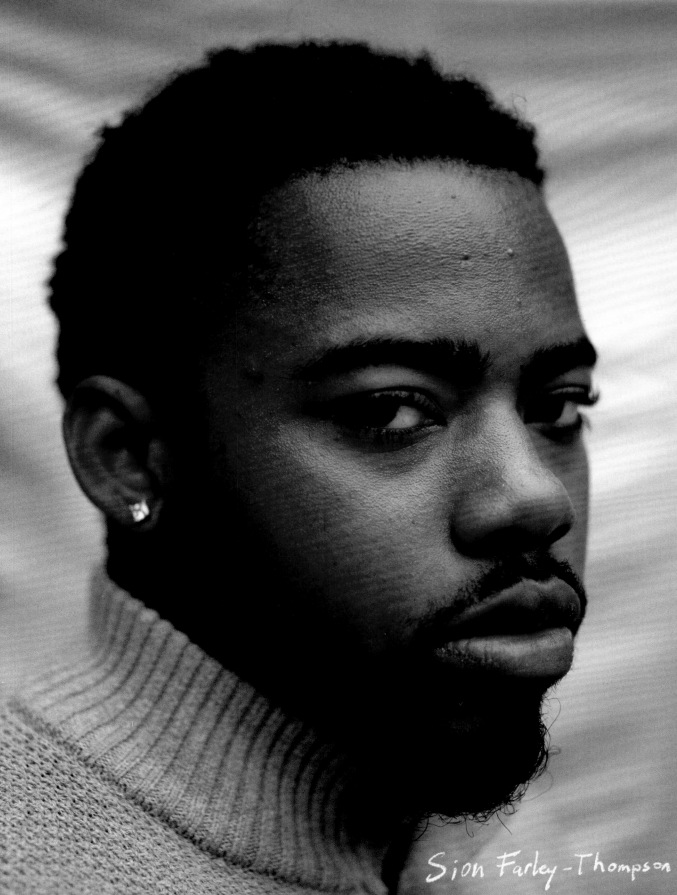

Sion Farley-Thompson

CODEE JONES
LOUISIANA STATE UNIVERSITY (LSU)

MAJOR	POLITICAL COMMUNICATION
CLASS	2022

ADRAINT How would you describe the difference between Baton Rouge and New Orleans, where you're from?

CODEE There are a lot of cultural differences. New Orleans is the crazy liberal city in Louisiana, and I get to see a lot of examples of successful Black people that really care about the city and look to preserve the area. In Baton Rouge, in the past four years that I've been here, it's a little different. There are a lot of successful Black people in Baton Rouge, but I haven't seen representation in a similar capacity to my upbringing in New Orleans. New Orleans is more welcoming to everyone, whether it be different minorities or immigrants.

ADRAINT Yeah. How did you end up choosing LSU? Were there other schools you were looking at?

CODEE Louisiana has a program called TOPS, which is a program aimed at retaining students to come back for post-grad by paying for a majority of your tuition based on your ACT scores. I was able to receive secondary layers of TOPS funding, and that covered all of my tuition in LSU. I went to a private, all-girl, predominantly white high school in New Orleans, and a lot people ended up going to LSU. Out of two hundred students in our class, ninety went to LSU, with a good portion of us attending because of the influence of TOPS. There were constant reminders to take advantage of this opportunity because you don't want to take on debt, and that's something I'm thankful for. I'm graduating with little to no debt at LSU!

ADRAINT

Before we started the interview, you mentioned something about the restaurant that we're sitting in right now; can you elaborate?

CODEE

The owners of this restaurant, Chimes to be exact, were at the Capitol riots. They, as well as the owners of Red Zeppelin Pizza and Parrain's Seafood, were at the Capitol riots. This is public information. There were pictures on Twitter and Facebook, and everybody was like, "These are literally the owners of a bunch of restaurants!" And, honestly, I'm not surprised. I'm really not surprised. Everybody's entitled to their political opinion, but based on this event and what it stood for, it was just a QAnon festival. It was an event that reflected the systems of oppression that Black people and everybody else faces in the world.

ADRAINT

Can you talk to me about the campus climate over the past four years and some of the social dynamics on campus?

CODEE

When I first was a freshman at LSU, I was a finance major in the business college, and it was really because my family wanted me to major in something I could easily get a job with. I hated math, and I hated finance. I found that out very quickly. The college of business at LSU really is not that diverse, with majority white male counterparts. We had, out of a class of two hundred, my first year, a 70 percent fail-out rate because it's really hard. It was me and a few Black people I met at orientation. We all decided we were going to stick together. I passed with a B luckily, but a lot of people did fail out.

Black mental health counselors are a big thing at LSU. They made sure that there was more of a safe space for Black LSU. The class of 2025 is the most diverse with majority minorities, so they're doing really well, but we want to make sure that the minorities are retained since a lot of people do drop out really fast. So that's something that we've done with diversity, but there are blatantly racist things. We've called them out, and the administration did take action in a sense.

ADRAINT

Do you think those promises have been held up over time? Has LSU done the work to demonstrate they mean business?

CODEE

Yes, I would say so. President Tate, the first Black president at LSU and in the history of the SEC,* was recently elected. The university was seeking to ensure they had a diverse candidacy, and I tasked Black students, especially those in my Black Student Union, with voting for President Tate. LSU has recently prioritized student involvement. We had the opportunity to attend Zoom meetings with presidential candidates, and they held a town hall meeting to discuss racism on campus during the LSU Blackout initiative. For the most part, the university has made an effort to be transparent about doing better and has wanted to hear the ideas of students—especially Black students—when it comes to diversity on campus and the state of the university. However, that hasn't been reflected outside of campus within the city of Baton Rouge.

Nightlife around LSU still employs discriminatory entry policies, for example. Tigerland bars still have rules such as if you don't have two earrings in your ear as a man then you can't get in, if you have a white t-shirt on then you can't get in, if you have tennis shoes on then you can't get in. The dress codes are to keep Black students or citizens from entering, and they are pretty blatant as to what kind of people they *want* to let in.

LSU has no control over this since it's not an LSU issue, but it reflects the culture of the university. For pre-game and post-game, it's honestly one of the safest options for people to go, so for the bars to do this, it's obvious what the intention is.

* THE SOUTHEASTERN CONFERENCE (SEC) IS A COLLEGIATE ATHLETIC CONFERENCE WHOSE MEMBERS INCLUDE SCHOOLS IN LOUISIANA, OKLAHOMA, TWO SCHOOLS IN TEXAS, ALABAMA, MISSISSIPPI, ARKANSAS, GEORGIA, FLORIDA, SOUTH CAROLINA, TENNESSEE, KENTUCKY, AND MISSOURI.

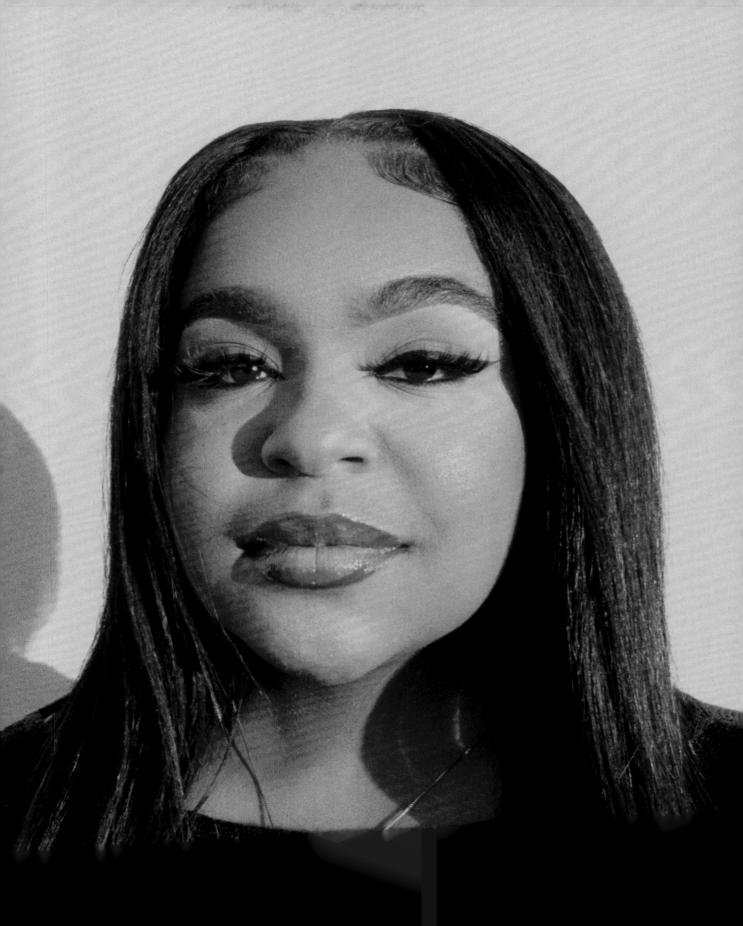

NYA LEWIS
LOUISIANA STATE UNIVERSITY (LSU)

MAJOR	ANIMAL SCIENCE
CLASS	2023

ADRAINT Introduce yourself, Nya! Tell us who you are.

NYA I'm currently a junior studying animal science, but funny story, I started developing allergies to animals. I'm currently trying to change my major and exploring some options right now. I'm currently looking at food and nutrition, and if I could be a dietitian and a personal trainer at the same time.

LSU was actually my last option and Texas A&M was my first, but that was a bad experience when I went to visit. Texas A&M is twice as big, and with about 60,000 students there I didn't see any Black people at all. I talked to the president of agriculture, who's also a Black woman, and I asked her, "So are there any organizations where Black people come together, because I haven't seen any?" She was like, "Well, if you need to be around Black people, maybe you should go to an HBCU."

Before my visit, I had read about some students harassing Black people, just walking through "free speech alley." And I was like, "How do y'all address those issues or deal with them?" She was like, "Racism's a part of life, you just have to deal with it." It was nothing proactive about helping Black students there. So after that, I knew I wouldn't feel comfortable going there.

ADRAINT That's really unfortunate on so many levels, and what a huge disappointment as someone who was seriously considering attending that school. Well now that you're here at LSU, what is the social scene like?

NYA I've talked to people, and I've been more open-minded about what I want or what I would be willing to date. I've been considering more dating outside of my race and talking to people outside of my race. It's still hard though. The pool is so small.

ADRAINT

What's the ratio of Black men to Black women on campus?*

NYA

I wouldn't know that. In my experience, the Black women are so beautiful, and so nice, and so cool, and so goal oriented and focused on school. And then the Black men are . . . here. They want to fuck and are not really interested in dating for real.

ADRAINT

How does that make you feel as someone that might potentially want to be courted in the future?

NYA

Sometimes it is frustrating, especially when I've talked to some of these guys and their mindsets are just gross. But, I also try to look at it as a positive thing: If there are no boys here to distract me, then I can focus on school! Boys are a distraction. Me and my roommate say that all the time. Boys are a distraction, so we just focus on school. Even just *liking* a boy gets distracting.

ADRAINT

It's very mature of you to set a dating standard for yourself and stand firm on how you would like to be treated. Not everyone has that level of discernment in college or throughout life in general.

NYA

I'm grateful that I came to LSU, and I've learned a lot. I feel like every year I just grow so much. I do have a lot of experiences, a lot of crazy stories. It's a roller coaster up and down.

* AT THIS MOMENT, WE ARE GRACEFULLY PAUSED BY A STUDENT SAYING, "YOU'RE SO PRETTY" TO NYA. WE SMILE, AND SHE SAYS, "THANK YOU!"

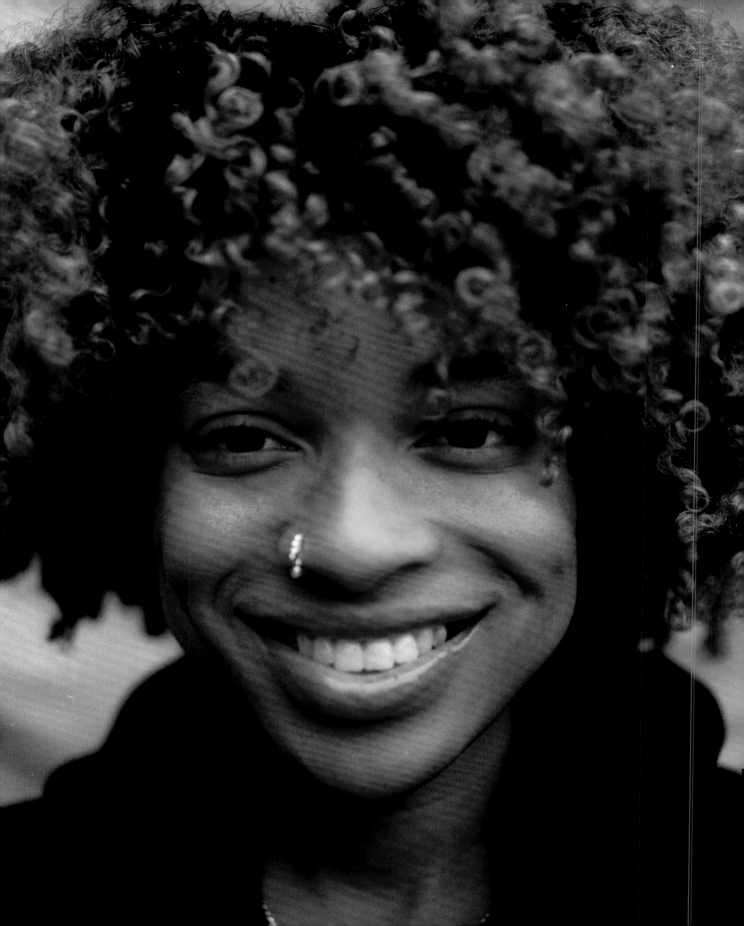

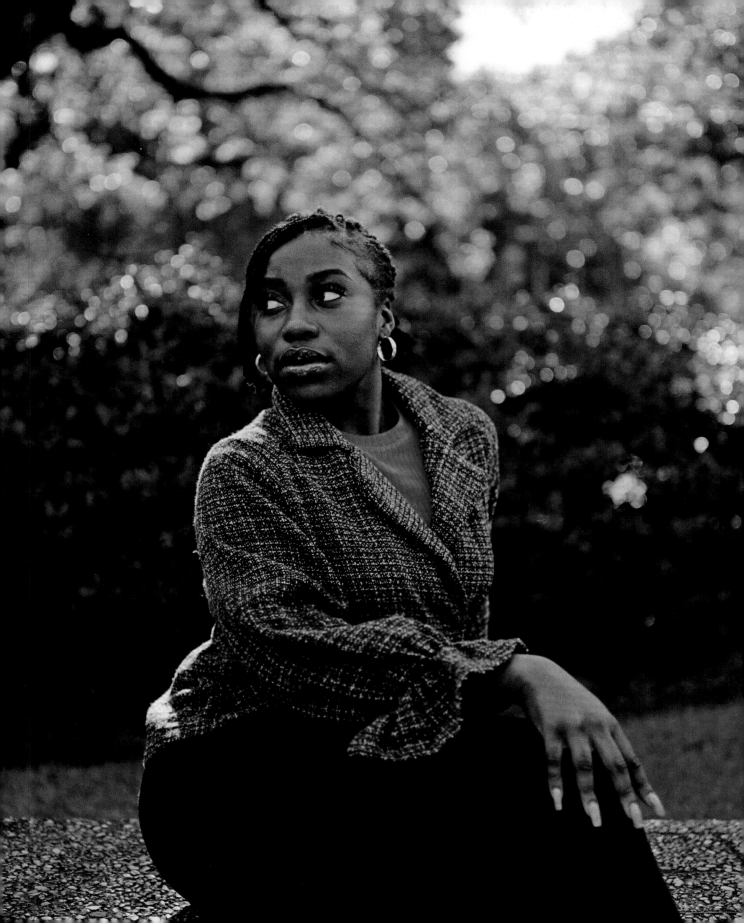

VANESSA TETTEH
LOUISIANA STATE UNIVERSITY (LSU)

MAJOR	KINESIOLOGY, PRE-MEDICINE
CLASS	2022

ADRAINT

What do you think about LSU so far? You grew up in Texas, which is also in the Deep South, but I think the terrain is so different.

VANESSA

Even though the two states are neighbors, my experiences as a Black woman have been very different. The colorism is a bit more prominent in Louisiana, especially being in college and going to LSU. I had finally built up my confidence around the time I turned eighteen, graduated, and came here. Within my first week here, my confidence went back to square one because of an unfortunate experience that I had at welcome week. It made me realize that I'm in a new place, but it doesn't mean anything; people are still going to be cruel. No matter where I go, I remember that strength matters and I have to be strong for myself. Unfortunately, the progress can only be seen by the darker-skin people because we are on the receiving end of that most of the time.

ADRAINT

For sure. How has that impacted your dating life here at LSU?

VANESSA

The people that I've been involved with say that color doesn't matter, but they don't realize that the way they act and treat me, as opposed to someone else who looks different is a very . . . obvious distinction. People have just been conditioned to favor something else. As far as my dating life, I haven't really had too many issues. Honestly, I don't really date like that, but from the men that I haven't been involved with, they say, "Oh, you're my type. You're so beautiful," but it doesn't add up with their social media likes, who they hang around, or who they used to date. So, it makes me feel like, am I an exception? Do you really care for me? People overuse the word "preference" to cover up the fact that they are prejudiced or colorist—it's a blanket word. I don't like the term because there are so many people in the world who have so much to offer, all bringing something different from the next. The closed-mindedness is revealed by that word.

ADRAINT

I think on college campuses, it's even more aggressive. There's a hyperfixation on social hierarchy. What does that look like here?

VANESSA

Greeks and student government or anything political share a tier. Then there are those who I call the NARPs, nonathletic regular people. (I'm one of them obviously.) Athletes are at the top of the food chain. Everybody looks up to them, loves them, and treats them as celebrities. From what I've seen, people try hard to infiltrate friend groups that are well known. I'm happy with the genuine people that I have in my life, so I've never been the type to do that. If there's a girl that's very popular, guys want to be attached to her, and it's sickening because it's never genuine. I've experienced a lot of instances where guys just want it to be known that they know you, and they use you for everything you have. And when you actually need a friend, you can't call on them because they were never your friend in the first place. They were just using you. It's unfortunate, but it actually happens a lot.

ADRAINT

What have been the successes of your time here at LSU?

VANESSA

I would say keeping good grades while maintaining my mental health. That's a huge plus for me since it's the most important thing. I suffer from really bad depression and, on top of that, I went through a breakup during one of my worst semesters here. That really set me back, but I'm proud of my growth and self-discovery. I feel like I never really knew who I was or had an identity until I got to college. My whole life I was living to please others, living in the shadow of somebody else. Now that I'm here, I was able to break away and become an individual. I appreciate myself so much for that because it's not easy, and not everybody gets the chance to truly *know* themselves.

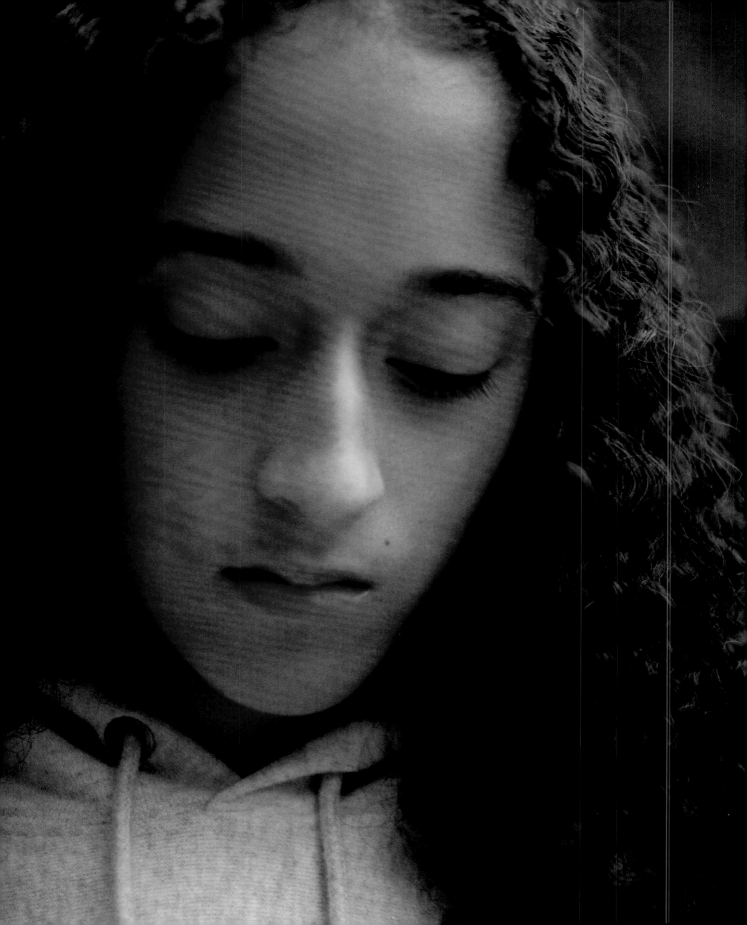

ON BEING STUDENT BODY PRESIDENT

—JAVIN BOWMAN

MAJOR: SOCIOLOGY
(CRIMINOLOGY) & POLITICAL
SCIENCE (AMERICAN GOVERNMENT
AND POLITICAL ANALYSIS)

CLASS OF 2022

LOUISIANA STATE UNIVERSITY
(LSU)

This year's whole campaign season was about how being Black is not a monolith. It is a story that we have created for each other in our fight for equity because equity encompasses equality. Our opinions on how we get there are going to be different.

There are a lot of internal things that need change, but the main things that we fought for were climate, culture, and community. We really try to change the way of thinking and to try to see it from other perspectives, which is so hard to do with so many people who are rooted in what the American South is—*what it used to be*. But if you can get through to those people, if you can talk to them and be like, "This is why it matters. This is why it's important. This is why we fight for what we fight for," it makes it worth it every single day.

I do not believe my job is to teach people. No, I don't. It's not to teach grown folks the difference between right and wrong or why racism is bad and why it still exists. No, it's not my job to teach people that.

Three things stick with me the most and they all connect because they deal with my love for LSU, for Louisiana, and my belief that we're going in a good direction.

First, Dr. William Tate is our president. He is the first Black president of an SEC institution (the Southeastern Conference is Louisiana, Oklahoma, two schools in Texas, Alabama, Mississippi, Arkansas, Georgia, Florida, South Carolina, Tennessee, Kentucky, Missouri— all historically racist). Not only was Dr. Tate the first Black president, he was also the first Black provost, which is the second-highest position within a university. When he became our president, Black board supervisors and members cried; among them was a man named Collis Temple. He was the first Black integrated basketball player on campus, now sitting with board supervisors and seeing a Black man become president of the university. That was heartwarming for me because I'm like, "Wow. We can make change."

Second, in that same meeting, we elected our first Black woman chairperson of the institution. The chair of the board represents LSU in its most literal sense, so for the first time in our university's history, a Black woman *is* LSU.

Third, and when I think about this semester, I think about my friend Chandler. He's homecoming king—a Black homecoming king. And I'm a Black student body president. All of these things are positive signs of moving forward, progressing as a state, as a people.

Now, I do understand my privileges, whether that be economic status or being a man in America, but I have experienced the racism. From being belittled, to walking into rooms where you're the only person of color, to being tokenized, to just tap dancing, to everything. All in one. It's a hard fight because if you don't believe people really can change, then it kind of goes against the work. But if you believe that people can at least move forward, then it's a worthwhile fight. There are so many other fights going on in the world, but you have to start somewhere and realize you can't do it alone. I always say I don't think anybody comes together like the people of Louisiana when a hurricane hits. It don't matter who you are, what you look like, what you believe in. We just come together.

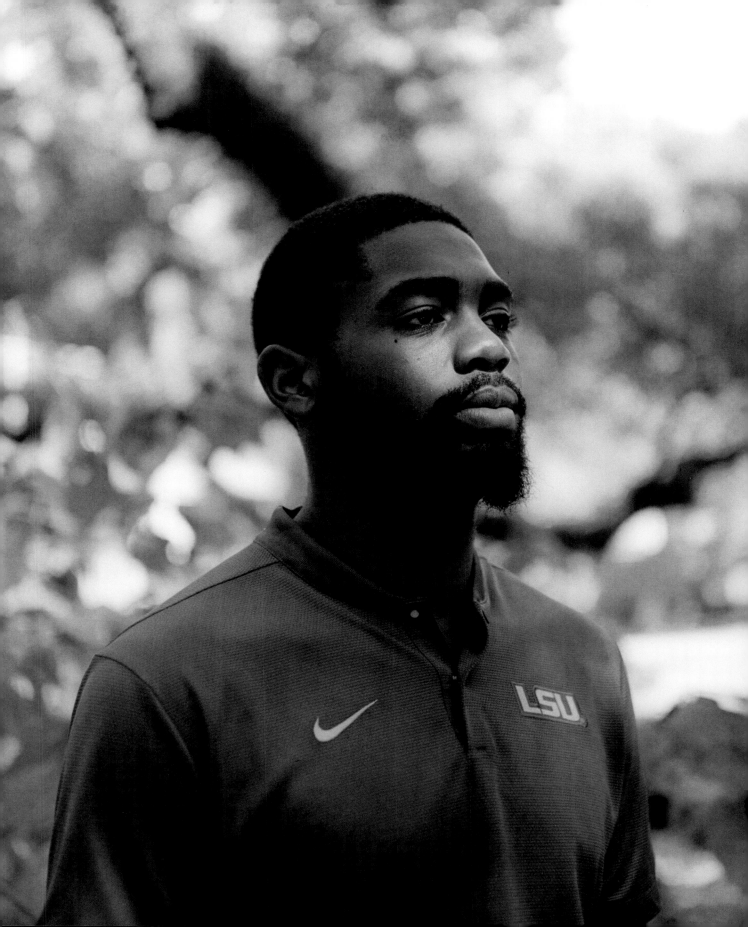

HARVARD UNIVERSITY

CAMBRIDGE, MA

MILES MOODY
HARVARD UNIVERSITY

MAJOR	ECONOMICS & AFRICAN AMERICAN STUDIES
CLASS	2023

ADRAINT

What's your story that led you to Harvard?

MILES

I had a cousin, two years older than me, that came to Harvard. She was like, "You got to apply early. This is the place." I didn't want to apply, but my parents and my sister told me, "You have the credentials, definitely consider it." And so I did and somehow ended up getting in.

The visiting days my senior year of high school helped convince me. Part of the pull was definitely the Black community. There are a lot of different Black boards on campus and a strong sense of community and organization in general. I felt I could find myself in different spaces, and hearing about my parents' and sister's undergraduate experiences, I thought, "Okay. I will be in that fold, and I want to be a part of the Black community." I also saw how I could meet so many different types of people here. You will meet Olympians and future presidents in this space, and I found it really rewarding being a part of that community.

On visit days, Harvard has a certain brand that they want to portray to incoming students. Obviously, the Black students who are currently here want to get more Black students into the school. Those first few days, I saw all the organizations working together, and they didn't feel insulated from each other. But what I found was the Black community is very segmented among (1) your ethnic identity; (2) your social class; and (3) your political identity, your sexual orientation, or your political views.

ADRAINT

What's your opinion of the Black community now that you've been here?

MILES

It's a space that you can always go back to and feel like it's home. But there are some people who buy into this idea of this community so much that they actually cut off opportunities to meet so many other amazing people. For instance, all the freshmen eat together in the big dining hall called Annenberg, and you can meet whoever you want. There were the few Black tables in that space, and while I was a participant, I felt as though people were starting to frown upon you if you stepped away and moved outside of those spaces.

ADRAINT

So how did that impact you emotionally? Was that ever frustrating trying to find a balance between how far away is too far away and how close is the right amount of closeness?

MILES

Absolutely. I grew up in a predominantly white area, so that dynamic navigating white spaces but also having Black friends has been a constant struggle of my life. Freshman year, I felt a need to be a part of the Black community because I didn't want to miss out on this bigger thing. If you're not in it and seen in it, then that's it. That was my biggest fear. So I went in thinking I need to go to all the Black events, I need to meet all the Black people. Then I realized not everyone's going to fuck with everyone just because you're Black.

It shifted to searching for people that I just enjoy being around and can grow with. Again, that steps outside of your Blackness. The balance became about who is making me a better person, who can I learn from.

ADRAINT

What have you walked away from that experience with? It's a little dizzying when the world around you defies your assumed reality. Are there any Black student organizations that have been integral to your time here so far?

MILES

The Generational African American Student Association was formed in my time here. I was part of the founding board, which was a really important space for me. Before coming here, when I thought about Black people—and this was ignorant of me—I always just was like, "Oh, you're Black, you're Black." I wasn't really thinking about the multitude of being I'm Nigerian American or other different ethnicities. I felt like there wasn't a group at the time that really resonated with my cultural identity as a generational African American. They asked me to join the board, so I served as treasurer. Now I'm vice president, and that's been a really big highlight for me. We just had our club meeting, and there were so many freshmen coming up like, "Oh, my God. I heard about this club. I'm so excited to join."

Outside of that, it's the ability to say I'm going to leave this space with friends for life. College is really hyped up to be like this major part of your life, so I'm glad I can say I actually made genuine friends and people who will continue to care about me for the rest of my life.

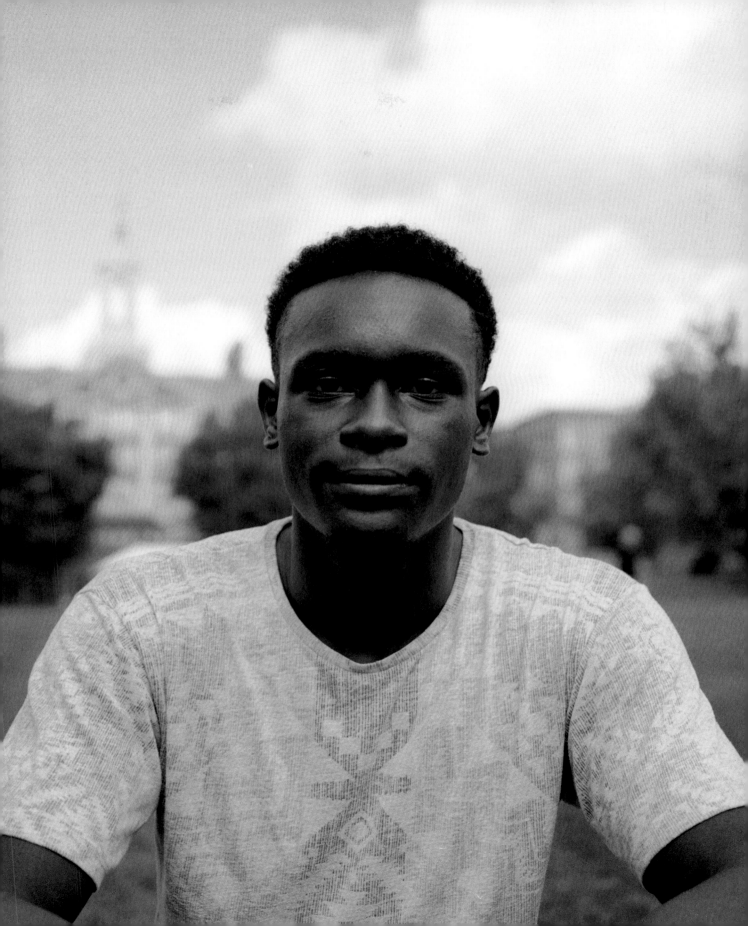

NOAH HARRIS
HARVARD UNIVERSITY

MAJOR	GOVERNMENT
CLASS	2022

ADRAINT

I saw you're from Hattiesburg, and I knew I had to talk to you because I feel like I never really meet anybody from Hattiesburg outside of Hattiesburg.

NOAH

Mississippi, in general, has a lot of people who really love that area, and I do too. But there are a lot of people who do want to see other places, and I think that really expands your world view. Sometimes that makes home feel even that more special. It's a cool opportunity for me to be up here at a school like Harvard. I never really saw myself being able to go to an Ivy League school. I was always focused on what I call the "Southern Ivies"—Vanderbilt, Duke, maybe even Georgetown or something like that. So, I'm just trying to take advantage of every opportunity and bring people along, encouraging others to feel empowered in their strengths and what they can do. I wouldn't be here if people didn't do that for me.

ADRAINT

Yeah, and you're the first Black student body president at Harvard, right?

NOAH

Well, first Black *man* to be student body president. I think when people see "first" and "Black" and "Harvard," some of the details get left out. I want to make sure people know that Fentrice Driskell becoming the first Black student body president at Harvard in 2001 and creating a narrative for what's possible for someone like me is really important.

ADRAINT Can you speak to your undergraduate experience so far?

NOAH I've really enjoyed my time here. I've been involved with stu-
 dent government from right when I got to campus. But the
 transition was probably the hardest part, trying to get used to
 what it is like to be up here with some of the smartest young
 people in the world. And that's not hyperbole. This is a very
 hyperactive elite space that I was just not used to, so it was a
 tough period of not only getting used to college—which is hard
 enough—but getting used to *Harvard*.

 I'm glad I found a great community of people up here who
 really appreciate me for who I am. It has been really nice to
 know that you don't have to worry about trying to be the best.
 You can just be yourself and work on what you're passionate
 about and have peace in knowing that you are at Harvard. I try
 to tell people all the time: Don't overextend yourself or try to be
 somebody you're not just because you are a Harvard student.

ADRAINT How were you able to find your community here?

NOAH It took a minute. Originally, you have your people who live in
 the same dorm, and you make some friends there. I had this
 really cool pre-orientation program called the First-Year Urban
 Program that helps students from rural or Southern areas get
 used to living in a city and everything that comes with that.
 I made a lot of friends there too. As with any school or any new
 context, you meet people here and there, and then you just
 continue to build up until you start to get pretty comfortable.

ADRAINT You spoke at the Black Students Association's Black
 Convocation. Can you talk to me about what you said?

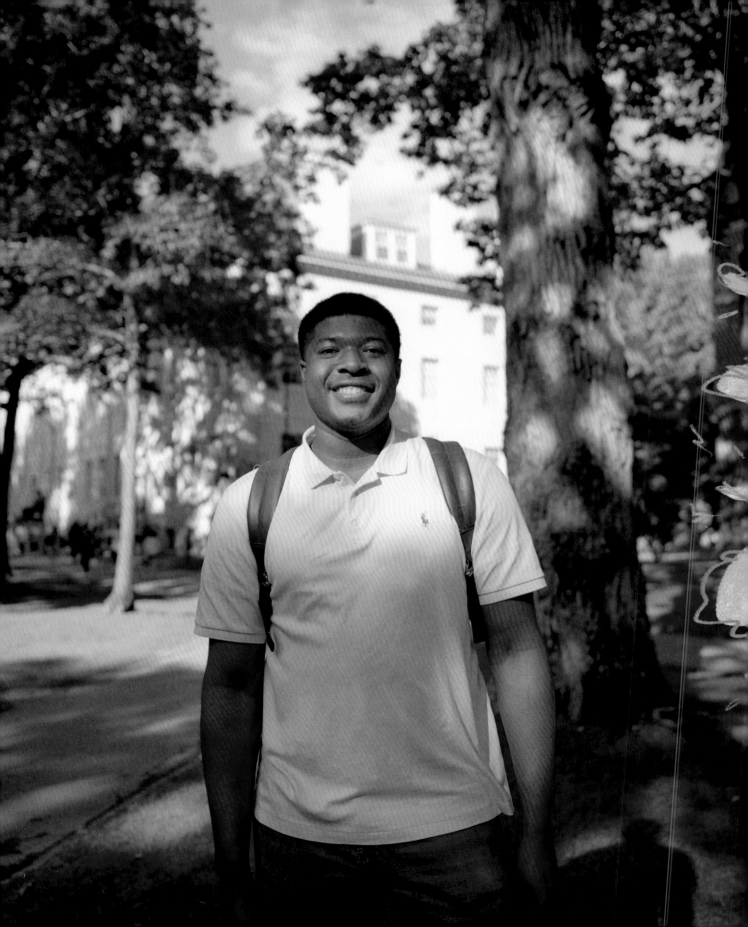

NOAH

I talked about my story as somebody who literally considered not submitting an application. But my mom, she's been in education for over twenty-five years, told me that schools like Harvard aren't looking for you to be perfect. They're looking for you to display the passion and drive to execute the things that you're interested in, but also to just be a positive influence on that community. You don't have to be a genius to go to Harvard, you can be somebody who works really hard and who knows how to make the most out of certain situations.

That was an eye-opener for me, and now that I've come here, I can see these people are normal. Then, being able to go back home and tell other people those things, I'm seeing the kids in my community expanding the range of schools that they feel that they can belong at. One of the coolest things about my experience is being able to shine the light on what is very unclear for a lot of people where we live.

We're definitely a family, the Black community here. We look after one another, we give each other advice, and we bring people along. We have 15 percent Black people at Harvard, which I think is close to the most out of all the Ivy League schools. We are a very well-represented group here, and I think that's amazing.

NOAH

Of course, every family does have their disagreements on certain things. Out of the 15 percent of Black/African American students, about 65 percent of these people are either first-generation African or they more closely identify with being Nigerian, Caribbean, or Jamaican instead. And then you have your generational African American people descended from slavery. There is a little bit of a divide there, a little bit of friction. It's not much, but it's definitely noticeable because Harvard does accept more people who are *not* descendants of slavery. And so what does that conversation mean? And these are questions that you continue to ask yourself, what is the Black experience in America? Who does it include? The generational oppression, whose families were affected by that, whose weren't? It's different for everyone. These are conversations that we are grappling with as a diaspora.

In Mississippi, all the Black people are descendants of slavery, we're all African American. We're just Black. But now my world view of what it means to be Black in America has grown so much, and I think that's really valuable.

OSAZI AL KHALIQ
HARVARD UNIVERSITY

MAJOR	GOVERNMENT
CLASS	2023

ADRAINT

What has been your greatest takeaway so far here at Harvard? What has been the thing that's been the most impactful?

OSAZI

A pretty early realization that I had, just based off the opportunities that are present here at Harvard, is that it's very much a professional space. It's a lot about where the opportunities here push you, whether directly or indirectly. Which I considered coming into college, but I hadn't really thought through the implications that it would have on my ambitions, my goals, and my desires.

ADRAINT

What do your friends think back home? Does Atlanta still feel like somewhere that you identify with?

OSAZI

Yeah, Atlanta's definitely home. Everybody from friends to family to acquaintances are very happy for me to attend a place like Harvard. Being a Harvard student is most fulfilling when I go back to Atlanta and I'm in interaction with those who aspire to be in the position that I'm in.

PIERRE LESPERANCE
HARVARD UNIVERSITY

MAJOR	ECONOMICS
CLASS	2023

ADRAINT

How'd you end up in Harvard?

PIERRE

I really wanted to go to Stanford. That was my number-one choice just because I grew up in Florida, I wanted another warm-weather college. I ended up getting deferred, and then denied. I recycled my Stanford essay and applied to Harvard. At the time, Harvard wasn't even my *second* choice. I wanted to go to Penn. I just applied because it's a very easy, short application, and it ended up working out! When it was time to choose which college, I ended up choosing Penn. And then the next day, I couldn't sleep. Everyone at school the next day was like, "Why'd you choose Penn over Harvard?" I just kept hearing that voice in my head. I tried to go home, take a nap. I couldn't. So, I called up Harvard and asked, "Is it too late to commit?"

ADRAINT

You said your dad's Haitian, your mom's Jamaican. What did your parents think about the whole Harvard thing? Was that always something they knew? Like, all right, we know that he's going to go to this tier of schools.

PIERRE

Since middle school I had always expressed interest in going to one of these schools—Penn at first, then Stanford took over later on. They always knew I wanted to go somewhere. My dad kept arguing for me to apply to Harvard because the financial aid here was actually really, really good. I just never wanted to go here. I'm not a big New England guy, but now I like it. They were very supportive, but they never pushed me in that direction. I wanted to do this on my own, and they just said, "How can we help him do that?"

ADRAINT Well now that you've made it, what do you do for fun around
 campus?

PIERRE We play a lot of pickup basketball. It's funny because when
 you're Black you're expected to be good at basketball. I am
 not that good. And you see other people from all kinds of
 backgrounds just balling it. It's nice to see because, I guess,
 it's breaking stereotypes.

 I also joined the Black Men's Forum freshman year. They bring
 a lot of speakers, do a lot of social events. It's really just about
 learning, talking to other people, and networking.

ADRAINT That's tight. We had something similar. A lot of my friends
 who maybe weren't cis heterosexual men always had hes-
 itation around joining due to the environment not being the
 most inclusive.

PIERRE Yeah, we had the same problem before I got here. I think peo-
 ple with certain gender identities or sexual orientations didn't
 quite feel comfortable. They've tried to make a better effort
 now, not just defining masculinity in one way, but it'll probably
 take a while for certain communities to feel comfortable. There
 were some bad experiences, ostracizing some of the Black
 female organizations, stuff like that.

 It's actually crazy to see how common that is. At first, I
 thought maybe that was very specific to Harvard, but it seems
 to be everywhere. I think it's going to take some time, like
 with anything.

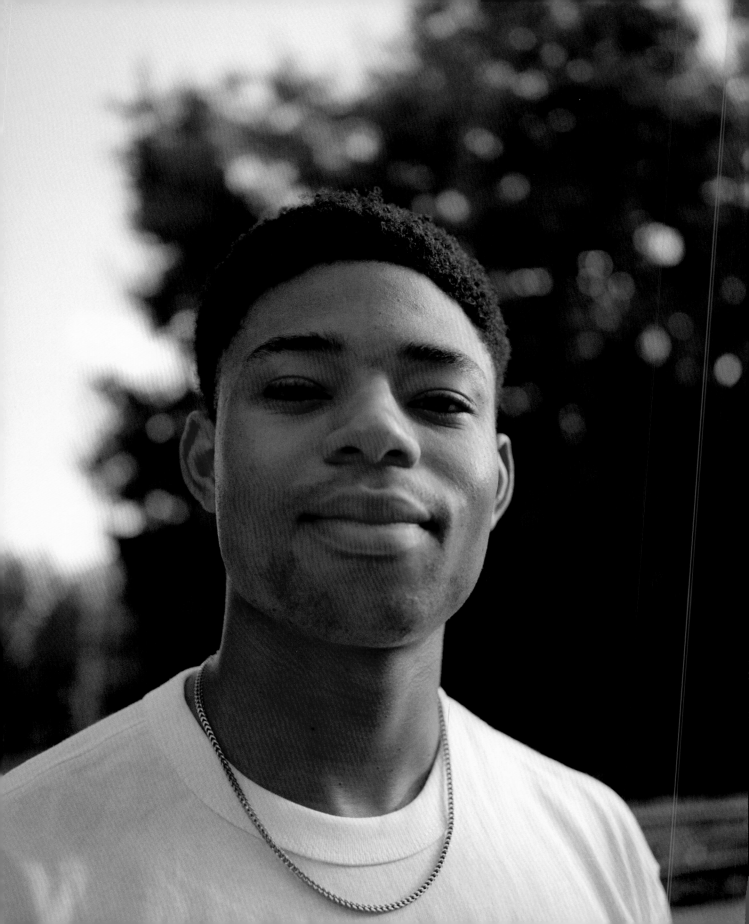

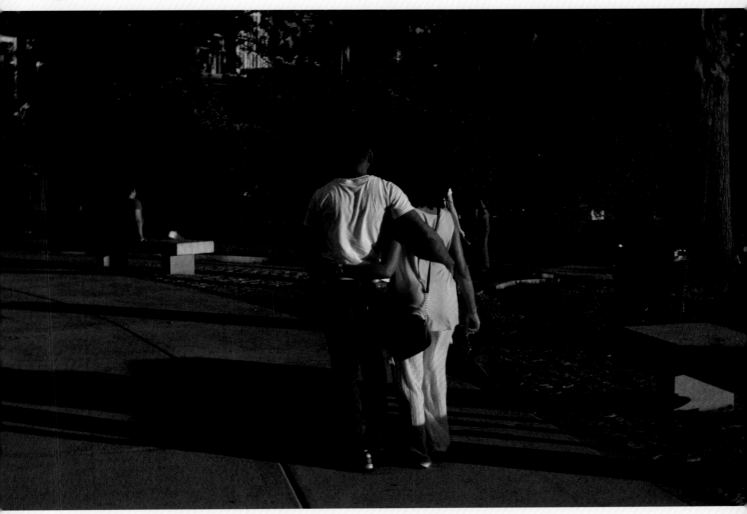

PREDOMINANTLY WHITE INSTITUTIONS (PWI)

ON COLORISM AND THE NUANCE OF "PREFERENCE"

—MARISSA JOSEPH

MAJOR: HISTORY & LITERATURE

CLASS OF 2023

HARVARD UNIVERSITY

Colleges used to be a center for political engagement and political activism. That work isn't happening here anymore, and it's concerning because we're supposed to be the brightest minds of the Black community. To a certain extent, I think that's because Harvard as a whole has gotten more inclusive. We are more welcome in white spaces, so that lends to greater comfort. You can join white organizations, and they'll make you feel great about yourself and included. So the only time that you feel the need to speak up is when that comfort is challenged within the context of the university. We don't talk enough about what's going on in the larger world.

Whenever there's a lot of discourse happening about an issue within the Black community on campus, we'll have a conversation about it. Within this past year, the big stirs were about colorism, sexual assault, and a diaspora war, for lack of a better term. The Black women on this campus have ended up bearing a lot of the weight for these issues.

The colorism conversation took place because the dating culture here is weird. There's a large hookup culture, but not many people who are in healthy relationships—keyword, *healthy*—and the ones that are in relationships are often light-skinned and biracial. There's a lot of internal beef in social politics among women here about desirability: who gets boys, who doesn't.

When we talk about colorism, it's always in reference to the male gaze and not to the institutional aspects. And when you frame colorism as a conversation about desirability, it is easier for men to try and discredit you by saying, "Oh, it's just a preference." But when you talk about colorism as a wider systemic issue preventing you from seeking opportunities because the world revolves around a certain beauty standard, that's when you get into the meat of a conversation. That's not the conversation we're having at Harvard.

As a dark-skinned woman, I didn't think it was a productive conversation. It was just a lot of people needing to air out their grievances. The Black men on this campus are pretty consistently disrespectful toward women in romantic situations, and that disrespect significantly increases when they're dealing with dark-skinned women.

Harvard is like a microcosm of the larger world. My light-skinned friends have an easier time here socially with white people because they're seen as less aggressive, more approachable. Because of this, I have had to work extra hard in a lot of spaces to remain authentic while trying not to be seen as the ghetto loud Black girl (even though I'm very much a suburbanized bitch and not from the hood by any capacity). Colorism takes its form on this campus in the same way that it takes its form out in the world.

The colorism conversation is still not really resolved because, again, it was only framed around the dating culture here. I'm not going to sit on a Zoom call or in whatever forum and convince you that I am worthy of being loved. If you don't see that, then that's on you, but what you're not going to do is deny me opportunities and respect. I would like to open your eyes to the biases that are clouding your judgment. I don't think that was achieved, to be honest with you. So that's colorism.

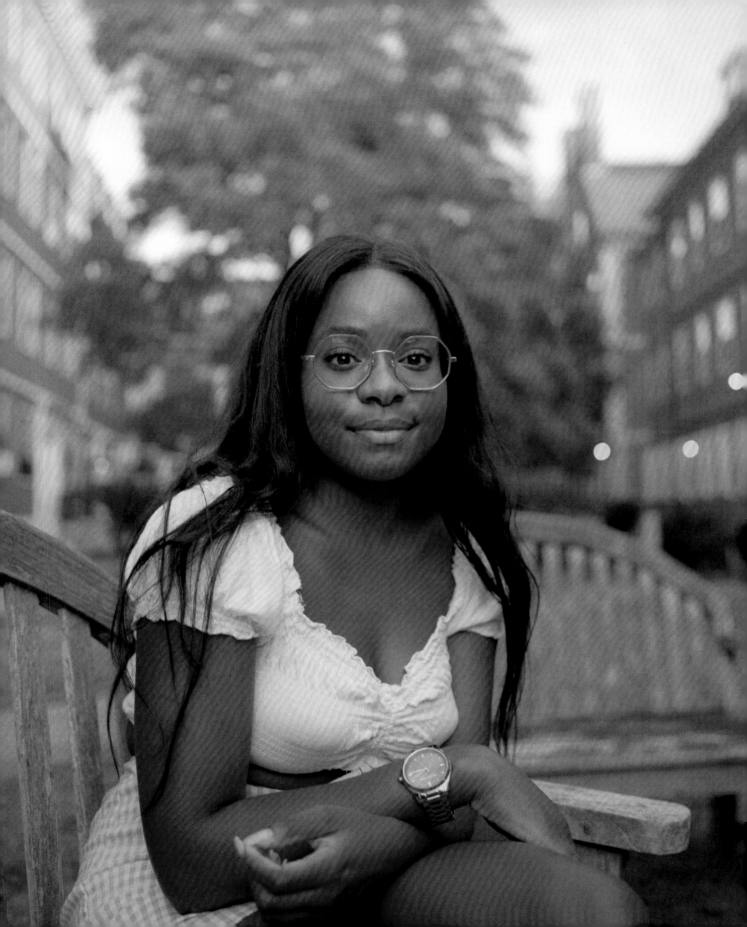

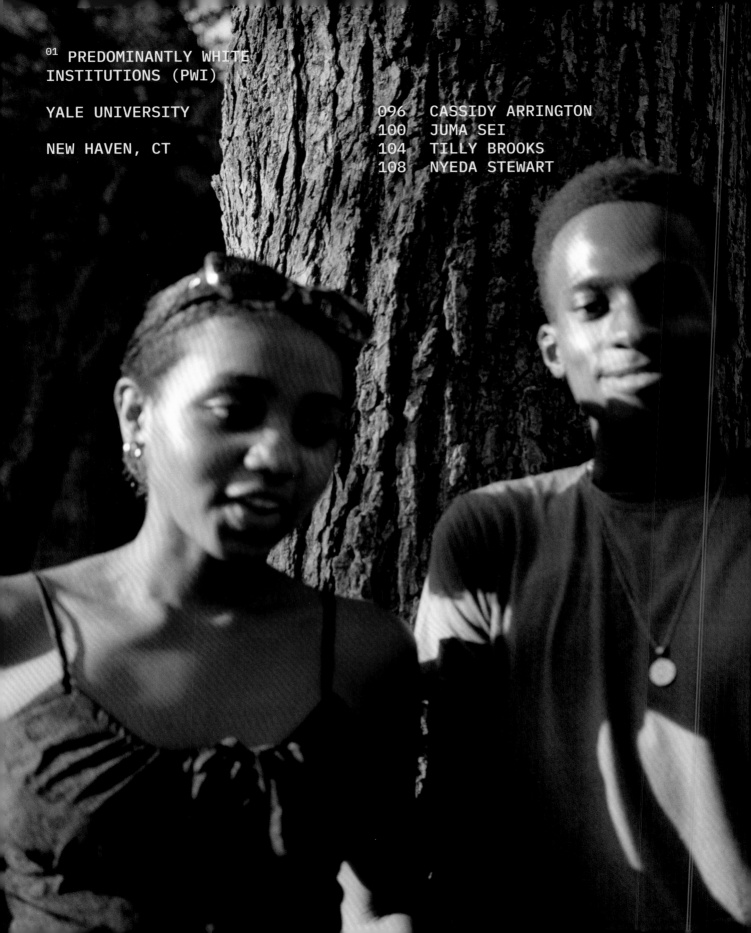

YALE UNIVERSITY

NEW HAVEN, CT

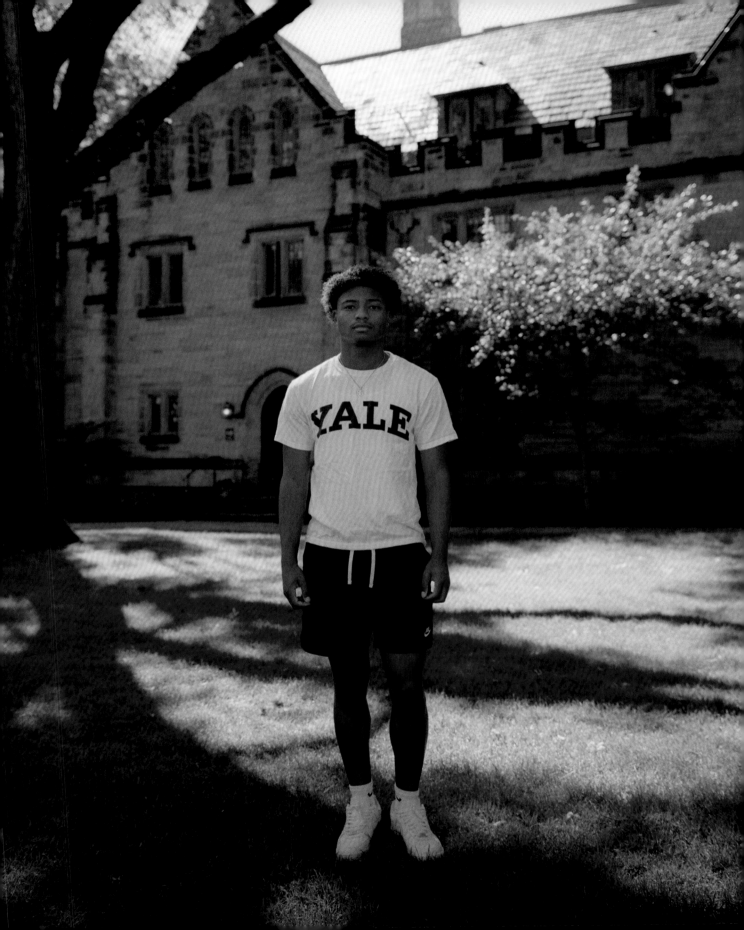

CASSIDY ARRINGTON
YALE UNIVERSITY

MAJOR	WOMEN, GENDER, AND SEXUALITY STUDIES; ENVIRONMENTAL STUDIES & FRENCH
CLASS	2023

ADRAINT

What's been your experience at Yale so far? What did your first interactions with the campus look like?

CASSIDY

When I first visited Yale, for whatever reason, there were only Black women giving the tours that day. I'm not sure why, but I was so brainwashed. I was like, "Oh my God, you are basically an HBCU."

Fast-forward to visiting again during Bulldog Days; I remember I went up to the registration table, and there were none of those Black women. There was a big crowd of students who all knew each other from the same school. They shook my hand (which we don't do in Philly) and asked me how many Ivies I got into. So, I was already really stressed out and didn't really engage in the activities they had planned for us. After that, I just shut down a lot and thought this school might not be it.

What changed my mind was when I was sitting alone, and some current Yale students came up to talk and eat lunch there with me, unprompted. It was really nice and welcoming. That moment is the whole reason why I ended up coming here.

When I got on campus, I was really homesick and didn't make any friends. I joined WORD: Performance Poetry, and that was my space for the first semester. I started doing a bunch of things that were practices of solitude, but that helped me so tremendously to get through that period, like listening to music, writing poems, and bookbinding.

And then it got better, I found out where the people of color were and felt less like I was at a PWI with a bunch of rich people, but more like I can really craft this space in the same way that I learned to craft space in high school.

ADRAINT

Yeah, it's a very common feeling of what you did have very early on, but what's been your relationship with the Black community at Yale?

CASSIDY

I met more kids of color on campus when I started going to the Afro-American Cultural Center. That was really great for me. Beyond just being in clubs there, I was making a lot of friends that I could study with for hours, and that quality time was very important. I felt more comfortable talking and expressing myself. After a while, though, it became suffocatingly frustrating to be around so many straight people. The only people I cared about were women of color, those were my circles, but a lot of them weren't queer.

At Yale, there's the presence of Southern Christian Jack-and-Jill families and first-gen families from Catholic or Christian, colonized countries. I was having to advocate for more cis, straight Black men to come into the space when I didn't really care if they were there or not! It wasn't actively homophobic, but it felt like a way of exclusion. I made queer friends by joining BlackOut, the queer affinity group, and it was nice to be around people of different genders and sexualities. We all related on a lot of different topics, but also just how we feel at Yale.

The Black community at Yale is really like every other community in that you're going to find people with very different interests. I figured that there wouldn't be the same level of diversity of Blackness that you might have at an HBCU, maybe there isn't, but in any microcosm of Blackness, you're still going to see it.

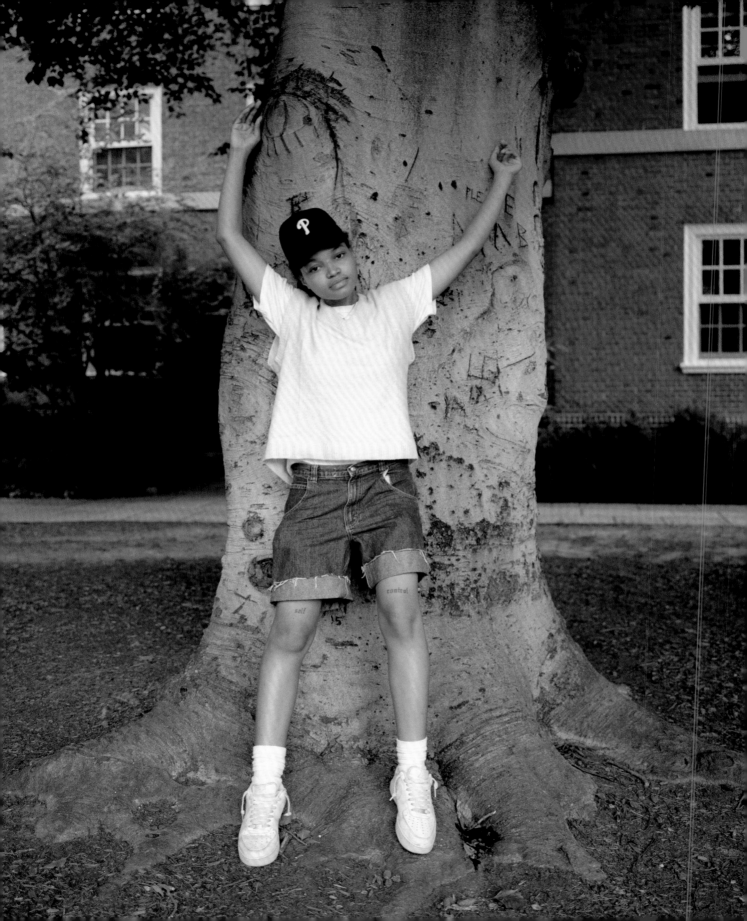

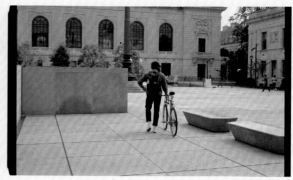

Juma at Yale University

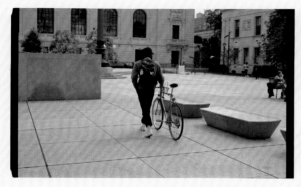

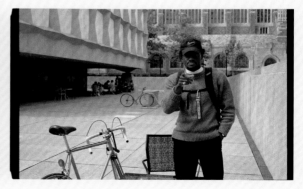

JUMA SEI
YALE UNIVERSITY

MAJOR	AMERICAN STUDIES
CLASS	2022

ADRAINT

You're from Portland and went to a predominantly white high school. I imagine Yale in a lot of ways is very similar to where you grew up. Talk to me about your undergraduate experience in comparison to where you were raised. How do you affirm yourself here?

JUMA

My experience at Yale in the classroom, at least the points of most static have had to do with the fact that I'm an athlete. Primarily because not only am I a nigga, I'm a nigga athlete. And if we're talking about impostor syndrome coming into Yale, I had two strikes against me from get-go.

Not only do people already think that I got in just because I was one of the only Black kids from my area or my high school, but I also literally went through a different admissions process than most people. Or at least the process immediately following submitting my application was very, very different.

I can see that in the comments people make about, "Oh, I didn't know you were an athlete," or "You're not like most people on the track team or the football team." It's all just high-key racially coded. In just saying, "Oh, you are separate from or other than the other niggas that we see." Which I don't know what to do with that. I definitely felt the impulse to not use my athletic backpack and use my regular backpack.

The frustrating thing is I don't know how much of me choosing not to present as a typical athlete is because that is my own genuine self-expression or if it's a projection of all the things and all the stereotypes that people impose upon me. That's the most frustrating bit about navigating Yale, just in terms . . . in general . . . about being a Black student here.

ADRAINT

When did you know that choosing Yale was the right decision?

JUMA

The first point that made me feel I made the right choice and that this is a community I could really mess with, was the first month of my sophomore year. It was when *Noir* by Smino dropped. The night that it dropped, I was with my best friend at the time and then three of our other friends who were in the year above.

We had so much work to do. We were in the AFAM house, and all of us had to write essays up. We decided we were going to grind until midnight and get this done. Once it's done, once we submit our work, we're just going to go down to the lighting room (one of the rooms in the AFAM house), turn off all the lights, and just vibe and listen to *Noir* all the way through.

I still remember hearing "Covert" come on for the very first time and being like, "Okay, first, this album is fire. But also, wow, literally nothing matters right now. I'm at school. These are people that I don't really know very well, but this is a bonding moment that I'm going to remember for a very, very long time." I was really fortunate to have one of those moments pretty early on.

ADRAINT

So, you're on the track team, and it's been a huge part of your time here. Not to fixate on numbers, but there aren't a ton of Black students at Yale, and I imagine there are even less within the track team. As someone who knows absolutely nothing about sports, can you walk me through that space? What's the landscape like?

JUMA

Small. Yes. And that was a point of tension for me when deciding where I wanted to commit. Harvard's track team is a lot Blacker than ours. Actually, most of the track teams in the Ivy League are much Blacker than ours. I think we have six or so Black first-years coming in this year. When I was a first-year, it was three across sprints, jumps, throws, and a cross country. Mind you, track and field is 110 people total.

In a lot of ways, the track community is the whitest space that I actively engage in outside of my classes, which was a point of frustration for me my first year. It felt very uncomfortable in a way that was weird to me. I know how to be around white people, but this is a different kind of whiteness that I didn't know how to navigate. Honestly, socially it was very "vineyard mind," you know what I mean? I know how to handle granola white, liberal white, and Portland white, but this was very much country-club white. I felt out of place. The senior class when I came in were not people that I felt the most comfortable with, but now it feels very different. I have four years of history with all the white folks that are in my year and the years below. And I'm captain, so I have a different relationship and level of buy-in with the program now.

ADRAINT

It's such a special feeling to be able to carve out a space for yourself somewhere you spend a lot of time. I struggled a lot with that in undergrad, so it makes me happy hearing how you've been able to affirm yourself at every step of the way so confidently. That's the type of thing people dream of. And surely it hasn't all been happy because that's just life, but what's been your pride and joy?

JUMA

Honestly my pride and joy is feeling like I know so many people on campus. There's something pretty radical in knowing that this is a university that, when it was founded, I literally would not be allowed to be a member of. You know what I mean? Hey, I literally could not attend. And now I walk campus and it genuinely feels like this is mine to some degree. And there's obviously moments when that is very much a conflicting feeling to have, or moments when it doesn't feel very easy and it's especially challenging to feel like this place is mine. But I love the idea of riding my bike around New Haven and being able to say hi to five, ten, fifteen, twenty people. I think that is my biggest accomplishment at Yale. That I've been able to make it a home. The university talks a lot about how it does that for students, and I do think that there is some validity to that. I'm a first-year counselor. I work with my dean and head of college, and I see that the systems of support are there. But I know the reality is that there are a lot of students who can't find that community at Yale, especially a lot of Black students, so just feeling I've been one of the lucky ones is definitely one of my greatest accomplishments. It has not been an easy journey at all, but I'm here.

TILLY BROOKS
YALE UNIVERSITY

| MAJOR | LINGUISTICS |
| CLASS | 2023 |

ADRAINT

You're possibly the first linguistics major I've ever met before. You mentioned part of your family immigrated here earlier. What's it like seeing this area of Connecticut change over time?

TILLY

I don't know how much of New Haven you've seen, but you've probably already noticed that Yale is very different from the rest of this city and the campus is very separated from it too. But Yale owns a lot of the property and manipulates it in a way that's often harmful to New Haven residents.

I'm a member of two Dwight Hall organizations. Dwight Hall is the community engagement center here at Yale, which I was looking to join right off the bat. I did FOCUS, the pre-orientation group that runs through Dwight Hall the beginning of my first year.

I'm also a member of the Volunteer Income Tax association. I joined my first year as an intake coordinator, and now I'm an advanced preparer. So, when tax season starts, I'll go to the free public library and prepare taxes for residents of the greater New Haven area who are eligible for our services. So, it's a Yale extracurricular, but it operates through the IRS larger scale, which I think is the best way for Dwight Hall organizations to run.

There are community-oriented student groups that are started by Yale students, but they're not set up in a way to endure after they graduate. So, I really try to join Dwight Hall groups that are already set up in New Haven.

I was a member of the Legal Aid Association last year, and I was on a housing rights project with the Connecticut Center for Fair Housing, which was a really rewarding experience for a lot of reasons. I mentioned that my family is Jamaican and settled around southern Connecticut.

When my grandmother, father, and uncle first arrived, they settled in Norwalk. They had some issues with housing discrimination, and I got to read and decode the housing regulations that were used against my family. It can be really frustrating to watch these inequalities reassert themselves as soon as you begin your first year, especially because a lot of people pretend that once you get to Yale, everyone starts on the same foot. They don't always take care to actually help students.

ADRAINT

You sit in so many different intersections of identity that lend to so many different spaces. How has that affected the way people perceive you on campus, specifically your Black peers? Is that something that impacts the way that you interact with other Black students?

TILLY

Definitely. To other Black students, I come across as someone who spends a lot of time in white spaces. I'm in a department that does not have very many Black students. I actually think I might currently be the only Black linguistics major.

ADRAINT

Yeah, as someone that studies language essentially, as far as code-switching and Ebonics, African American Vernacular, do you see that as being something that will ever be accepted institutionally as "proper" English? I don't think we will ever reach that point.

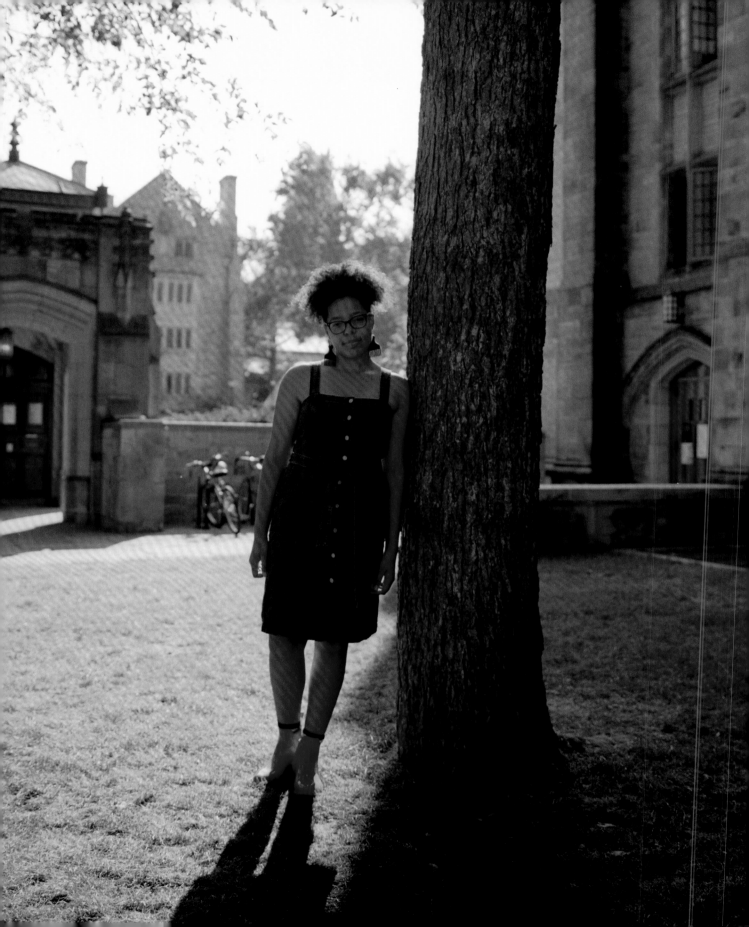

TILLY

I agree with you that it will never really reach a point of acceptance that's not just superficial, which is unfortunate for a lot of reasons and also just so frustrating. People don't even understand that there are a lot of things that AAVE can do that northeastern English, for example, can't. I am not someone who grew up speaking AAVE. So, it's personal because I was discouraged from using it, and I've been accused of "talking white." Actually, I just had a funny encounter trying to schedule a hair appointment, and this stylist thought I was white over the phone! I don't have a very optimistic view of things becoming accepted at an institutional level, which speaks to our limitations of seeing past our biases.

I could explain to someone all the intricacies of AAVE grammar and why it's not just corrupted English. I could present the evidence. I could make a case for mutual respect on a sociolinguistic basis, on a social basis. But I'm not sure that I would get past a superficial acceptance of the points, even if you present all the evidence.

There's going to be a point where you just hit a wall because someone who is committed to being racist, not even consciously, but who has absorbed mental biases is not committed to eliminating them, is not going to look past the biases that they have already internalized.

ADRAINT

Right. And have you found that to be true on this campus as well?

TILLY

I still think Yale is a place where you can find community as a Black person. I've been really lucky to have access to a lot of spaces to explore your identity. I won't shrug my shoulders and say, "It is what it is." I am not thoroughly satisfied with the current state of things, but I don't want to fall into the trap of acting like there aren't things that can be done or think it's not possible to improve. Because then the natural next step would be to do nothing, and that's not acceptable right now.

ON THE BLACK COMMUNITY AT YALE

—NYEDA STEWART

MAJOR: AFRICAN AMERICAN STUDIES

CLASS OF 2022

YALE UNIVERSITY

Starting at my first year, I went to a few Black Student Alliance at Yale meetings, went to a few Yale Black Women's Coalition meetings. I felt like the environment wasn't really what I was looking for in a community. I gained the most out of my experience with Heritage Theater Ensemble, which I have to say, Angela Bassett founded when she went there. I'm a playwright, so it was just really cool being around Black theater makers, writers, directors, and producers. We collectively wrote a play together one year and stayed up all night to do it. That experience created a beautiful bond between us. And because the play was commissioned by a Yale alum, who I think owned a theater in California, some people from the group eventually went to perform the play and kept on writing it. Just being a part of that initial writing process was a really cool and central Black experience for me here.

We put up a showcase during my sophomore year called *Black's Futurity*. I was the dramaturge, reading people's plays and basically guiding their creative vision. That was a new experience, and it was cool to be making Black theater without feeling like it was in response to white people or anything like that. We were just creating work. It was beautiful. In my sophomore year, I also started a Black arts group called the Neo Collective (Sony Carter and Swewey McCain were helpful in pushing it forward). Initially when I started it, I wanted it to be a space where Black people from New Haven and Black people from Yale could come together. There's a very big divide between Yale and New Haven, because Yale is an imperial colonizer.

In a lot of ways, Yale is gentrifying New Haven by building new apartment complexes for students, including me, to live off campus and take up housing that New Haveners could use. There's a very toxic relationship, and I don't want to say it's getting better, but the Black community has been actively forming more alliances with Black New Haveners. With the Neo Collective, my initial vision was to collaborate with more New Haven arts groups. We had a showcase the last year that went really well, it was really successful, so that's also been a big part of my Black experience.

Honestly, I felt the most fulfilled as a Black person here when I'm creating with Black people and taking classes that are about Black studies and with Black people. I went to a predominantly white private school where there were a lot of wealthy white people in my class. So, coming here, I was already used to being around rich white people, and I was used to racism. I was just like, "I'm going to put all that shit I've experienced to the side."

I feel confident that I can speak up when things happen. I can also just ignore what doesn't have to be a part of my reality or my circle. Yale can indoctrinate you into living in their reality, but it is not real.

Nyeda introduced
me to a Black Panther

THE UNIVERSITY OF ALASKA, JUNEAU 112 TY CORTESE

JUNEAU, AK

TY CORTESE
THE UNIVERSITY OF ALASKA, JUNEAU

MAJOR	HISTORY
CLASS	2025

ADRAINT

What's your first semester been like so far?

TY

It's been kind of easy. It's a lot of studying, but I'm not good with time management. I like to livestream, play video games, work on my clothing brand, and read. I'm a history major, so I love history, but I just don't like to study. I had to drop my math class because when it comes to math, usually I have always been pretty good at it, but the teacher taught in such a way that I was like, "I'm not even dealing with this." I did some open mics and tried to perform music—horrible. I freeze up on stage, which I never knew I would do because I'm a pretty confident, outgoing person.

ADRAINT

Yeah. What informed your decision to come to school here? Obviously you've seen a lot of other places, but what made you want to go here specifically?

TY

I didn't. I was trying to get into Harvard, but I didn't do any clubs, sports, or anything, and they love that stuff. I was a theater nerd, and I love acting. My next choice was Columbia or New York University, but it was a lot of money just to get to New York and then I'd be paying out-of-state tuition. So then I came up here to work in construction for my uncle. He was like, "You should go to college." It was either that or move back in with my grandma in Schweitzer. I applied here and almost got kicked out, actually, because of FAFSA issues that I literally finalized on the very last day. I remember I was in math class when they sent me an email or text saying, "Yo, you need to pay this or you're going to get kicked out." It was my entire tuition. I was like, "I have to pay that right now?" That's how I found out about student loans, grants, and all of that. I didn't know any of that stuff existed. Now I'm kind of just here until I decide to pursue my dream.

ADRAINT What would that be?

TY It's really just doing everything I want to do: I like livestream-
 ing, working on my clothing brand, and making music. I used
 to think I was going to be the next big rapper and I was going
 to be rich, but I just like to make music because I like to. The
 last song I posted on SoundCloud is the first song I've made
 in half a year for a storytelling-focused club. It's about the
 disconnect between me and my father, really. I used a bunch
 of different beats that I found through rappers, got an X beat
 on there, Mac Miller beat, JID, and then Kendrick. And that's
 eight minutes.

ADRAINT This is most definitely the school where everyone knows
 everyone for the most part, right?

TY Once you start getting to upper housing, not so much. Upper
 housing is either for when you first come and you're twenty-
 one and older, or maybe twenty-four, or if you're just not a
 first-year student. When I first got here, before I started dating
 my girlfriend, I got Tinder. I'm pansexual, so I had my shit on
 "open" and all the horny dudes at upper house would hit me
 up at 3:00 in the morning like, "Yo, you down to fuck?" I'd be
 like, "I ain't no bottom." And then they just never reply.

ADRAINT Tell 'em! What do you think draws people here? It's very
 remote and cold, although I do find the remoteness peaceful
 so far.

TY Man, everyone I talk to that's not from here and lives here,
 they're like, "I got here and I fell in love with it." That's some
 bullshit. Nobody fucking loves it here. Everybody comes here
 for one thing: the money. That's the only reason I came back
 up here, which is horrible. Dating up here's weird too. My girl-
 friend's from Colorado, so I won big on the lottery with that one.
 People is crazy up here.

ADRAINT The money and what? If you don't mind me asking.

TY The first job I had before this was in Texas; I was working as
 a grocery store clerk, getting paid like $7.25, minimum wage.
 You don't come up here to become a grocery stocker, you
 could do that anywhere. People come up here if they have a
 specific skill or know they have something to add to this town.
 Or maybe you just want to be a labor worker, that's what I did
 working construction with my uncle.

 The cost of living up here is crazy. Everything is expensive.
 That's why I want to get out of here. When I first got here, I tried
 getting a bag of Takis at the store near me called Duck Creek,
 and they were like seven bucks for a bag because they're
 imported. I don't know what they do to them, but they're not
 the same. Everything here tastes different. That's another
 thing, if you're from here, you'll never know because you've
 never been anywhere else. But if you've lived somewhere else
 and then you come back here, everything tastes weird and
 sometimes it's worse. A bag of a Cool Ranch Doritos tastes
 like metal to me! I thought something was wrong with me, like,
 "Oh, did I get COVID again? Yeah, I'm going to die." It was
 horrible, man.

ADRAINT Does the weather kind of make you delusional? What do you
 do to combat the gloomier days?

TY The main thing is the darkness. You wake up and it's dark, go
 to sleep and it's dark. I don't get to see anything. I had to start
 taking vitamin D. On top of never seeing the light, whenever
 it's hot, I usually just stay in my room. I've been trying to work
 out more, like boxing or I'll go off for a run, because I got to
 be healthy.

 The first couple days I got here, we had orientation. We went
 downtown and hung out. After the first week, we'd be playing
 a different board game and hanging out in the dorms every
 night. But that gets pretty boring after a while. There's not a
 lot to do here. Mainly for me because I'm from here, I already
 know everything. If you got money it's cool, you can go down-
 town and find some cool little shops and stuff like that. The
 other day I found this fabric shop that I never knew was here.
 They do First Friday, which is a whole festival, but that's too
 many people for me. Don't really get busy here often. There
 might be a group of friends hanging out down at the grill or the
 library; people come here to study all the time.

 I've felt more growing pains this semester, and not exactly in
 a bad way. I understand that I'm an adult now. I've had to do
 taxes for the first time, and it's not stressful, but it's a new leaf
 being turned over for me. I won vice president of the student
 body, and that's a general achievement for me. Completing a
 semester was a grand achievement for me though. I've learned
 so much, and I appreciate that.

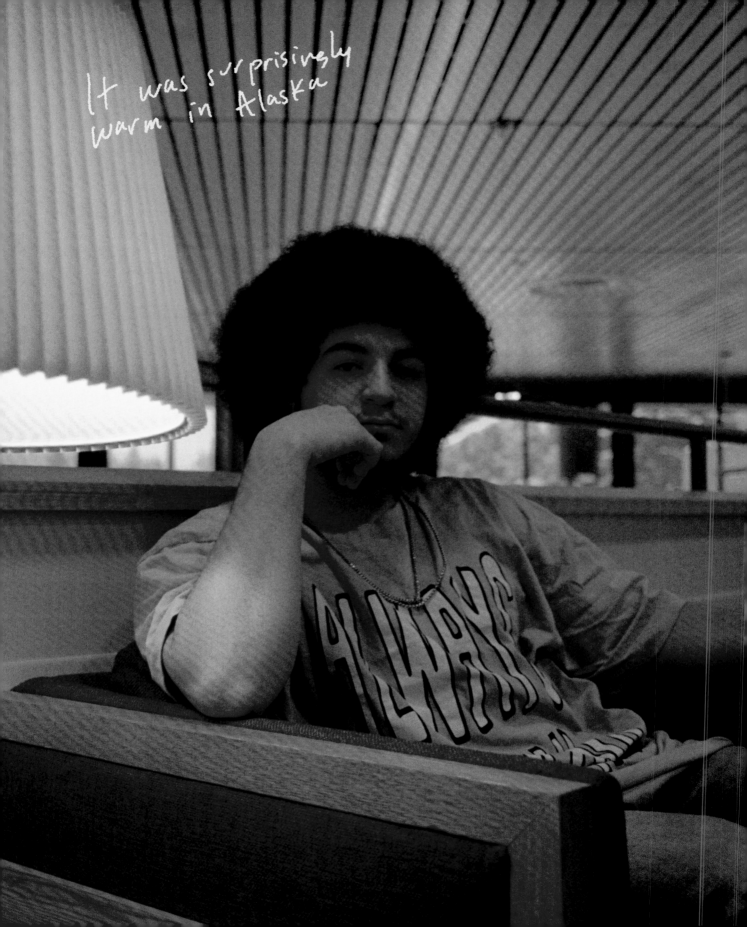

It was surprisingly warm in Alaska

Before the first colleges in America were founded and before we were allowed to attend them, we've always had our trades: the skills that continue to keep entire cities operating to this day. Community colleges and trade schools are often perceived as nontraditional or, as I've heard before, "not as great" as the college experience that a four-year university would offer. In actuality, these programs provide the practical experience and real skills necessary for joining the workforce. Four-year universities may offer social opportunities and institutional power, but so do community colleges and trade schools. These opportunities just look a little different. In this setting, cosmetology students can receive hands-on training for their craft and technical designers will have better access to hyper-specific or unconventional internships since they're already doing the work. Many technical programs even offer students the opportunity to work with businesses in the local community and develop tangible skills throughout their studies.

This path is about ordering exactly what you want. If you already know your favorite element of a meal, you can get it separate instead of having to order the full meal *and then* learn which elements you enjoy and which you don't. The validity and quality of these programs should be held to the same regard as any four-year school. Sometimes I wish I had identified my personal academic interests and taken hold of them earlier on like some of these trade school students.

In contrast to the path for vocational school, the benefit of community college is that you don't have to have it all figured out at the start of your application. As I've learned from CC students, you don't even have to have the answers after the first year. While it's always ideal to narrow down what you're interested in, community college is just a gentler and safer route to getting there. When students were asked why they decided to go to community college, the most common and earnest reasons were to save money, take care of family, or be kinder to oneself. Most students end up feeling confident in their choice to prioritize being patient with their future instead of rushing into a wrong decision. The world is constantly selling students this idea of "Go, go, go, go. Get it now before it's too late. If you don't do it the way everyone else is, you'll miss out." That projected urgency to get out and leave home can actually end up hurting students. As we've now seen, not everyone that starts at the prestigious institution finishes. It takes a lot of courage to say, "I'm going to be patient with myself and go to school with the level of urgency that feels appropriate for me." Where peer pressure could have bested these students into making a life-altering decision, they stood in their truth. In understanding that we will grow over time, one size surely does not fit all when it comes to selecting a place of learning.

MONÉ PERKINS
EMPIRE BEAUTY SCHOOL, NY

FOCUS COSMETOLOGY

MONÉ

My name is Moné Perkins. I currently attend Empire Beauty School located on 34th Street. I'm originally from the Bronx, and I started cosmetology school in September. It's seven months, so 1,000 hours, and I'm in my third month with about 600 hours now. I'm trying to get my license and open up my own shop.

I've always had an interest in hair. I started by doing braids and twists for men and simple ponytails, and when I started to get clients really fast, I knew that I wanted to be legit. My interest for hair grew stronger than my interest in college, so I took a break and decided to go to cosmetology school for what I loved.

ADRAINT

Nice. Where were you going to school before you started the cosmetology program?

MONÉ

I was going to SUNY Oswego. It's upstate but kind of close to Syracuse.

ADRAINT

When you started going to your program, what did your family think about that? Were they supportive of you pursuing your passion, the thing that you really loved?

MONÉ

Yes, my mom is my biggest supporter. She told me, "I want you to do whatever you love, whatever you want to do." I was still in college when I was doing hair. When school went virtual, I would be in Zoom class, but also braiding a client's hair at the same time. I was trying to manage both of them, but my love for hair overpowered me. My mom was really supportive because she saw the drive and the passion I had.

ADRAINT

That's amazing. What's it like being in a cosmetology program? That's not a space that we hear from very often.

MONÉ

I honestly love it, even though it's more stressful and time-consuming than college because I'm in school Monday through Friday, nine to five. I also make up my hours Saturday from nine to one. I'm in school as if I have a job. And with my hair business, I never have a day off. For some people, it goes over their heads—"Oh, that's not a job"—but doing hair takes a toll on everything. You got to be in the right mental because it could be hurtful for your hands, your body, and your time. But I love it, so that balances out all the time and the work I put into it.

ADRAINT

Have you been able to make friends with other people in your program? Is it fairly social?

MONÉ

It's very social! We support each other. If I know how to do braiding and how to do wigs, and neither of us know how to do what the other person does, we swap techniques—I'll teach you how to braid, you'll teach me how to lay this wig down.

ADRAINT

That's got to be a really great feeling. Inside your program, are there a lot of other Black students? What does the racial breakdown look like?

MONÉ

I don't know the exact racial breakdown, but I know the school is majority Black. It's majority Black or Spanish. There's not a lot of Caucasian people. The first face I see is Black, and that definitely made me more comfortable because I'm around my people. I visited different schools and this was the one that spoke out to me. The culture that Black people bring made me feel so at home. The walls are colorful, everybody was colorful. The vibe was just different. The professors are very loving and caring too. It's homey. My first teacher was like a parent to me. I was having a little difficulty with time management. Sometimes I would sleep straight through my alarm and my teacher would call me like, "Where you at? You're not here. Hurry up."

I go live every Friday on TikTok with a faculty person who's not even a teacher. I brought him an idea for TikTok once, and now he comes and checks on me asking, "How you doing? How is TikTok?" He brings me new ideas, and now I get so many clients who find me from that.

These seven months have been one of the hardest periods of my life, but I know it's an investment to make me bigger and greater and better. All the traditional stuff is out the window. Everybody is finding their income from social media and all sorts of places. Pursue what you want. Don't worry about what anybody's going to think of it. If you want it to be big, it could be big as long as you're speaking life into it. And that's what I'm doing right now: speaking my journey. I'm just following it through.

ON STATUS AND STARTING LINES

—VICTOR THOMAS

My cousin is at a four-year college in Austin. The dynamic for her is different. I was like, "I don't want to go to an HBCU because I want to experience all cultures." And she was like, "You write that down." We check up on each other periodically, and she always tells me about the social standards since it's very small amount of Black people at her school. It would be an awkward situation to be in an all-white school. It's already awkward to be in all-white classes sometimes.

At MCC, we did the study where they ask you questions and you either walk forward, stay still, or take a step back. I'm the only Black person in that class, and I'm not going to say majority white, but it's 30 percent to 40 percent Mexican and 60 percent white. By the end of the study, it was only me and two Hispanic girls was still in the back on the grass. Everybody else was on the sidewalk a good amount away from us.

People are put in positions because of their race, or their status, or their money. And then there are some positions that people *don't* get in because of their race, their status, and their money. We all know how it goes: If you weren't who you were, how you were, with the money you have, then that wouldn't be you. It's that simple. If I was wealthy and Black, I would get a couple more doors open, but it still wouldn't be the same amount of doors that a white male can get. And I'm saying white male because females still get doors slammed in their face. It's levels, and at the top level is a white man.

KADEN HUFF
MCLENNAN COMMUNITY COLLEGE, TX

FOCUS · · · · · · · · · · · · · · · · · CYBERSECURITY

ADRAINT

You used to be a computer science major. What made you make the jump to cybersecurity?

KADEN

When I started my computer science degree, it was pretty broad and more for people who were going on to get their bachelor's or master's. I was more interested in entering the workforce as soon as possible. With the cybersecurity degree, you get a lot of certifications. Then, you can enter the workforce right after and start applying what you learn.

ADRAINT

What made you pick MCC? Did you grow up here? What has your time here been like so far?

KADEN

No. So, after I was adopted from Ethiopia when I was eight years old, I lived in Washington State, and I was there for about nine years. My family moved to Texas in 2017, to a town called Mexia about 45 minutes west from Waco. And then in 2019, I moved out to Waco on my own.

It's just been a huge experience. I was homeschooled, so my circle of friends was really limited and I was more of an introvert. It took a lot for me to start branching out, and at MCC I was able to expand my circle of friends and get involved in volunteer work and different organizations.

ADRAINT

Right. You mentioned you had siblings. Are they also adopted?

KADEN

So, I do have siblings—my parents actually adopted a total of nine kids, and then they also had nine of their own kids. They waited until their biological kids were almost all grown up before they started adopting.

My family is Christian, so we follow God's will. I believe God called them to adopt and help others. They have a program called God Works, which offers financial assistance for families who are wanting to adopt, because adopting out of the country is really expensive. By adopting us, I can say they saved my life and my siblings' lives. We all have stories of where we were at the time when we were adopted or what our future looked like before our adoption. To think now that we are in the United States of America, almost like the land of opportunity where you can be anything you want to be, it is a lot.

I remember this one specific time when we were at the airport and my parents had come to pick us up to fly to America. We were sitting at one of the benches at the terminal, and there were these guys behind us saying, "These kids are being sold." They had the idea that basically Americans are coming and buying us, but that's not what happens; you may be an orphan or you may have a parent, but they have to give you up. I have to say thank you to my parents for letting me go, they chose to give me up so that I can have a better life than they can ever offer me.

ADRAINT

Are you still in touch with them?

KADEN

My father has died, but my mother is still around, and I do stay in touch with her. I actually have plans to go visit her this summer or this coming summer.

ADRAINT

Man, that warms my heart so much. I love that for you. And I hope that that's a really fruitful visit back there for you and that you really enjoy that as well. How has it been getting adjusted to campus in your first semester?

KADEN

I've only been on campus a few times before COVID, and that was when I had just enrolled at MCC. When I started classes, it was a rough season in my life: I was new to Waco, I was trying to get my living situation figured out, I didn't own a car, I was working on getting a job, and I was taking six classes. So, I decided to try to sort out my living situation and dropped all my classes in January 2020. I started taking classes again in March, and the day I was supposed to start was the day they extended spring break for a week because of COVID. After that, I was like, "Okay, I'll be ready to go back to school," but everything moved online. That was my first semester at MCC.

ADRAINT

Did you think, "Oh, I'm moving to Waco to go to MCC," or were you thinking, "I just want to get out of the house"? What happened in that sequence of events?

KADEN

I didn't know that I was going to go to MCC. I was just trying to get out of the house and didn't even think I was going to stay in Waco. That was just where I was at the time, but then I met some really good people who asked me what I wanted to do in life. This lady, who is now my caseworker, said that I could go to college. College was the last thing on my mind because I wanted to start working and making money to get a house and a car, but an opportunity opened up for me to literally go to college for free, thanks to financial aid. I hear a lot about people who go back to school for a degree later in life, but that wasn't something I wanted to do.

ADRAINT

No, exactly.

KADEN

I started in January, but it didn't work out so I dropped out and restarted in March. I thought online learning wasn't going to be too hard coming from homeschooling, which was super flexible, but in college, you had to turn everything in on time. At the time, I was actually staying at a Methodist home in an assisted-living program because when I got to Waco I was homeless.

Because of COVID, everything was locked down. There was a lot of distraction, and I didn't do too well that first semester. By the time summer came around, I had learned a lot from my first semester and felt more ready. The summer schedule was way shorter than the spring schedule, so I was basically trying to knock out eight weeks of work in five weeks. Some nights I was literally staying up all around the clock, which I had never done before. So it was like, "Okay, this is what it takes to stay in college. This is what I'm willing to do."

In the fall they actually opened the campus back up, and by then I was really eager to get out of the house and into the community. I was really excited. I felt more like a veteran of college just because I've been through the crazy COVID season and the intense summer classes. It was cool to just see the people that I've been talking to in person instead of just on Zoom.

ADRAINT Yeah. Do you think that you made the right choice going to a two-year over a four-year?

KADEN Yes. When I first started at MCC, it was more for convenience. I was trying to get in and get out. I feel like I was just in the right place, at the right time, in the right equations, and in the right hands with the people who were basically my support system. Looking back now, I was like, "Wow, that's crazy to think that everything was so crucial because . . ." So, this is a little bit of a backstory too. At the time, I was new in Waco, and my first way out was Job Corps. I don't know if you've heard of Job Corps?

ADRAINT No.

KADEN Basically, those are government-funded boot camps for education. Job Corps will teach you a trade and provide meals, dorms, and an allowance. The last thing I wanted to worry about as a homeless individual in a whole new city was where I'm going to sleep and how I was going to pay my bills. I applied for Job Corps and got accepted, but I had a few weeks before the program started. Central Texas Youth Services was able to set me up with a caseworker, who told me about MCC and the Methodist home.

KADEN

It came to a point where I was like, "Do I want to stay here in Waco and go to school and possibly not achieve my dream of getting a job, making money, and rising as quickly as I could?" I decided to trash the Job Corps acceptance letters and stay in Waco to go to college. A friend went on to go to Job Corps and when everything went into a lockdown, they shut down Job Corps and sent all the students home. My friend was homeless. I felt really bad, but because of that one choice, whether to go or stay, here I am pretty settled and making progress in my education. If I had went, I would've been back to square one, I'd be homeless. I had God on my side so I was pretty confident that no matter what happens, He would be with me.

It's been a long road. So, what I want to say for future students contemplating college, is it's good to have a solid foundation and a support system. College is hard, and it's even harder when you're on your own. One thing I learned from a TRIO workshop was "there are lots of ships, relationships, but they're either sailing ships or sinking ships." Sailing ships are the relationships that help you progress in the goals that you want to achieve. Sinking ships are relationships that are causing you to not achieve your dreams or goals. Every person, every relationship you come across, you want to always ask yourself, "Is this a sailing ship or is this a sinking ship? Is this going to help me achieve my goal or is it going to hinder me from achieving that?"

FOCUS BUSINESS MANAGEMENT

SADERAN

My name's Saderan McDowell. I'm born and raised here in Waco, Texas. I'm a previous college graduate of MCC and came here for my associate degree.

ADRAINT

Okay, cool. What brings you back to MCC?

SADERAN

I'm working on getting a bachelor's degree in business management. I got two semesters to do at MCC and then go to Tarleton State University.

I was at TSTC (Texas State Technical College) when I graduated out of high school to do video game design, but that didn't go as planned as always. My grandmother suggested coming here and when I did, it was like a breath of fresh air from out of that situation over there. For technical colleges, you have to graduate out of there with a degree, and you can't just be there just to laze about. When I came here, I was like, "Okay, I can get an associate degree at any time I want, at any given point." That was nice and refreshing and made it easier for myself. I graduated and now started on my bachelor's. I'm hoping to finish it within the year and then go to mortuary school, because my family runs a funeral home here at Waco.

ADRAINT

Oh wow. You never hear that.

SADERAN

It was an interest that I had since I was a kid. When my mama had me after high school, the only place I was at as a baby was literally at the funeral home. It stuck, and that was the one major thing I wanted to do until video games came about.

When I was doing a video game class in high school, I was like, "Wow. I love to play video games. I want to make them." But the funeral home thing was that one major thing in my head throughout my whole life.

For mortuary school, my associate's degree actually took care of most of the classes that I need. When I go there, I only have two classes left to do, then I'm a whole graduate at that point. If I had gone to a four-year college, I would've wasted a large amount of time, effort, money, and resources. I haven't had a job in a long time because I've always worked at the funeral home, but my grandfather always gave me a choice of, "It's either work or go to school." I focused on my education because my family's big on that, and I wanted to continue it for the next generation. If you don't know what you want to do, you can get your associate's degree. I keep all my old stuff, so when I show my kids, I'll say, "This is what I did. I got my associate's degree. You can do the same thing and then if you wish to get a bachelor's or master's, this here is going to already help you in the long run afterwards." It makes it easier for you.

Saderan McDowell

MCC Highlander
Statue

FOCUS CULINARY AND PASTRY ARTS

ADRAINT First, I've seen your cakes, and they look amazing! How did that get started, your interest in baking?

TOYOSI I feel like I've always had a passion for culinary, but it really started to grow when I got into high school. I started to do little competitions here and there. Then I found out that I appreciated the actual work that goes into food and the execution. That's how I landed in Dallas for school.

 Maybe around middle school when I said I wanted to be a chef, my parents were questioning why I wanted to go to culinary school just because they didn't really understand the money that goes into it. They didn't understand I could even make a living out of it, or the fact that I would have to be working two times as hard as other people who could get a regular job being a doctor or engineer. Sometimes in the African community, that's all they see. They want you to do something in STEM, they don't want you to do anything in the art category.

 After my freshman year of school, they really saw that I had a passion for it. And they knew that my passion would at least get me further than other people when it came to what I would do. That's why they really started to support me.

ADRAINT And then can you speak a little bit to maybe some of the things you've gained so far from being in the culinary program? Because you got like your own full-fledged business now, from what I can tell.

TOYOSI

For one, I would say mass production, working as efficiently as possible and getting the most out of the day. You want to always think how you can do it the fastest way possible, so you can make a good amount of profit. Another thing I learned was probably cross-contamination, trying to be as clean as possible so you're not actually getting anyone sick or giving anyone food poisoning in any type of way. Then, it's really having a keen eye for detail. Even though you made a whole cake, maybe this one detail could throw off the whole thing. You got to be able to see those types of things so you can really execute and change it if it's possible.

ADRAINT

Are there things that you see in your day-to-day life, or maybe in other people's cooking practices, that you start to want to correct because now you've been trained in a kitchen and through a culinary institution?

TOYOSI

All the time. I think it's been like that since high school since I started baking. When I really got into it, I really started to have the attention for detail. When I saw things that were incorrect or I saw things that weren't efficient, I'll be like, "Why'd they do it like that? Can I tell them something? Should I tell them something?"

ADRAINT

So whenever you started to look into this program, what were your peers' reactions in high school when you decided, "Okay, I want to go to this culinary program." Were they all shocked or were they of the mindset that like, "Oh, we knew you were going to go to a culinary program."

TOYOSI

You know when you see that one kid in high school and you're like, "Oh yeah, you're going to make it." That was basically me. Everyone would always say, "Yeah, we definitely see you baking 24/7 in the future, or on some type of TV show, or just making it in general in the food industry."

ADRAINT

After school, what's next for you? I know that's a daunting question. I used to hate getting that question when I was in college, but what would be ideally next up? What's your dream thing to fulfill after you graduate from this program?

TOYOSI

I really want to take my platforms a little bit further, getting on YouTube, Instagram, and TikTok and pushing it all the way through. I also want to start a master course for the people who can't go to culinary school because of their parents or because they don't have the opportunity. I'll do a masterclass, teaching them everything that I learned and giving them better tips and tricks on the food industry. Another one is probably being on a TV show as a judge, teaching people and showing them what they did wrong or what they could improve on, just so I can help them out more.

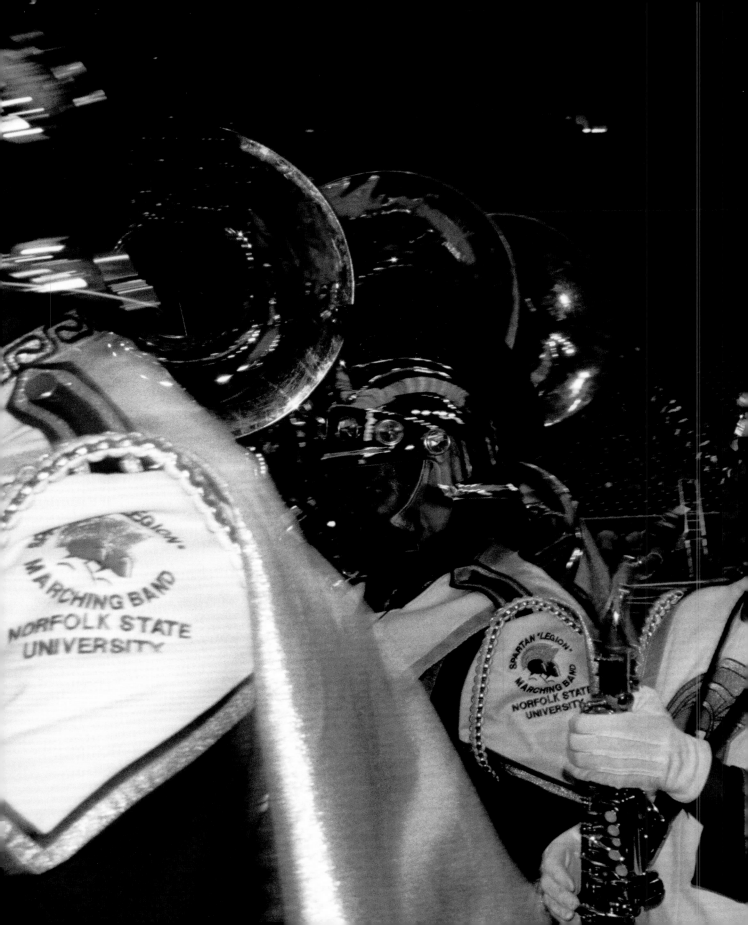

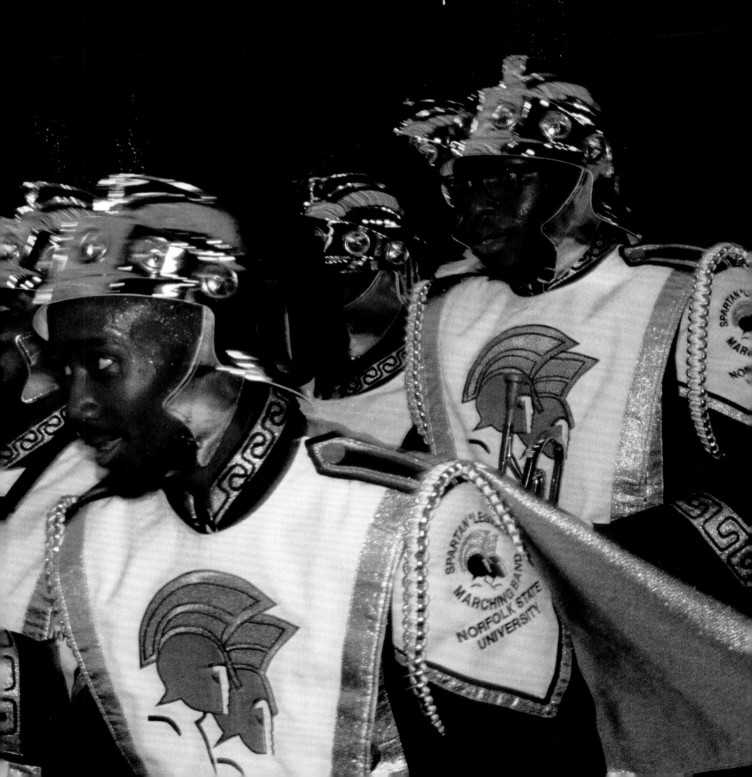

National Battle of
the Bands

Historically Black Colleges and Universities (HBCU)

Illustrious, proud, and coveted, HBCUs are a sort of utopia where Black students can learn and grow in private. These institutions serve as home to leaders of the civil rights movement, a battleground for student advocacy, and living museums where the past and present meet. While many of these schools are often underfunded, they have received a large influx of financial support at the federal and local level in recent years due to increased visibility. Attending an HBCU means committing and contributing to a historical cornerstone of Black academic advancement and enrichment in America. Each student walks a unique path whether it be at Jackson State University, NCAT (North Carolina Agricultural and Technical State University), Grambling State University, Huston-Tillotson University, Prairie View A&M University, or one of the four universities within the Atlanta University Center Consortium (Morehouse College, Clark Atlanta University, Morehouse School of Medicine, and

Spelman College). However, they all carry the same cultural torch that's been passed down for generations; they've been entrusted with something sacred.

All HBCU campuses are home to a rich plethora of narratives and history. For example, Florida A&M University (FAMU) was originally a plantation. While visiting the Meek-Eaton Black Archives Research Center & Museum on campus—which features everything from relics dating back to the founding of the university and historical records of iconic people such as Wilhemina Jakes and Carrie Patterson to Klan robes on mannequins—I was forced to reflect on my presence there. I learned that our ancestors are buried on the grounds of many universities across the country. This reminded me of Seneca Village, where thousands of Black people were buried in what is now Central Park. Due to improper burials, the amount of Black people buried at some of these campuses is often unknown. Most HBCUs will tell you not to walk on the grass, as a sign of respect for those who have passed. This show of universal reverence is shared across all HBCUs and is also reflected in the campus culture.

This deep connection creates a magnetic environment not only for students but for alumni and fans as well. There's magic in congregating with others who have also been historically and institutionally denied the space to seek joy and advancement. When I visited FAMU, I felt like I was part of the family. The students and staff were incredibly welcoming and open with their time. Without fail, I always see someone from FAMU going viral for their creative graduation photos, and what I saw online was nothing short of what I saw in person at homecoming and various festivals.

On the way to Howard University, I came across the hashtag #BlackburnTakeover used on Twitter by students who were protesting for housing and financial needs. As I watched the video of students camping out in tents, I began to question how it's possible that one of the most recognized HBCUs could consistently fail to meet student needs. Some boiled it down to being "an HBCU thing," and others blamed a lack of oversight and management in funds. One rationale a student gave was that much of the donations received are explicitly for scholarships and not to maintain buildings or update housing. As the protests continued, homecoming week at Howard carried on. In my few days on campus, I saw food and toiletries funneled in from alumni to support protestors during the takeover. Though there were mixed reactions to the protests, it's clear the students were still supported by their unbreakable bond with generations of alumni.

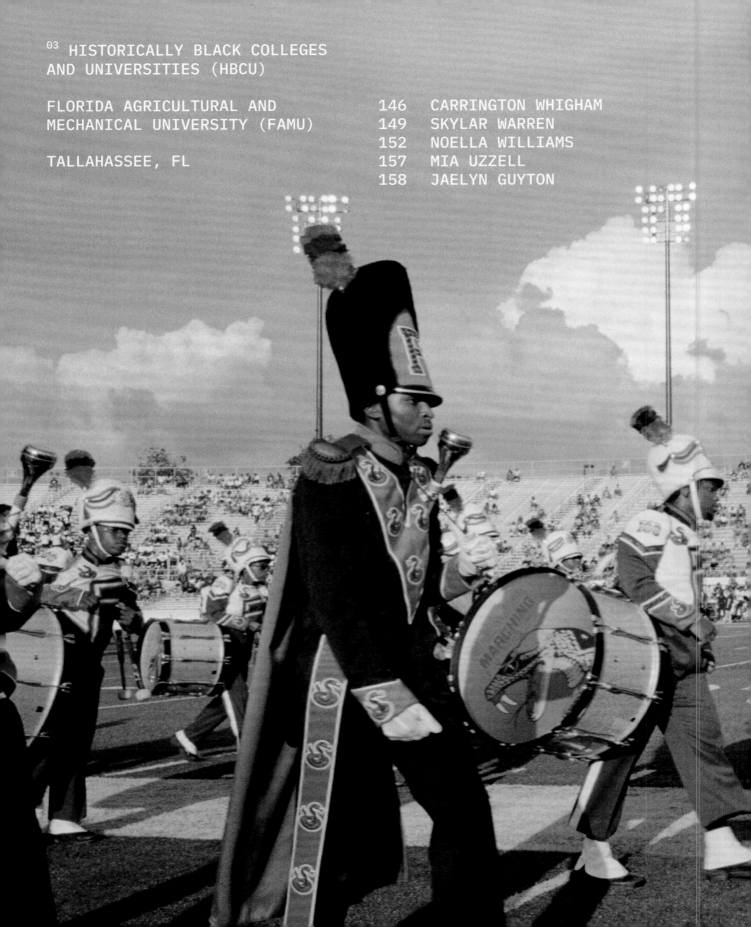

FLORIDA AGRICULTURAL AND
MECHANICAL UNIVERSITY (FAMU)

TALLAHASSEE, FL

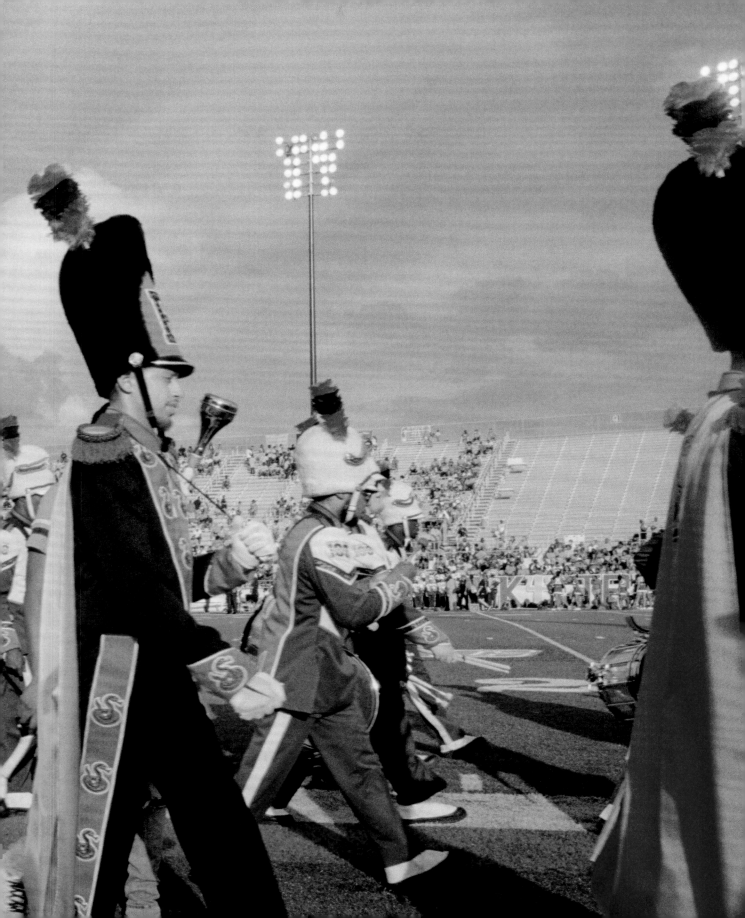

ON THE ART OF GETTING UNCOMFORTABLE

—CARRINGTON WHIGHAM

MAJOR: BROADCAST JOURNALISM

CLASS OF 2022

FLORIDA AGRICULTURAL AND
MECHANICAL UNIVERSITY (FAMU)

There are a lot of the things that people are doing now without degrees. Broadcast journalism? Hop on YouTube and do what you got to do. Business? There are two-year-olds that have businesses. However, I think time spent maximizing opportunities in college is what's so important. If you don't do it, then why are you here spending money? You're going to learn a little something. These concrete majors teach a lot of hard skills, but what else are you doing with your time? Who are you meeting? What do people think about you? Did you do something that made you uncomfortable to gain the confidence to be the person that you want to be in the future? Or were you just really comfortable the whole time?

After college, it's life. You're working, you're trying to be who you are, you're trying to make money. If you didn't experiment now in this experimental era, then what did you do? When I got here, I re-created myself. In high school, I was very bitter, losing friends, and just . . . not okay. Here, I decided I'm turning the leaf and I'm going to be who I am. I'm going to set myself in this professional role and I'm going to play the role until it becomes a lifestyle. So, now I know my next phase of life: Keep what worked here and take off what didn't, so I can just keep being great.

I'm having fun, but trying not to be so one-dimensional. That's one thing I can say I don't like about this campus: I'm not playing the role that you want me to play. My Instagram is not as traditional as other SGA [Student Government Association] presidents, but it's the role that I'm choosing to stick with because that's who I am. The hardest thing in the Black community has been to allow people to be who they are. Do you support your neighbor? Do we really support each other? Do we practice what we preach?

SKYLAR WARREN
FLORIDA AGRICULTURAL AND MECHANICAL UNIVERSITY (FAMU)

MAJOR	BUSINESS ADMINISTRATION
CLASS	2022

ADRAINT
What's been your FAMU experience?

SKYLAR
Well, I'm a second-year senior. I had high school dual enroll-ment, so I just skipped ahead. My first year was in the pandemic so I didn't get that full freshman experience, and now that I'm a second-year senior, I still feel like a freshman with a bunch of students that are about to graduate. I'm in the five-year MBA program so, at this point, I'm staying to get another year with my college experience *and* another degree out of it. It would be dumb not to!

ADRAINT
Wow, this is actually your first time in classes on campus then? How was it last year?

SKYLAR
I was on campus last year, but it was either you're going out or you're in your dorm on Zoom.

And, I mean, I really got out there. I was running for Miss Sophomore Attendant, so it got to the point where people on campus were just knowing me from that and from my social media handle when other HBCU pages would repost my content.

ADRAINT
What's it like pursuing the royal court? This is something even students from other campuses, alumni, and even prospective students direct their attention toward every year. The royal court at FAMU and other HBCUs has a very particular gravitas! How'd you handle that pressure? That's a lot of eyes and scru-tiny directed at one person!

SKYLAR

Students at other HBCUs started to get to know me. My following went up: I started college with 1,000, and then I got another 6,000 from my campaign. Even on TikTok, I'm at 11K now, just from being at FAMU and taking steps to be a student leader *without* a title. My whole campaign was about being "the queen bee on the crown." You can win, but still do nothing. You can lose, and still make a big impact. I lost, and I made a bigger impact without a title than I could have with it. When you have a title, you have so many restrictions on how you present yourself. The funny stuff that I post on Instagram and TikTok, I probably wouldn't have been able to post because I had to keep the image of being, you know, *the pageant girl*.

And then the incoming freshman, they go, "Oh my God, you really showed me what campus is like in a pandemic. And it made me excited to be there." People were actually impacted by what I did, so that made me feel better about not winning. I never felt like, "Oh! I lost." It was always, "What's next?" You can't just end it there even when you get the prize, or the title, or the position.

ADRAINT

What do people normally spend money on for their campaigns?

SKYLAR

You have a campaign to meet. It's seven days, and you need a new outfit each day. And your gown, I spent a bag on my gown. But the great thing about FAMU is there's always going to be a student doing a giveaway, to put their self out there on campus. FAMU T-shirts, a whole FAMU outfit, $500, a cute purse—I won it all because I competed in every single event they had. Somebody gave away one full month rent . . . I didn't get that one. And then somebody gave away a plane ticket back to campus from wherever you live, even out of state.

ADRAINT

And these are students campaigning? Wow, that's insane. They're spending real money.

SKYLAR

Money-money. FAMU is the hardest with campaigns. We set the standard at other HBCUs. You have to grow a thick skin, because people will make fun of you and try to put you down for little things. They'll go straight to Twitter after the pageant if you performed something and messed up. "Not her messing up" all over Twitter. And it's like, "Dang, you all. Can't a girl make a mistake?"

ADRAINT

Yeah, I feel like it's a lot to be scrutinized so early on, but also by the place where you're supposed to be socially accepted.

SKYLAR

I'm just trying to be better for myself. I'm not in competition with anybody else—not even during the pageant. You don't look at people you're going against as competition, you look at them as somebody that has the same goal as you. It's all about who takes action in the right ways. The girl that won did, and that's why she got the crown.

Looking back, I didn't really want that position. I wanted something higher than that, but I just felt like having the biggest crown and the biggest title was the first step to get there. Now, after going to this career fair, I want the summer internship that's paying $1,000 a week with a free car and free housing. Your mindset changes through college. I wanted to try to be a good influence, and now that I do have eyes on me a lot of times, I can present myself in a fully thought-out way. There will always be a lot of judgment, but at the end of the day, that's life. If people aren't judging you, then you're not doing anything. If they're hating on you, then you're doing something right. You know how many people have accused Beyoncé of being Illuminati? I'm Beyoncé *and* the Illuminati at this point.

ON FINDING YOURSELF AS A TRANSFER STUDENT

—NOELLA WILLIAMS

MAJOR: BROADCAST JOURNALISM

CLASS OF 2022

FLORIDA AGRICULTURAL AND MECHANICAL UNIVERSITY (FAMU)

I remember the exact moment I learned I had no idea where I wanted to go for the next four years. I was graduating from West Florida High School and I was in the medical academy—which was a pressure put on me by my Caribbean parents to make money and not really care about what I'm doing.

I was accepted to University of Alabama at Birmingham and Valdosta State University, but learned my parents could not afford that. I decided to stay home and go to Pensacola State College. It was the best decision. I made so many friends within my hometown, but I had my moments of being depressed when my boyfriend and all my friends moved away to go to different universities. I stopped going to church because I realized I wasn't religious and I didn't want to subscribe to Christianity anymore. I came out to myself, but never came out publicly as bisexual because I still lived with my parents. I was dealing with a lot of beauty insecurities and shaved my head. That was a tough semester for me.

I decided to study journalism. I knew that I *liked* to write, but I didn't know if I had the experience because I wasn't familiar with writing. When I had my first journalism courses and my English courses at Pensacola State, I was encouraged to write more and was given the freedom to write about whatever I liked. My African American literature class and African American history classes were taught by white people because the college was in a very predominantly white town, but taking those classes helped me realize the topics that I was interested in writing about.

When I graduated from Pensacola State, I found a home here at Florida A&M University. It was difficult to be a transfer coming back in, getting involved, and getting acclimated. I'm glad I am where I am now but, three years later, I can definitely say that FAMU culture did not make it easy. There are a lot of things that I do not like about it, and there are obstacles that get in the way of it being an inclusive campus. There is a lot of homophobia, and our LGBTQ+ club, Spectrum, is very underfunded and doesn't get the recognition that it deserves. We barely got gender-neutral bathrooms in one of the dorms when school started in August. Sexual assault and how the school treats it is an entirely different thing. The founder of #MeToo visited our campus and left because she did not appreciate the way that FAMU was treating her. It's embarrassing how they don't handle sexual assault or anything concerning reproductive rights as a priority on this campus.

As far as the journalism school here, I do appreciate it. There's a lot of work to be done with updating the curriculum, but I found people like myself that are interested in digital or print writing versus just broadcast. I've had to pave my own way for success as far as freelancing and writing for other publications outside of the school, outside of the city. It's rough as a student because impostor syndrome can make it hard to create my own path. Overall, I am grateful for all the connections I've made at FAMU. They really mean it when they say the HBCU alumni looks out for you. I've had great opportunities—my current job—thanks to being a HBCU alumni, so I'm grateful for that... but the best part about things you love is that you can critique them.

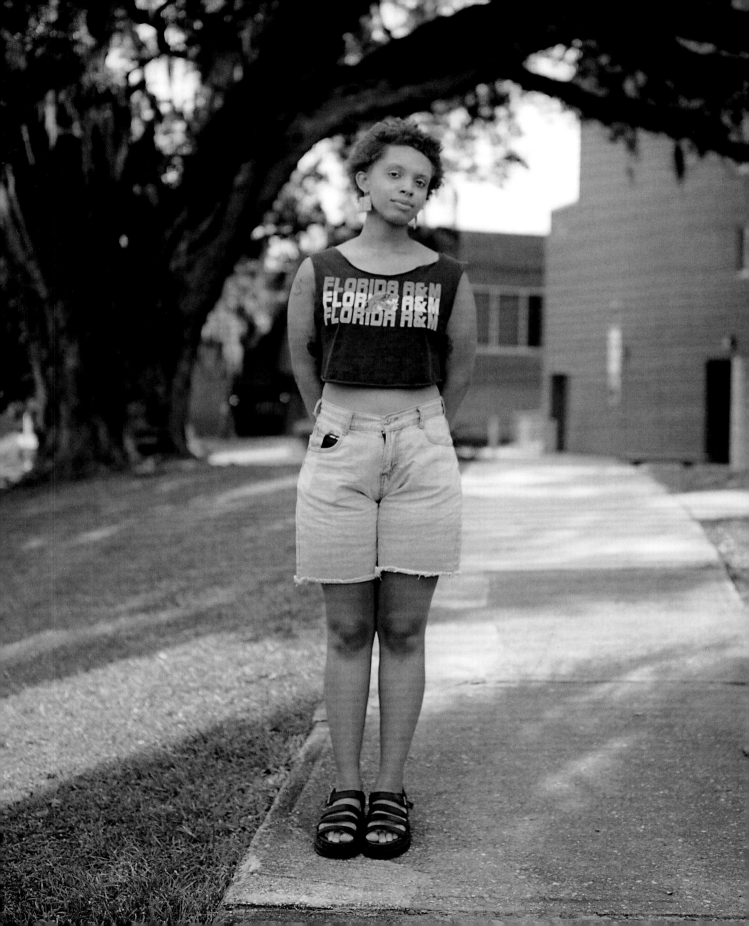

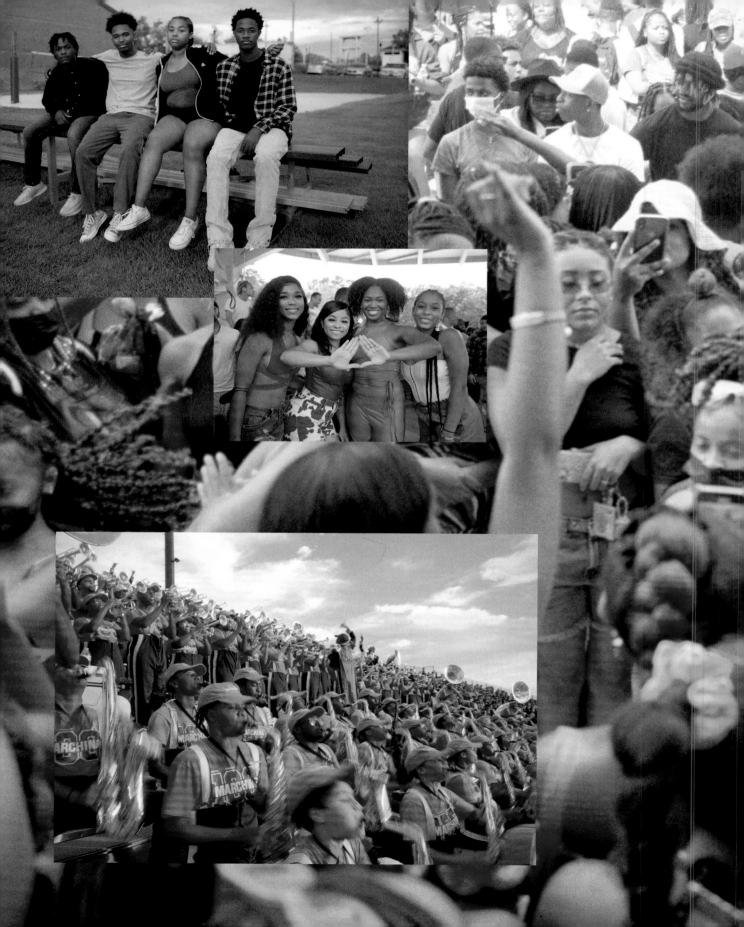

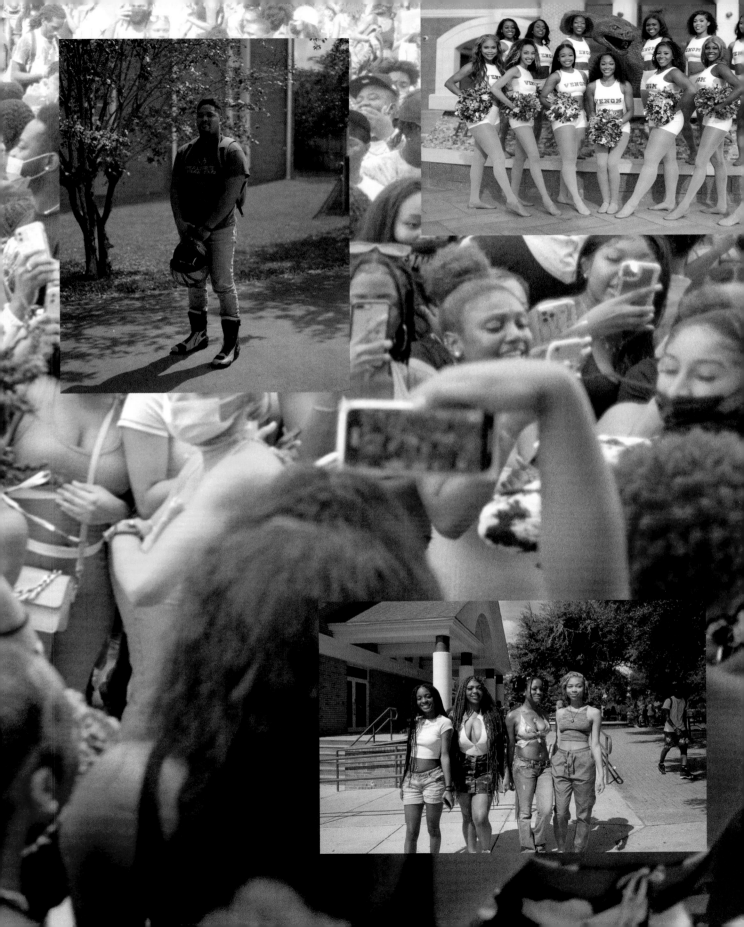

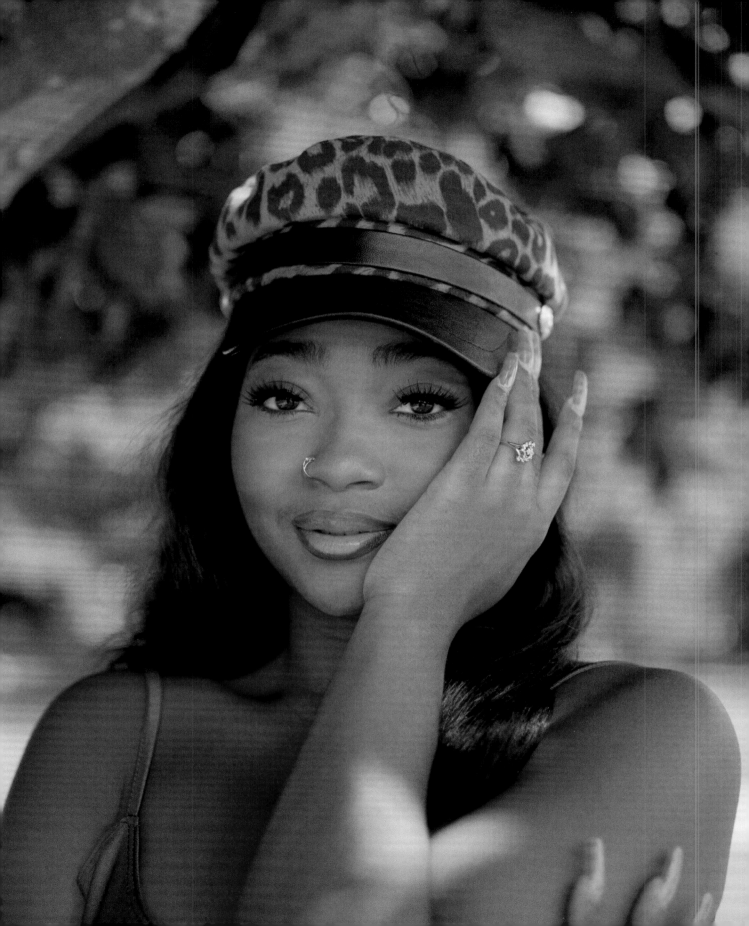

ON FREEING CAMPUS CULTURE FROM TRADITION

—MIA UZZELL

My class was this era of FAMU that didn't hang on tradition as much. Sometimes alums are very invested in FAMU in a very weird and obsessive way. As I'm analyzing it, I think it's because this is the first time in their life they've been accepted or been in a place where they can flourish. They're still holding on to that joy and that atmosphere. They would make comments like, "You guys don't dress up for class anymore," or "You guys don't wear suits and ties to class anymore." Naturally, just like my ancestors, looking good was all they had to their name. Making sure you present yourself well—even though we already do our greetings and salutations, "I'm Mia Diamond, a first year, so and so and so..."—is an ostentatious display that you have autonomy over who you are. I see that in our school a lot. Sometimes people call us extra, but I think it's just rooted in the fact that we didn't have anything before. I don't love these outdated traditions that are just a form of respectability politics.

When you don't have an example for yourself, you have to look to the white man. A lot of these HBCUs are built on the social structures and the cultures that the PWIs were built on. So we do still have the elitism of SGA, royal court, and Greek life. Our school is built up of the 10 percent and the 90 percent: ten people make it to SGA, royal court, and Greek life out of ten thousand students. These are all power dynamics and forms of asserting yourself. You don't want to just be the regular person on campus. You want to be part of the who's who and the infrastructure.

I love seeing our generation have a more alternative space for people who don't want to be that. I'm in J school and SBI [School of Business and Industry], and I see other people branching out of the respectability politics and leaving that mold. We're going to get to a new way of acceptance, and I hope more HBCUs start radicalizing themselves. We don't have to hold on to the same structures of the 1960s. We can be more free. That's what I hope for the future and our social culture here.

JAELYN GUYTON
FLORIDA AGRICULTURAL AND MECHANICAL UNIVERSITY (FAMU)

MAJOR	POLITICAL SCIENCE
CLASS	2022

ADRAINT

Can you speak to how people have publicly responded to you announcing your sexual orientation and how it has impacted your student experience?

JAELYN

In all honesty, it really depends on the way that you do it. I did mine out of frustration. I was never the type of person to be like, "Hey, I don't want nobody to know that." You ask, I'm going to tell you. Usually people, they even stop me like, "You straight? You gay?" And then they just leave it at that, not knowing there's a spectrum to it. I'm going to always be fully transparent, but it's up to you how much you really want to dig into it. But the reasoning or how I did it was through social media, and it was not in the traditional sense of, "Oh, I'm coming out. This is my coming out day." It was in a response to someone who was a former student leader, who was terrible at their position.

There have been so many people on the spectrum that have been great leaders, and everyone knew, you know what I'm saying? But it wasn't like it was out there. Even when certain student leaders had come out, their mentors who are also a part of the community and queer were like, "That's not something I would've done." Or they would've said, "I didn't feel like that was appropriate."

I didn't get any negative feedback at all, even with the fraternity that I was in, people blew up in my fraternity group chat. They were like, "Oh, congratulations," or "I'm so proud of you."

Even with one of my neos*, once he had come out and I had spoken with him, because during their process, we had this thing called vulnerability and sensitivity training. Because we had a lot of issues in the past where, as Black men, we don't go to therapy, we don't talk about our problems. And we were like, "This has become so prevalent and it's getting really bad. It's getting out of hand."

So, we had to implement that into our processes, and that's what we're going to be doing going forward, hopefully even after I'm gone. I had to re-come out or whatever. And that night, I lived in the same residence hall as my future neos, and he said, "I didn't want to say anything, but yeah, I am [queer] too and I really looked up to you and I'm really glad that you said something." Which transpired into him coming out to his line brothers. And they're protective of him, just like how mine were protective of me.

So, for the most part, you're looking at a different FAMU. A lot of the stuff that we are doing has never happened before, it's never been done before. You're looking at a lot of firsts, and that says a lot about the community and how far along we've come and how much we've grown. I would say a lot of it has to do with the protests.

ADRAINT

That's a lot to deal with, especially in an environment that rewards heteronormativity and sometimes rejects people that perform outside those boundaries. Where did you go from there? What happened next?

JAELYN

All those protests happened; with Tallahassee in particular, Tony McDade, a Black trans man getting shot and killed by the police. You having a whole community of Black queer people out there leading the protests, and you think that they were just talking about George Floyd? No, they weren't going to let you get away with that.

Oluwatoyin Salau, I marched with her.

* *NEO* OR *NEOPHYTE* MEANING "NEW MEMBER"

JAELYN

She was out there, probably one of the handful of people that was like, "I know we're out here for George Floyd, but I want to talk about Tony McDade." We were at the police station one day, and that's where a lot of those photos that you see of her were taken, that was during that march and from the police station. And she was hot.** Everyone was hot, but she was hot. She was damn near about to pass out, and people's getting her orange slices and water-type shit.

I was just in awe of what I was seeing and what I was witnessing. And I didn't want to say anything. I didn't want to talk because of literally how big it had gotten. At first it was just one of my friends, it was two FAMU women that had started the protests here in Tallahassee. And I was like, "Oh wow, we're doing it. Getting back to how it used to be." I was astonished and when they said they needed more help, I said, "Okay, I'll help you. Wherever you need me to be, I'll help you. Blocking off intersections? I'm there. You need somebody to deliver some snacks for the protestors? I'm with you."

That's really a lot of what I've been doing throughout my time here at FAMU. People were actually out there. They did not sit there in that moment, and then transpiring over the death of Toyin . . .

ADRAINT

It sounds like you're speaking to something that is important and at times confusing: grieving.

JAELYN

I'm in ROTC, so I went to officer candidate school. I didn't have enough time to grieve, so I barely even graduated from there. But coming back and seeing everything that transpired from that, it was a totally different campus, completely different landscape. You could feel it. The tension was palpable, you could cut through it with a butter knife and everyone was just mad, just mad. They were cooped up in their houses. They were told that you can't do anything anymore. They started getting cabin fever, then just let loose out into the streets during them protests, and then they had to go back home. They were letting it all out.

** AS IN "ANGRY"

And it has done a great toll on the psyche. If FAMU was a bellwether of the rest of the country, that summer of 2020 has taken a great toll on the Black psyche of America. And people were just like, "I don't know how long I have." Even with myself and dealing with my own mental issues and having some nights . . . I had existential crises where I'd just think about my own death, and how much am I able to get done in such a short amount of time, and how I don't have enough time left. And Oprah Winfrey said in her *Super Soul Sunday,* she was like, "Death is a motivator." So I just try and get as much done as possible because I don't know when I'm going to take my last breath or something crazy is going to happen to me. That's led to me becoming impatient. I expect a lot more from people. We need to get moving.

But for a lot of other people, in the toll that is taken on them, they're sluggish. They're not in it anymore. They're just waiting for the time to go through. And it's a really big brain fog, even now on campus, the counseling services are booked up for the whole month.

And a lot of people don't know that. And a lot of people will not get the help that they need. And as student leaders, some of us, we care and we care a lot, and it weighs extensively on our psyche, and it weighs extensively on our mental. One of the platform points that we're working on right now with just the Florida Student Association is mental health and how can we have digital therapy for the entire state university system.

A lot of people expect things from you. A lot of adults expect things from you. A lot of fellow students expect things from you. They sit and they look at us and they think you're just a part of this elitist organization. And yes, that's not to say that they're wrong, but nothing is black and white. Yeah, it's elitist; we take care of ourselves, but we also take care of our own. We try and grab other people to bring up into the positions with us. That is about as American as apple pie. And I'm giving you the God's honest truth.

ADRAINT

What's been the highlight of all of this for you?

JAELYN

If I could just summarize the culmination of all my experiences at FAMU, I would say hope.

I hope for a lot of things. I hope as my journey in this life continues, that I will never have to see someone make the ultimate sacrifice while in the service. I hope that the posterity of this country, which would be future generations, born and unborn, will continue to lead and fight for their own individual liberties as well as the liberties of others. I hope that FAMU is that breeding ground for other leaders to go out and pursue the same thing for other people. And that hope has already come into fruition in many ways; that hope has died here just as it was born here.

I think of Wilhelmina Jakes and Carrie Patterson and how they started the protest in Tallahassee. It was two women that started the protest in the late fifties. So, I'm hopeful. Someone's always going to be in that position. Someone's always going to do the right thing. I'm hopeful. And usually, it'll get done.

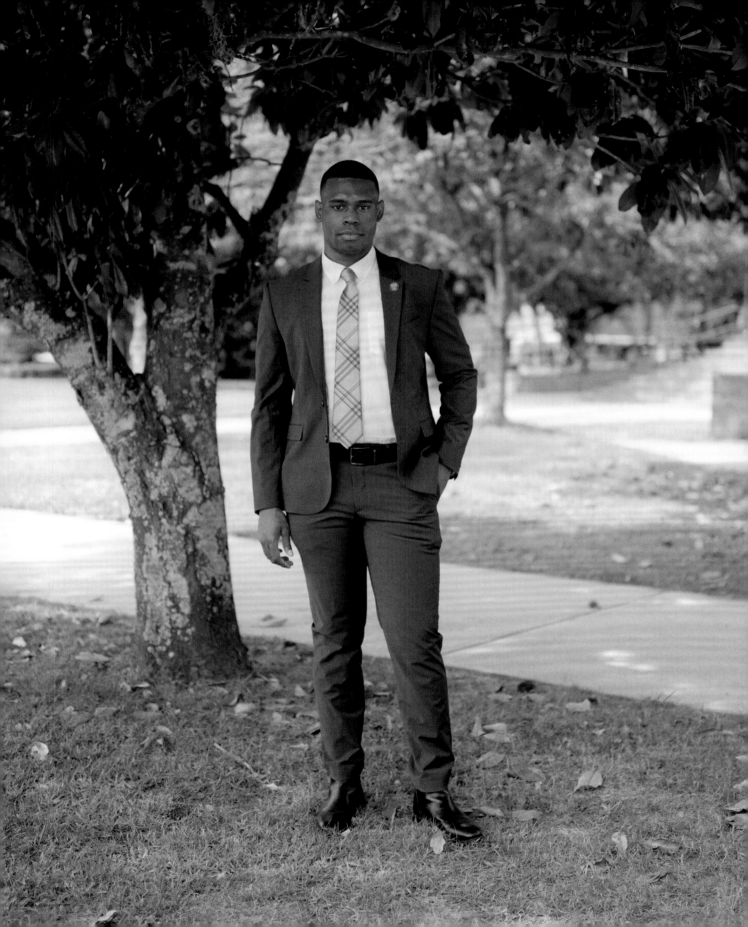

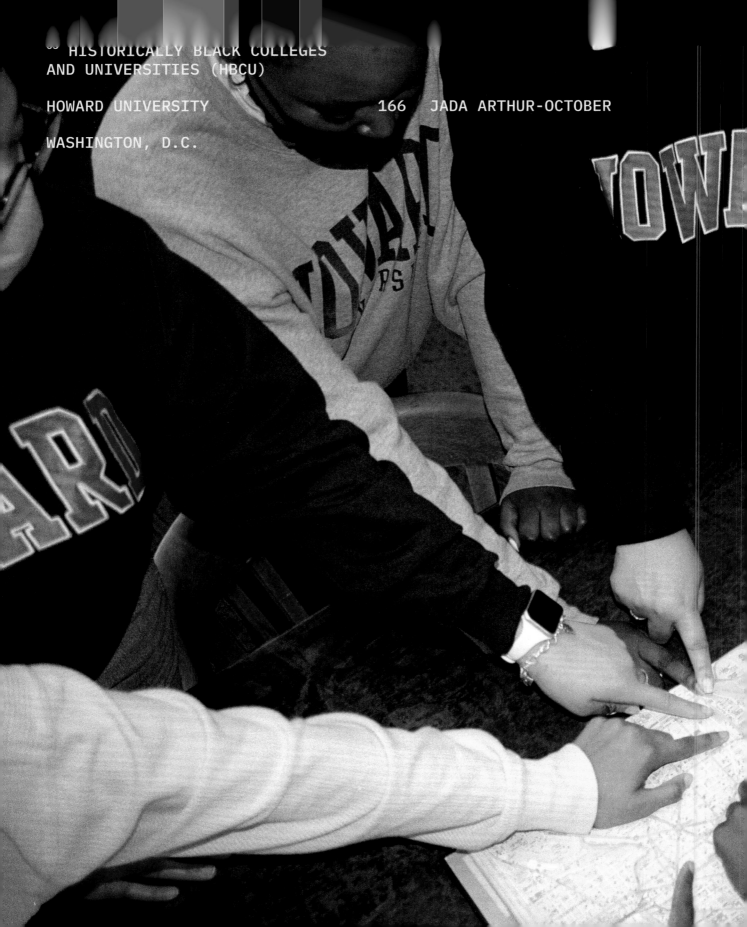

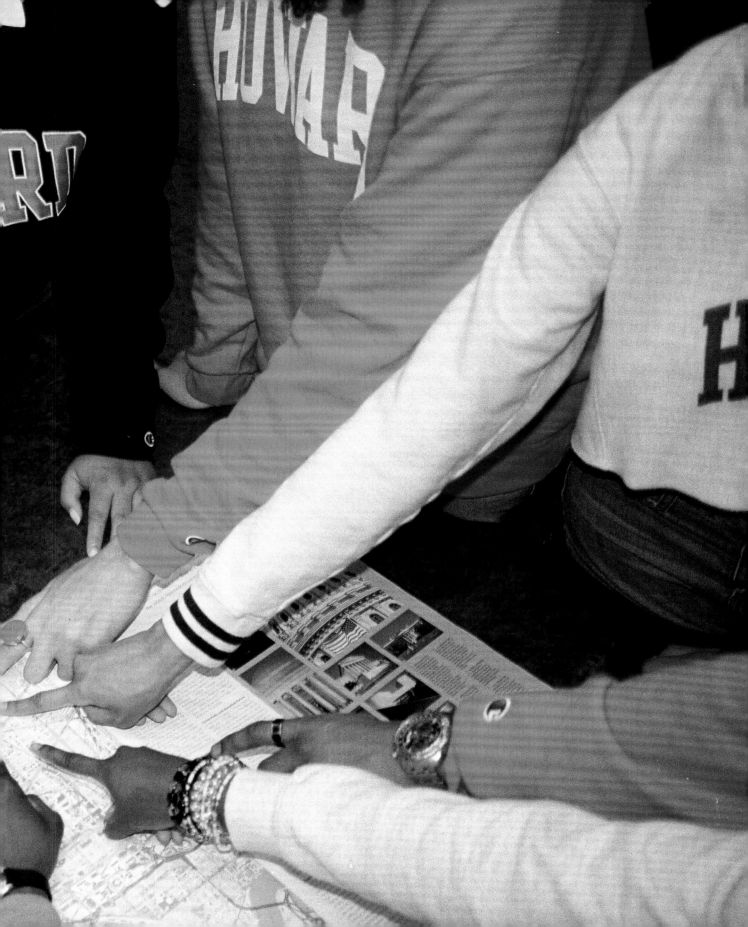

JADA ARTHUR-OCTOBER
HOWARD UNIVERSITY

..

MAJOR BIOLOGY

..

CLASS 2022

..

ADRAINT What was that defining moment where you were like, "I made the right choice, this is where I'm supposed to be"?

JADA When I came in and visited Howard for one of their new incoming student days, the culture, the vibe, and the campus really solidified my decision. When I set foot on campus, I saw how everyone was interacting with each other and you could just be yourself. There are different types of people, you don't have to feel like you fit in to any certain type of field. You just fit in where you find yourself. I'm a nerd, and there are a lot of big nerds on campus. Every aspect of Howard is very inviting. I don't have to feel like I'm doing too much or doing too little, I just feel like I fit in regardless.

ADRAINT Okay, cool. That's tight. Have there been any other extra-curricular organizations where you're like, "Yeah, this is also another place where I found community or just a different group of people"?

JADA It's been hard trying to get into organizations simply because we've been gone for so long with COVID. I was on the cheer team at one point in time, and they were nice. The coaching staff wasn't the greatest, but the cheerleaders were very welcoming and eager to help you learn. I'm also an RA, and we are all really tight even though we come from all different backgrounds. We try to make all our residents feel comfortable, so it's like having a sense of community inside a place that has its own community. It's just very comforting.

ADRAINT For sure. What made you want to be an RA?

JADA

I've always been like a big sister, a mentor, or somebody people could look up to and talk to. I managed two sports teams in my high school and was very involved, so being an RA is easy. Your residents come and knock on your door, or they text you about any situation, and I like being a listening ear for people who don't think they have one.

ADRAINT

Is there anything else that you might want to add to describe your Howard experience or anything that was very defining or pivotal for you?

JADA

When I saw my genetics professor, Fatimah Jackson . . . she is literally an amazing woman, and she has her focus on sickle cell. I never knew I loved genetics so much until I met her. She was my advisor for my freshman year and having her as a mentor and a tutor helped me all throughout my experience. In college, you feel like you're alone, but there are actually a lot of professors and people that care about you and your life. She showed that she was dedicated to helping us grow and helping us find connections outside of Howard. So that's really another reason why I really am proud of why I chose this school.

ADRAINT

Amazing. Dope. And so you're getting ready to graduate this spring? How does that feel? Almost being out?

JADA

Nerve-racking, especially because I'm a year early. I came in with class of '23, but I'm graduating with class of '22. I really did not have the optimal college experience because I had a semester and a half on campus, then COVID happened, but now I'm back. But graduating just feels so right. I'm glad for what I've done, where I've come from, and the growth I've made. I'm just happy to get it over with, like, the finish line's right there! I'm just ready to graduate and just continue on with my life.

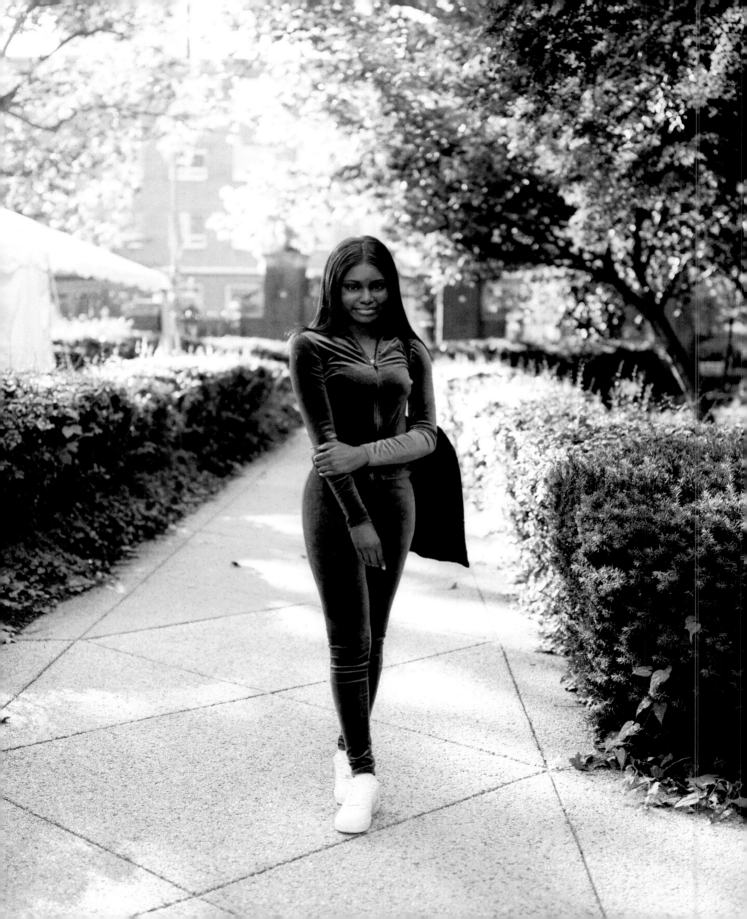

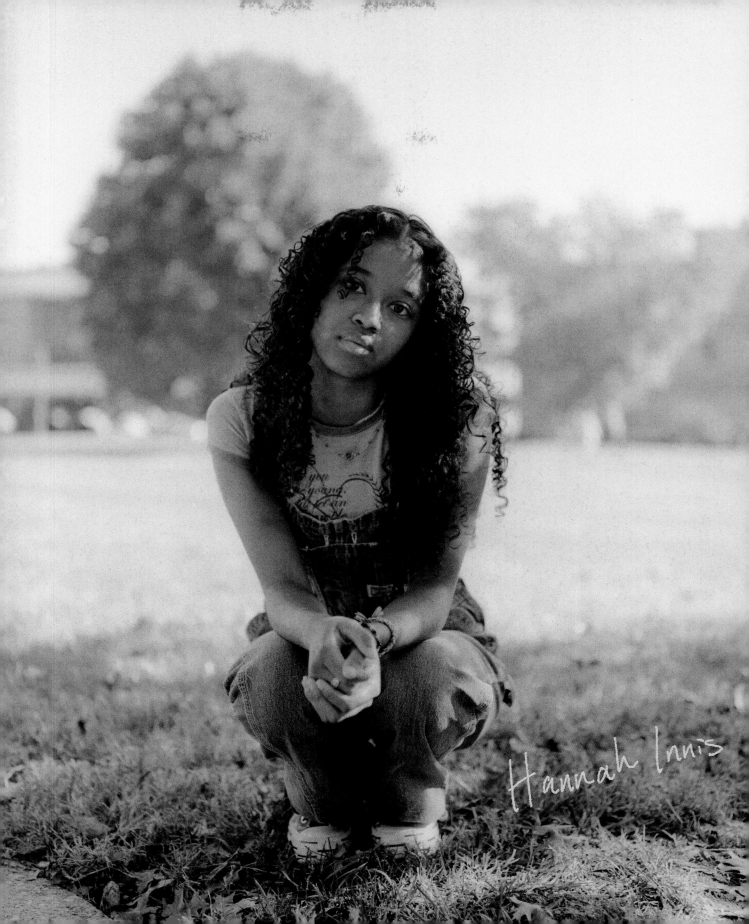

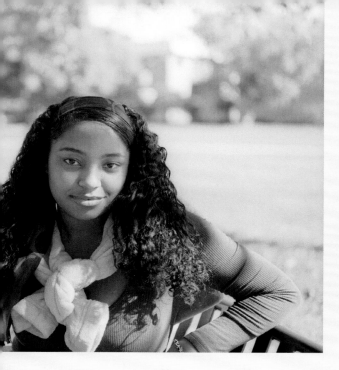
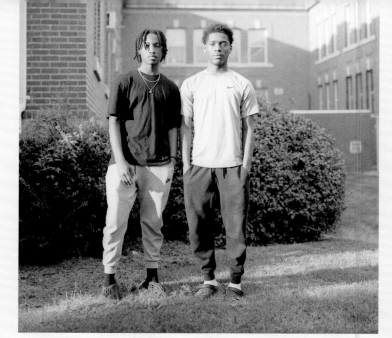
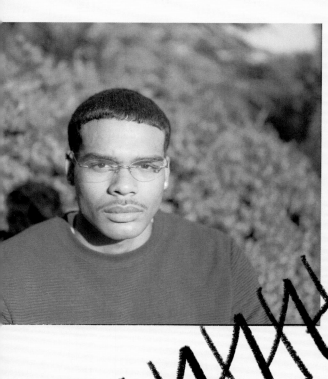
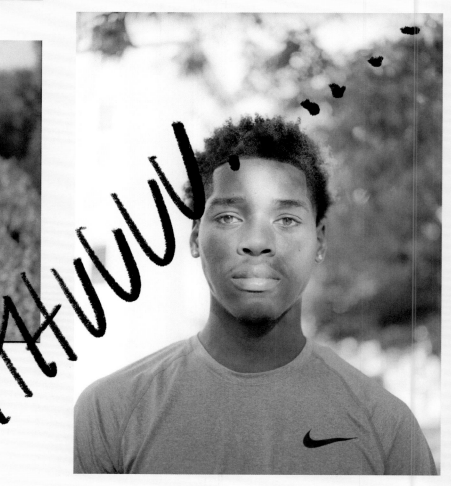

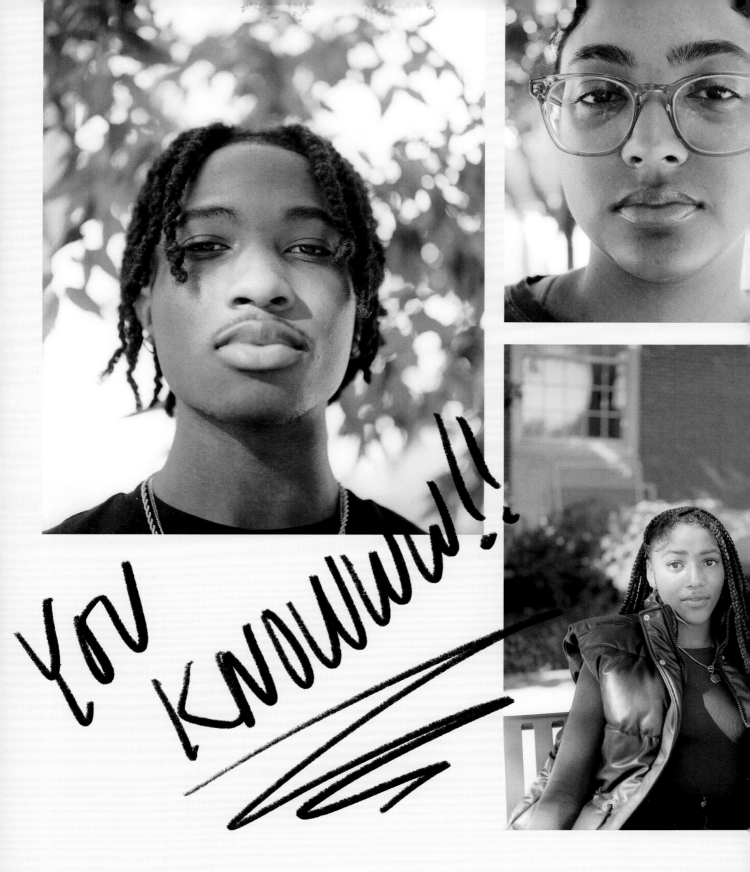

04·11

1881

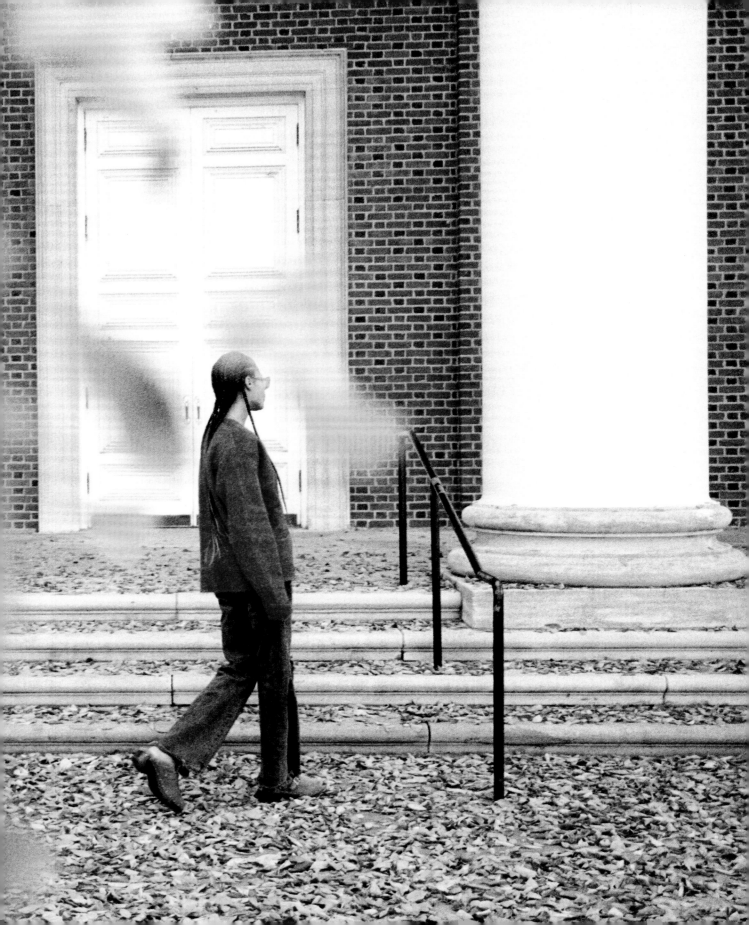

BROOKE THOMPSON
SPELMAN COLLEGE

MAJOR	ECONOMICS
CLASS	2025

ADRAINT

The AUC was most definitely on my radar in high school, but there wasn't anyone encouraging me to consider an HBCU. I remember looking at Morehouse for a second but moving on after not seeing a major I could get excited about. What was that source of influence for you?

BROOKE

My mom went to Spelman, and she always told me and my two siblings about it. When my sister decided to go to Spelman, I got to go to the move-in, and that was really the sealing deal. Once I saw the DJ and all the Black girls—I don't think I'd ever seen so many Black girls all together—it was so crazy. Seeing all the Black girls so happy to go to school and goal oriented, that was really powerful to me. Then when my brother went to Morehouse, it was really like, "Okay, this is what I'm working toward. This is what I want to be. This is where I want to go."

ADRAINT

Wow. What was your first week here like?

BROOKE

My first week here, it was kind of crazy. With COVID, I had to tell myself it might be a little different. I was really worried in my head because I had built it up my whole life. Is it going to be everything that you wanted it to be? Things were getting canceled, and I was getting nervous if it was going to live up to what I want. My first week was good, and then it got better eventually. A lot of people were nervous that they weren't going to make friends because, with social media, some people already had their little friend groups. I even had some moms reach out to me being like, "Can you hang with my daughter?" My sister and other Spelmanites told me it takes a couple weeks for you to make your first friends and get a friend group, so don't get nervous. Just be nice to everybody and it'll all work out.

ADRAINT

That's great. In terms of social media, what role has people communicating over the internet taken in being able to make friends? I'm sure there's some people on this whole school system that are "famous" on there. What does that look like? Have you participated in that?

BROOKE

There are several people that have a large following on TikTok, and it's kind of funny when you see them because they're just our classmates. TikTok and social media did play a role because I remember when everybody got admission to Spelman, they started making all these group chats. It definitely played a role in people making their friend groups, but a lot of those friend groups didn't really stay. I remember I made a TikTok after fall break of just my experience, and I had several people DM me from PWIs saying, "Dang. I feel like I made the wrong decision. I feel like I should have came here. You all look like you're all having so much fun." And I mean, I only put the best parts of my semester. There are highs and lows. Don't regret your decision based off a TikTok. You see people doing so many things, and you think, "am I doing enough? Am I getting in enough clubs? Am I doing enough community service?" People fear they're not doing enough, and social media can play negatively in that role. But you have to remember: I'm a freshman. I need to focus on my grades, get that in order, get my GPA in check, and then I can do all this extra stuff.

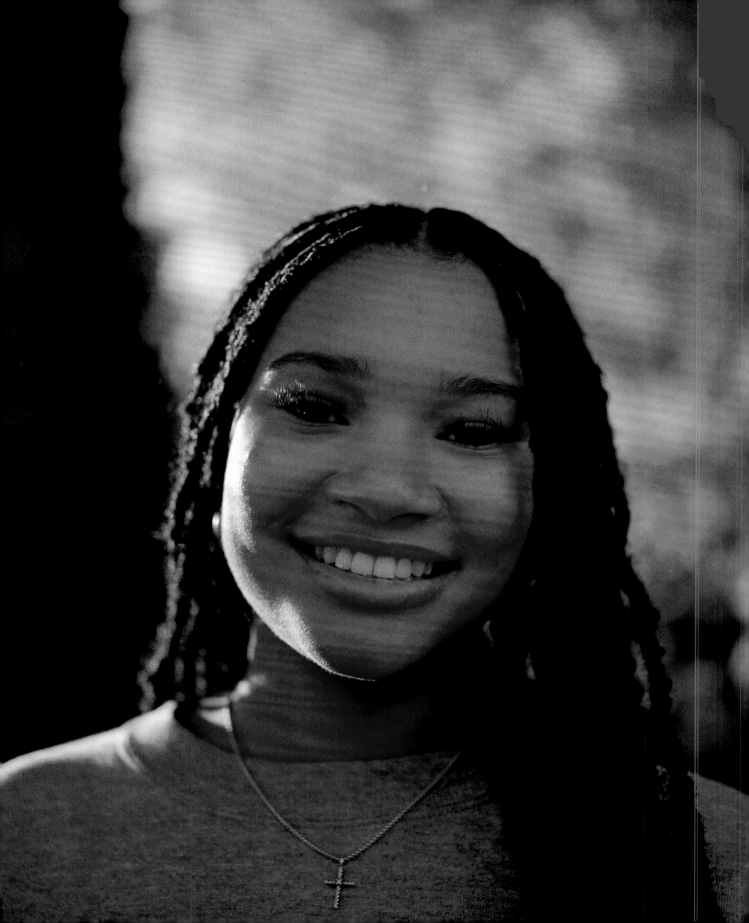

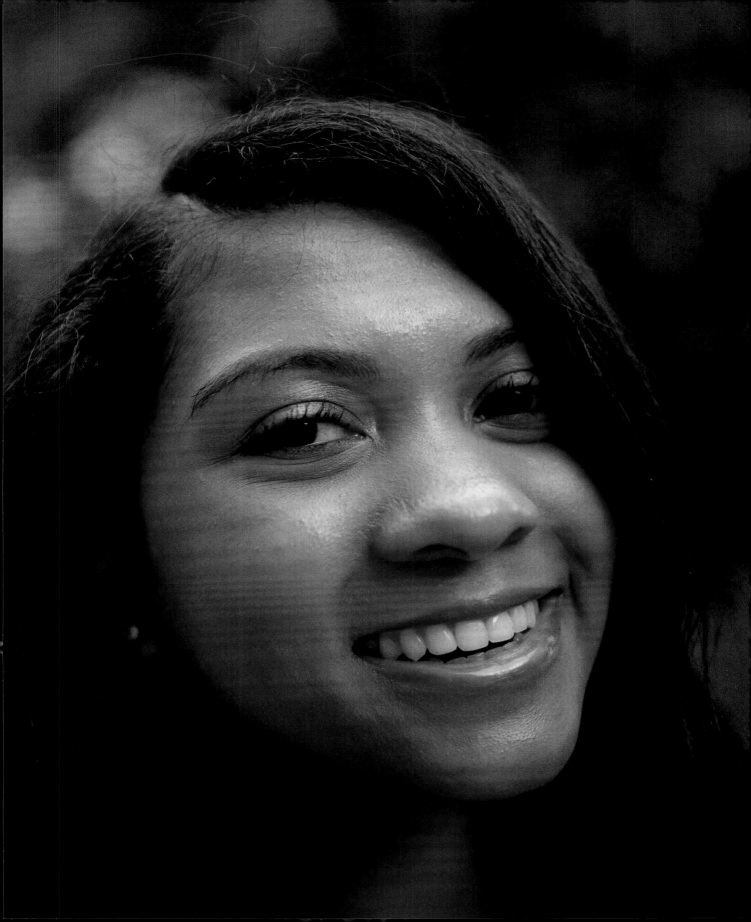

ON THE SKILLS AND STRENGTHS GAINED
AT SPELMAN AND HBCUs AS A WHOLE

—GIA MCCRAE

MAJOR: INTERNATIONAL STUDIES

CLASS OF 2022

SPELMAN COLLEGE

I'm originally from Houston, Texas, by way of London and Singapore. I'm not a military brat or anything, but we moved around a lot because of my father's corporate job. I came back to Houston and went to Episcopal High School, which is a predominantly white private school in Bellaire, Texas. By this point, I had many different friends and I already knew who I was, what direction I wanted to go. I stayed at Episcopal till I graduated, but my junior year I came to Spelman to visit for "A Day in Their Life," that's what they call it. I never had any intentions on going to an HBCU, but when you're in the South, you hear it all the time. The pride people share when you say you're going to a large state school is so different than when you're going to an HBCU. I was the only Black person from my high school that applied to an HBCU. My senior year, once I got into Spelman, I was over the moon. I was constantly validating why I wanted to go to a historically Black college and institution. I almost felt like it wasn't accredited because nobody around me saw the value in it.

Spelman was the best decision I ever made. When I got here, I realized that there was a spectrum of class, gender identity, sexual orientation—all the intersectionalities of Black people that I'd never thought about before. Your freshman year, you're required to take this class called African Diaspora in the World. It taught me so much because I don't think that we as Black people really sit and think about our diaspora in a way that's not solely related to slavery in the United States. That class really shook me—having this camaraderie with people in my class who also were sitting there, not knowing anything about our diaspora, learning new terms, and being more open to harder conversations.

If I say anything about being at an HBCU, it teaches you how to be comfortable with yourself in a room that may not make you feel so comfortable. I didn't realize it until I got my second internship with American Express. There were six interns, and only one other one was from an HBCU—Howard. It was interesting, and I'm speaking candidly here, to see the dynamics of the different interns. They all came in so competitively because usually at American Express, you have to be a junior to get an internship. I was a sophomore, and these were juniors trying to get full-time offers at the end of it. They were from Brown, Yale, or other schools with a reputation for having polished students. People underestimated how me and this Howard kid could be polished. At the end of it, you get your offer or you don't. I got a return offer and came back. I didn't realize how much these corporate people saw value in me and how much of a difference I made until people were telling me. That was the moment I knew that this institution that I always doubted so much in high school was the right choice because suddenly I realized that I'm comfortable in the real world. I'm comfortable with myself. I'm "polished" for the corporate life that I'm about to embark on.

At Spelman, I was able to explore dif-
ferent avenues. There's so much for
you to explore here, and that's what
I really loved about it. I'm one of
the Campus Queens, and I never knew
about pageants or saw myself being in
one before I came here. I'm the first
attendant to Miss Spelman in a court
of three: Miss Spelman, first atten-
dant, second attendant. It was just an
interesting experience. I think that
there's so much joy in knowing that in
most cases, not in all, every school
has its struggle. I've experienced
some form of sisterhood and some form
of siblinghood in any role, any compe-
tition, or any club that I joined.

MAJOR: PSYCHOLOGY

CLASS OF 2025

SPELMAN COLLEGE

When I started looking into HBCUs, it was solely my thing. Even though Miss Beyoncé inspired me, it was solely my decision. I wanted to go here, so I did my research and worked up the courage to finally tell my mom. I had always been in PWIs my whole life, so I wasn't really sure how she would take the HBCU thing. I told her, and she just started crying. I'm like, "Oh my God, she don't want me to go a HBCU. I'm going to a PWI. Please, I don't have time for this." But she was crying, and she just gave me this big hug and was so happy. She was like, "I always wanted to go to Spelman." She just never went because she was young and in love, and she stayed behind for my dad. I never even knew that, so it was a big shocker. That was the universe telling me I need to go here.

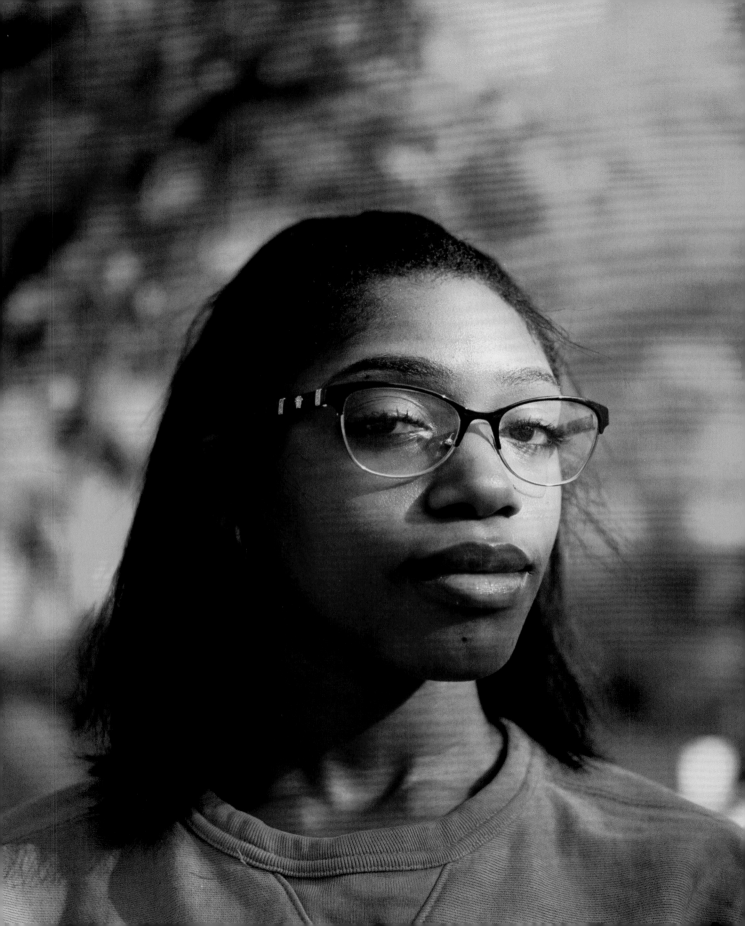

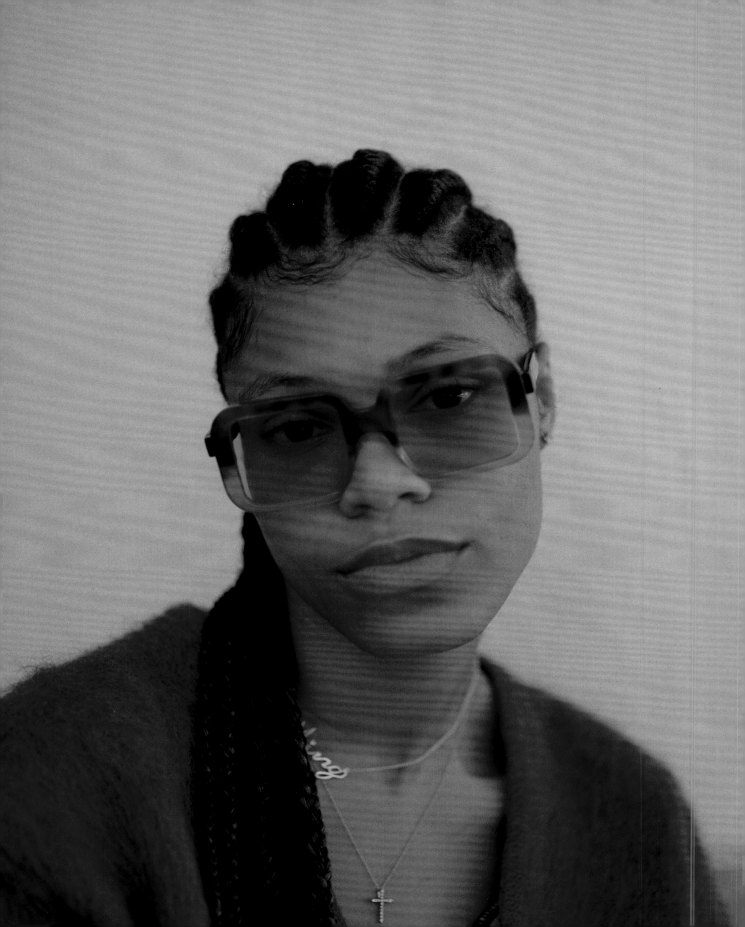

MING WASHINGTON
SPELMAN COLLEGE

MAJOR	ART HISTORY & CURATORIAL STUDIES
CLASS	2022

MING

My Spelman experience has loved me, and I am in awe. So many moments here have been overwhelming with joy. It's really nice to be present in a space that is meant to propel me beyond it. Some of my regret in the experience is that I held my work and my time here to such a high standard that I did not take full advantage of resting and having fun. That's not to say that I didn't have fun, but it's just that I have been going through these gates nonstop. The experiences with my Spelman siblings has been so special and has taught me so much about myself. At times, you really need to see yourself in other people or have someone tell you about yourself, and that has happened here. It is just humbling to learn from others and to observe. This college has been a forerunner in almost everything that it attempts. What a Spelman woman or a Spelman student is, or can be, is defined both by statements within the university and the world's perception of it. That has been interesting to move with being out in the world representing this school and the kind of conversations I have. It's one of pride. I'm also excited to be an alum, to sit with the women and people who have come out of here and look at the next generation like, "Okay, it's your turn."

Coming back after the pandemic, being on my way out, and experiencing so many new faces while also missing a lot of people, it's interesting to stand in a place of maturity and accomplishment here. I'm glad to grow into being a sister to so many of these people around here, to see what's next and who's coming in. At times, I don't want to tell them too much and just let them experience it. They'll figure it out. I am not going to spoil this part for you. But also, let me tell you this secret to keep you going. If this is your cup of tea or this is what you aspire to, I hope that it is known that you are well on your way to accomplish it. There are so many ways to make it possible. If this is not what you are after, I'm so excited, so thrilled, and so inspired by the courage and bravery to imagine for yourself. I'm so excited to see what becomes of you and to celebrate that.

DIOP RUSSELL
SPELMAN COLLEGE

MAJOR	ENGLISH
CLASS	2022

ADRAINT You're Miss Spelman so I don't doubt that you love Spelman, but how did you know it was right for you?

DIOP When I was applying to college, I knew that I wanted to go to an HBCU. I read Ta-Nehisi Coates' *Between the World and Me* as a high school senior, and the way he just marvels at Howard is just . . . it was so glorious. At that time, it was Howard, but my mom had another vision for me. When she was a teenager, all she ever wanted to do was go to Spelman, but she couldn't afford it. So, when it was my time around, she was like, "You're going to go to Spelman." I applied to all the scholarships that she could think of, and that's how I was able to step foot on campus.

I knew that Spelman was the right school for me after our new student orientation. A bunch of alum came back, brought their yearbooks and told us all the stories about their time at Spelman. I knew Spelman was the most radical place on earth and there wasn't going to be another space, a historically Black *women's* space, for me. I thought, "This is where I should go. This is where I want to be."

ADRAINT I love that. I love that for you. And I'm happy you were able to go. I think that's really beautiful. Can you talk to me about some of the things you've done while you've been at Spelman? That could be student involvement. That could be in general, in Atlanta. Yeah.

DIOP

It's a little silly thing, but I started a little smoothie business called Put Some Respect on My Plate and I sold them from my dorm to first years and everyone on campus. I'm a co-host on *The Blue Record Podcast,* which is Spelman's official student podcast. I humbly serve as Miss Spelman College. My platform, or my reign, are all about moving with ease. When it comes to Black women and Spelmanites, in general, we tend to do a lot. We do the most, we move at our own pace, and we lean on our community. I do a couple of initiatives around that. I create a safe space on campus for LGBTQIA+ students. I create more awareness around scholarships, and I want to bring back some of Spelman's traditions. Because of COVID-19, we've had to be very COVID safe, and some of our traditions have disappeared with the pandemic. I'm all about reviving them through what I do with Miss Spelman and *The Blue Record*. I also do reparations work with the Quarterman-Keller Scholars Program, a social justice project with two families: The Kellers are descendants of white people who enslaved people, and the Quartermans are descendants of enslaved people. They came together, and they're all about reconciling their history, truth-telling, and healing. I interview them and collect their stories to later influence policies around reparations for Black people, so it can be a tangible thing in the future.

ADRAINT

How do you find community on campus? How do you find *time* for your community with all the extracurriculars you have? What does that look like for you? When you wake up and you think, "Okay, maybe I'm not feeling well, or maybe I want to be embraced by my friends," how do you go out and find that community?

DIOP

As a queer student at Spelman, I really, really, really longed for community. Spelman has gifted me with that. There are depictions of a Spelman woman. Some of the most common images might be Black girls with straight hair and pearls on top of it; a straight cis woman doing great things. That's a lovely image of Spelman women, but that photo is a little limited. So, I joined lots of different orgs, but I found my community in the classroom. Spelman has a queer studies department that's emerging, and I took a lot of film and queer studies classes. That's where I met lots of my friends in the social justice department. Not only was I learning more about my identity in class, but I got to nurture those friendships while doing the assignments, making the films, and venting on our yard. I made community by seeking out the classes that I really wanted to take.

ADRAINT

What are you most looking forward to this semester?

DIOP

Senior year is the most precious time since I've been at Spelman. I'm looking forward to the final walk. I'm looking forward to just walking across stage and being like, "Diop, you did it, girl. There's nothing else that you need to do. The legacy is cemented. You're done." I'm ready to take a deep breath and just cherish the rest of this time. I'm looking forward to all the celebrations too.

MOREHOUSE COLLEGE

ATLANTA, GA

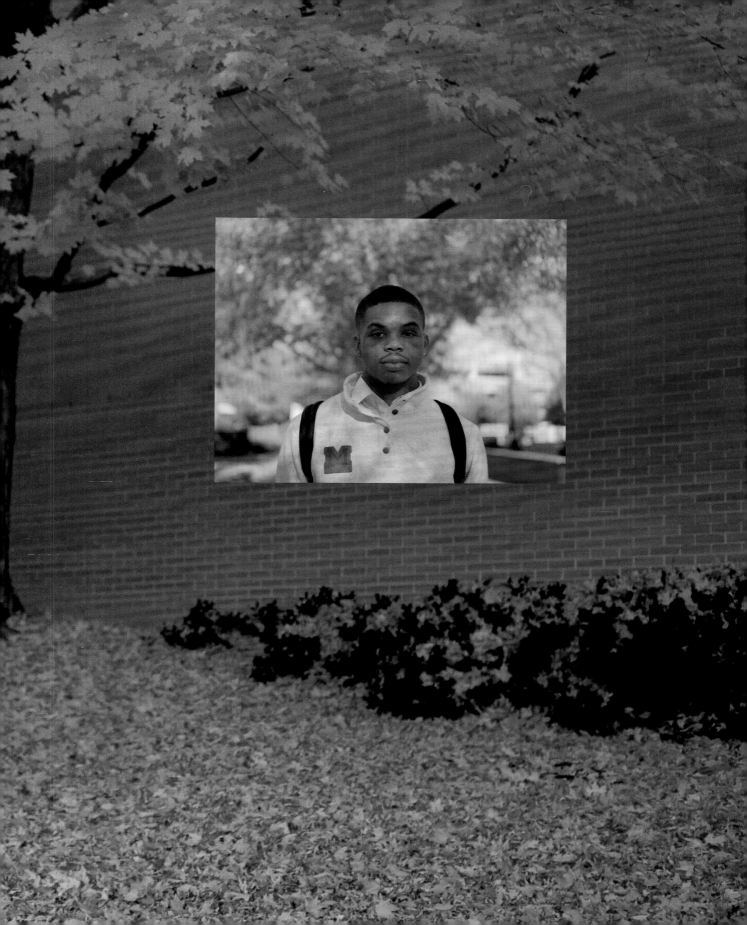

TYLER GREENE
MOREHOUSE COLLEGE

MAJOR	SOCIOLOGY
CLASS	2024

ADRAINT

What did your parents think of Morehouse? What was your first touchpoint into finding out about it?

TYLER

My dad is a graduate of Hampton University, so he understands the HBCU experience and was always pushing for me to go to one. For my mom, it didn't really matter. For her, it was more so a financial thing. When I got accepted to Morehouse with a $25,000 scholarship, which basically was going to cover half of my tuition and better than what most schools were giving me. I got a full ride a few months after that, and it was a no-brainer. Finances predicated a large part of the decision, but an upper-classman friend of mine, Troy Roberts, was one of the heaviest influences for me to even submit my application. He guided me into the process and kept imbuing me with the strength and fortitude to make sure that I saw it through.

ADRAINT

So much of whether or not a student will attend a school boils down to scholarship money at the end of the day. It's so helpful to have someone affirm a life-altering opportunity. When I started undergrad everything felt so daunting coming from a smaller rural town in Texas. How did you get situated emotionally? What kind of conversations were you having with your peers?

TYLER

There's so many, it's difficult to pinpoint one. Yesterday, I was speaking with a dorm mate who orchestrated and ran a clothing drive in less than a week. Somehow we got from the topic of the clothing drive as a direct action from a leftist ideological perspective and how they're trying to shift dynamics but then we got personal and started discussing conflicts within ourselves. I have one when it comes to maturity, he has one when it comes to ability and impostor syndrome. I love those conversations where someone else is acting as a mirror and I'm acting as a mirror for them and we're basically just looking as deep as possible to realize more about ourselves that can help us become more whole people.

ADRAINT I think there is an external perception of the "Morehouse Man" idea, and then I think there's an internal perception. What's your personal perception?

TYLER There are several examples of Morehouse men on campus. You can tell by how a Morehouse man carries himself that he is one. This is a phrase that's always used at Morehouse: *It's an air of expectation that befalls men of Morehouse, from those that are matriculating to those who've completed their matriculation here.* You can definitely feel that in your interactions with a Morehouse man.

 It's difficult to pinpoint what to internalize though. Sometimes you have conflicting narratives of what a Morehouse man is, historically or on text, because there are some who don't align with those values exactly. But another thing about a Morehouse man is that there's always going to be distinguishing factors. It's the ability to, even when you disagree, not be disagreeable and still maintain brotherhood despite challenges.

ADRAINT How would you say mediocrity fits into this idea of Black excellence? I imagine at Morehouse it's even more hyperbolic.

TYLER It's so pervasive because there's also romanticization of Black excellence. It's become a catchall term for the activities that Black people perform in society. If you're in a space only surrounded by Black people and this is already a place of excellence to begin with, anything that you do in this bubble is considered excellence. For me personally, I do see the majority of what's occurring on campus as displays of mediocrity. I have a different philosophy on excellence. In general, I think that it's a very white term, it's a very professional term. There are a lot of Black people here at this institution who are looking to do well in the professional environment, but it's being seen as this excellence thing and this "Black boy joy" and this "Black girl magic" when it's really not, in my opinion. I see a lot of examples of people being excellent in a nonprofessional or white way, right? People throwing themselves out into the world and showing people what they're about just fall by the wayside because of the societal pressures of what "excellence" looks like.

ADRAINT

Yeah, so much of college has been gamified under the condition that you learn to assimilate into white America. Do you think that bleeds into dress attire? I know some universities have "business days" where students will wear business professional attire that day.

TYLER

There are people who are just like, "I'm leaving my dorm. I'm going to be back later. There's no point in dressing up," and there's nothing against that whatsoever. Then there are people who really care how they're perceived. I like to say that fashion is the architecture of the person. When you enter a building, it's either comforting or it's not, right? Fashion is the same for the individual in that it's expressing who you are, it's showing people who you are, it's greeting people and inviting people into your mental home before they walk in. There are different fashion tastes here. I saw someone walking around in booty shorts and cowboy boots. I was like, "Wow, someone's actually pulling that look off in broad daylight!" A lot of styles may not seem familiar because once again, we're looking at so many different cultures. Black is not just Black Americans, and you have a bunch of different spaces converging.

I learned very quickly last semester that it's a fashion show. It really depends on how you want to enter that space and how you want to be remembered. It's a great way to communicate, "This is me, this is the kind of style that I wear, this is the kind of fashion that I move around with."

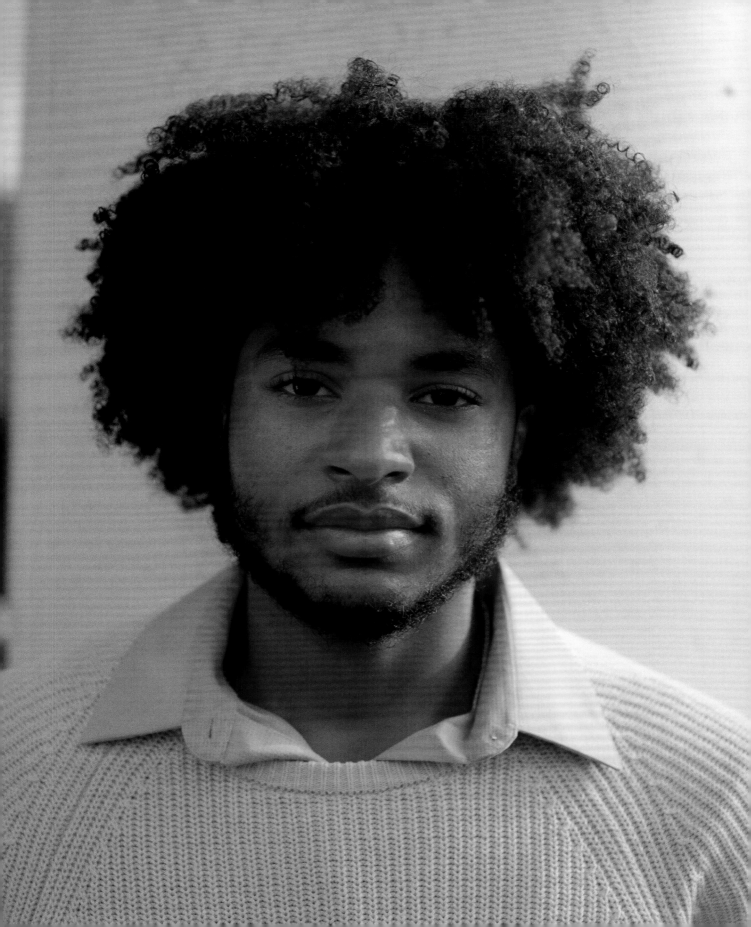

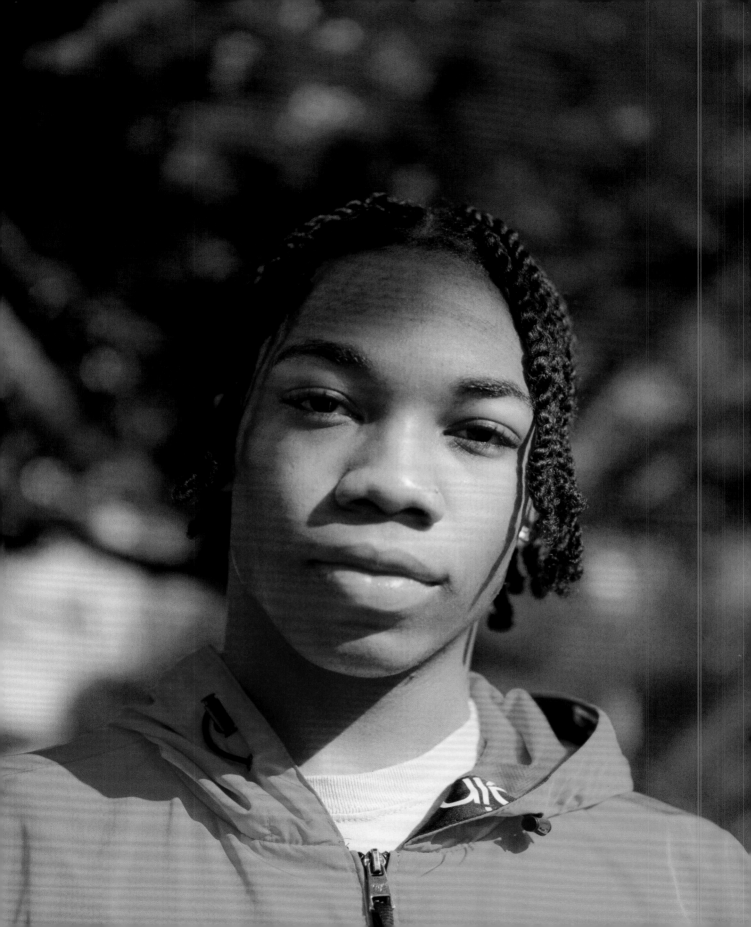

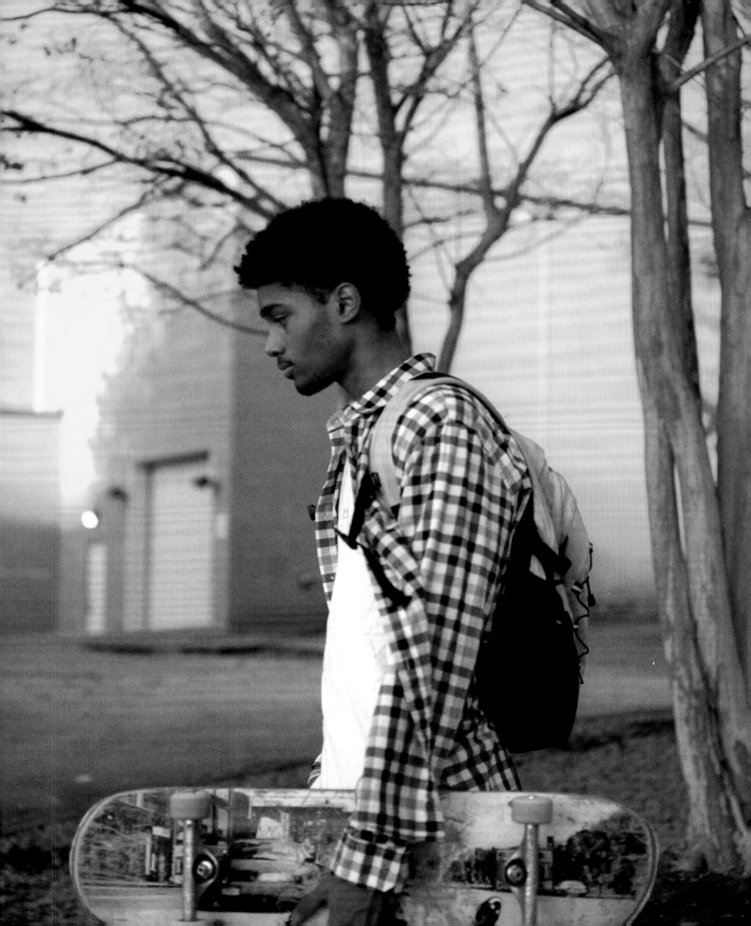

THEODORE "THEO" COLBERT
MOREHOUSE COLLEGE

MAJOR	BIOLOGY, PRE-DENTAL
CLASS	2022

ADRAINT

I've heard a lot about the Morehouse men via the internet and social, but also through coming to know the work of the incredible alumni. Martin Luther King Jr., Spike Lee, Samuel L. Jackson . . . just to name a few. Those few names alone carry great influence. Alumni aside, what influenced your decision to come to Morehouse?

THEO

My dad went to Morehouse, so I had always known about it. When I was applying to schools, I really wanted to go to a PWI. But when I visited Morehouse for the Admitted Students Weekend, the amount of Black men with suits on and Black men just carrying themselves in a different way than I had ever seen really stuck out to me. It made me want to go to Morehouse and just be around more Black people. Coming from a predominantly white high school, I definitely didn't know a lot about my culture. I came to Morehouse just to understand myself as a Black male again.

ADRAINT

What has been the highlight of Morehouse for you?

THEO

This year, seeing our orientation with all the men walking up Brown Street and seeing all the people that are coming into our family was great. That was probably the best experience I've had at Morehouse so far. To be a leader for them and help them move in, that's something I hadn't been able to really experience because of the pandemic. It was really good.

Alumni involvement is something that we talk about while we are at Morehouse and when we leave. We depend on the people before us to the point where we don't have to worry. Whether it's people that I met freshman year or sophomore year, I know that if I call them, they can help me out with a certain program or just different issues that we have at the college.

ADRAINT What was living on campus like?

THEO Living on campus was cool, always seeing your brothers
 and stuff. I don't see them as much since I stay off campus
 now, but just going to the cafe and always interacting with
 them was definitely really fun. I still see most of my friends
 from freshman year from my hall; there are people that I still
 call really good friends now. I even met my girlfriend through
 someone who stayed in my hall. Staying on campus helped
 me build relationships at the school.

ADRAINT Yeah. What have you been involved with while you're on
 campus?

THEO When I first got to campus, I was involved with a community
 service organization called Lighthouse, and we did mentoring
 at elementary schools. I also applied to become a part of an
 undergraduate sciences academy at Morehouse School of
 Medicine to prepare me for dental school. I'm just figuring out
 what careers I want to do in the pre-med world. I got a schol-
 arship through that, and they gave us iPads and stuff. One
 of my friends at Spelman started a little community service
 mentoring at another school in Atlanta, so I did that again my
 sophomore year. Then my spring semester of sophomore year,
 I became a member outside of Alpha Phi Alpha Fraternity, Inc.

 I'm the vice president of the chapter, so I pretty much make
 sure that everybody's doing what they need to do, that our
 calendar is working efficiently, and that we're just doing what
 we need to be doing.

ADRAINT How would you define success at Morehouse?

THEO Success at Morehouse is graduating and building the con-
 nections while you're there to be successful *after* graduating.
 That's successful. All of the tools will be there for you—the
 professors, the connections, and all that—but if you don't
 make that extra effort, you won't be successful at Morehouse.
 That's really what divides the group.

 Some people do well in their classes and make the connec-
 tions, but some people don't go to class, don't make the
 connections, fail out, lose their scholarship, and then have to
 drop out of school. I have lost friends because of that, like,
 almost half of my dorm hall doesn't go to Morehouse anymore.
 Morehouse's graduation rate is not even over 50 percent, so
 that's just something that we just try to work on. The main
 thing is money. So, that's really the divide right there. Are you
 able to just stand on your ten toes, keep your scholarship,
 and stay in Morehouse for the four years?

ON BLACK CULTURE IN NASHVILLE AND THE VALUE OF HBCUs

—RASHAD TOWNSEND

MAJOR: ECONOMICS

CLASS OF 2022

MOREHOUSE COLLEGE

You know how they call Nashville "Music City"? A lot of people think it has to do with country music, but it's really because of the Fisk Jubilee Singers. Nashville got its identity from Fisk and these Black artists. But what it's most known for, or what people almost mistake it for, is being this very white-centric city. Black people were really thriving in Nashville back in the fifties and sixties. We had this street, Jefferson Street, it was the major thoroughfare back then. It was the Black hub. We have Tennessee State, Fisk University, and Meharry Medical College, which produces a bunch of Black doctors. Nashville has so much Black cultural history, but you wouldn't know it unless you were there. For real, for real. It's not advertised.

Why should students go to HBCUs? What do you gain? The chance to see the multiplicities of Black experiences. In America, especially in academia, we so often see whiteness as the standard—or not even as the standard, but the bare minimum. So then anything that I'm doing is, by nature, adjacent. At Morehouse, for anything that I want to be, there's a Morehouse man who's done it, and he looks like me. For anything that I'm interested in, I have a Morehouse brother who's also interested in it. You can go through the network and talk to other Black men, and it's so affirming to see other people who are smart and look like you. Because it really is hard.

Coming from my high school, my standard of success wasn't really Black. I met people in Nashville who were doing well, but when I came to Morehouse, I really got to see Black men doing *really* well, and they don't have to be famous to be doing so. It's different when you're going to a place that's actually made for you. A place that knows about moving through America as a Black person. Morehouse has incorporated that into our curriculum, into our life, and our history.

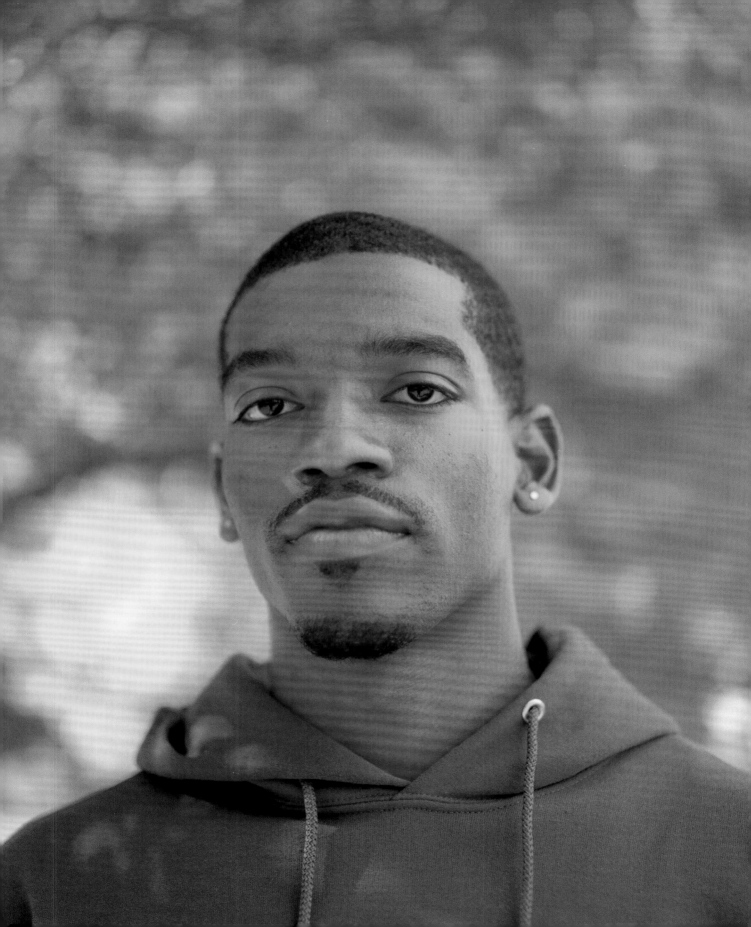

PRAIRIE VIEW AGRICULTURAL AND
MECHANICAL UNIVERSITY (PVAMU)

PRAIRIE VIEW, TX

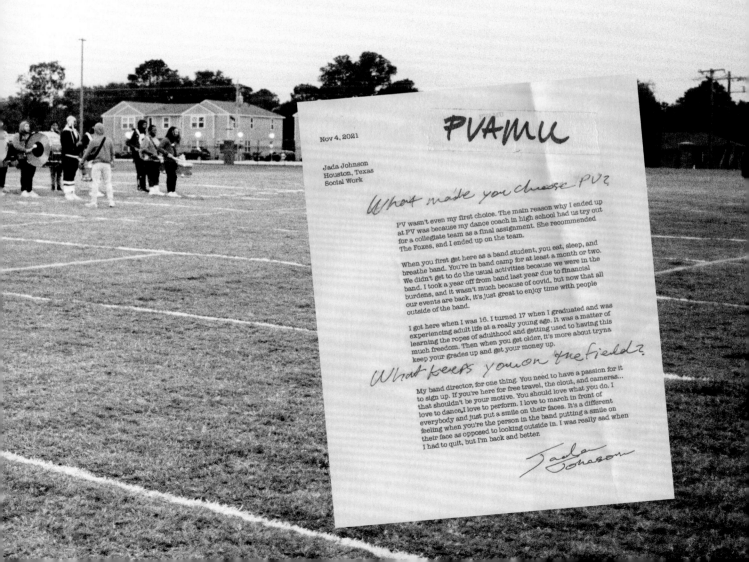

PVAMU

Nov 4, 2021

Jada Johnson
Houston, Texas
Social Work

What made you choose PV?

PV wasn't even my first choice. The main reason why I ended up at PV was because my dance coach in high school had us try out for a collegiate team as a final assignment. She recommended The Foxes, and I ended up on the team.

When you first get here as a band student, you eat, sleep, and breathe band. You're in band camp for at least a month or two. We didn't get to do the usual activities because we were in the band. I took a year off from band last year due to financial burdens, and it wasn't much because of covid, but now that all our events are back, it's just great to enjoy time with people outside of the band.

I got here when I was 16. I turned 17 when I graduated and was experiencing adult life at a really young age. It was a matter of learning the ropes of adulthood and getting used to having this much freedom. Then when you get older, it's more about tryna keep your grades up and get your money up.

What keeps you on the field?

My band director, for one thing. You need to have a passion for it to sign up. If you're here for free travel, the clout, and cameras... that shouldn't be your motive. You should love what you do. I love to dance, I love to perform. I love to march in front of everybody and just put a smile on their faces. It's a different feeling when you're the person in the band putting a smile on their face as opposed to looking outside in. I was really sad when I had to quit, but I'm back and better.

Jada Johnson

Eboni Price

I just want to make sure I have time to communicate with people and do my best to ensure that everyone is good. Many people struggle with battles that they don't want to voice, but I want to make sure that they're heard. Nobody's feelings are invalid. I just try to remind people that they know themselves and their place in this world, and that no type of pain that they endure is stronger than what they have going on in their heart and their minds. I don't want to leave anyone out. I want to make sure everyone is included. One piece of advice I will say: Your uniqueness is not a weakness, but it's something that you should hold strong. Stay pure to yourself and don't do evil nor harm, but if you do, be accountable, be better, and grow.

MAJOR: NURSING
MINOR: SOCIAL WORK

CLASS OF 2023

PRAIRIE VIEW AGRICULTURAL AND
MECHANICAL UNIVERSITY (PVAMU)

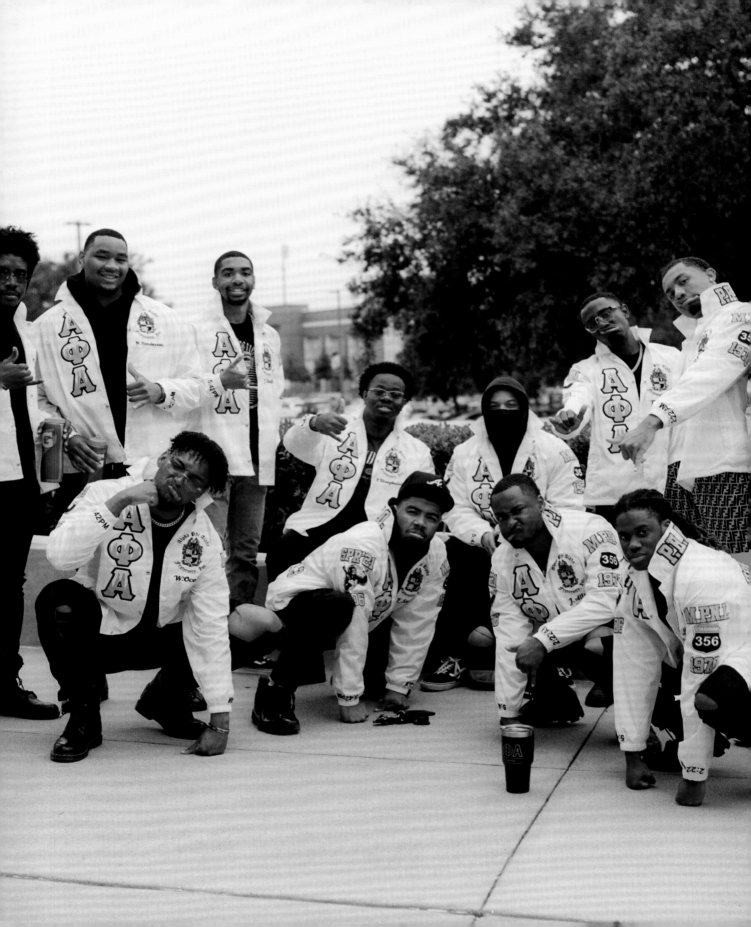

CHAD LAMONT COTTON II
PRAIRIE VIEW AGRICULTURAL AND MECHANICAL UNIVERSITY (PVAMU)

MAJOR	MUSIC EDUCATION
CLASS	2022

ADRAINT

Tell me about how you discovered PV. How'd you know this was your place?

CHAD

I found out about PV at a young age, I would say. My mom used to take me to Dallas every year for the State Fair Classics, which is a big game between Prairie View and Grambling. They would do a battle-of-the-bands competition between the high schools and then, at the end of that performance, PV and Grambling would always come and do a couple of songs. That was the band I grew up looking forward to. I knew in high school that band was going to be my major. I knew PV's band, so case closed, I'm going.

ADRAINT

Yeah. Got you. How have you been able to find community on campus and within the band?

CHAD

I am a bit outgoing. I can be shy, but I'm not . . . I'm not scared to talk. The first day I remember moving in and just happened to be complaining out loud about how it was raining. Someone came up to me and we became friends from day one. In another instance, I remember walking up the stairs and my Gatorade fell. My crab brother* in band caught it and introduced himself. I found out that he played saxophone, and we just talked, found out we have more in common than we thought, and became friends. So, I'm just a person that's good with talking. I gained all my friends that I'm friends with to this day by sitting at the dinner table because they make your whole section sit together freshman year. I was forced to sit down with those people, but that turned into real friendships.

* EACH NEW COHORT IN BAND ARE NICKNAMED "CRABS," SIMILAR TO "NEWMEN" OR "FISH" ELSEWHERE.

ADRAINT I've seen your videos on Instagram of you turning up, but tell me what role you play in the band.

CHAD There are a few of us in the band that float around, and we share that love, that energy. Sometimes you have band practice and it's dead. I ain't going to say I'm the hype man *every* time, but you can count on me most of the time to be over there, hyping everyone up, helping everyone get live, and finding those blank moments to just do some sporadic shit. Just scream out of nowhere and bring the morale up. We start enjoying ourselves rather than sitting there dreading all the hours that we're there. I definitely am one of those hype people . . . 90 percent of the time.

And at the games, if there's a band there, of course we finna battle. Zero quarter is a battle. And the fifth quarter is a battle.** In between the game, you can't play during certain times of the football game, so you can't just go head-to-head. But zero quarter, ain't no rules. In the fifth quarter, ain't no rules. You go until you can't go no more.

ADRAINT Who is the best band in the South?

CHAD In the South? The best band? That is a real question?

ADRAINT Yeah. I'm asking you for real!

CHAD Well, of course the best band anywhere . . . Anywhere that we slip down, we're going to be the best. So, to answer your question: The Marching Storm Prairie View Band, the best band all around.

** ZERO QUARTER IS PRE-COMPETITION AND FIFTH QUARTER IS POST-COMPETITION.

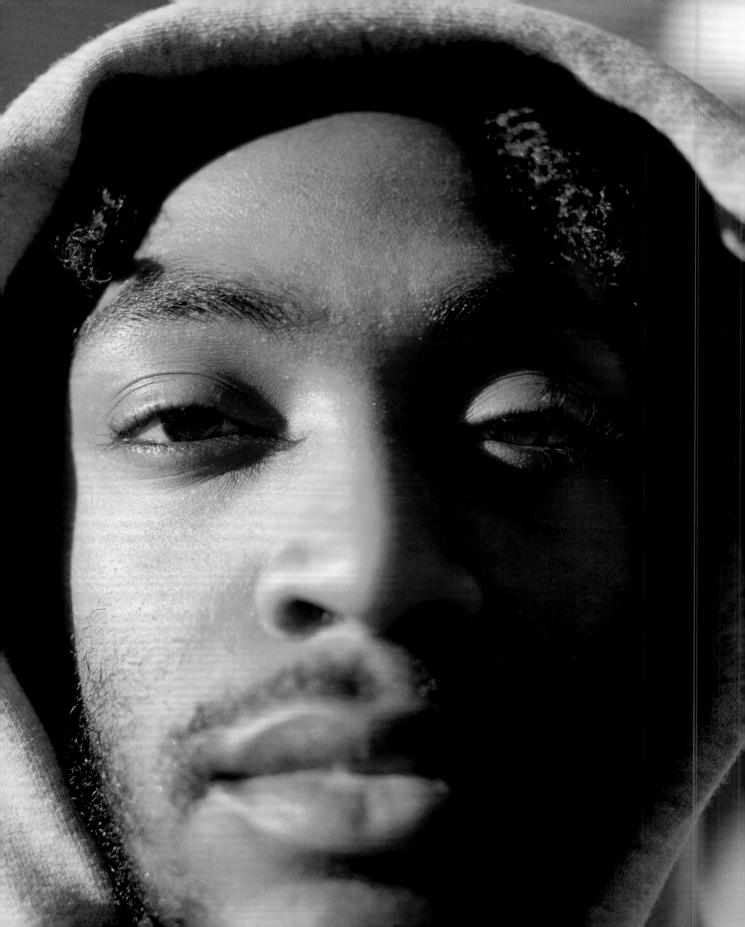

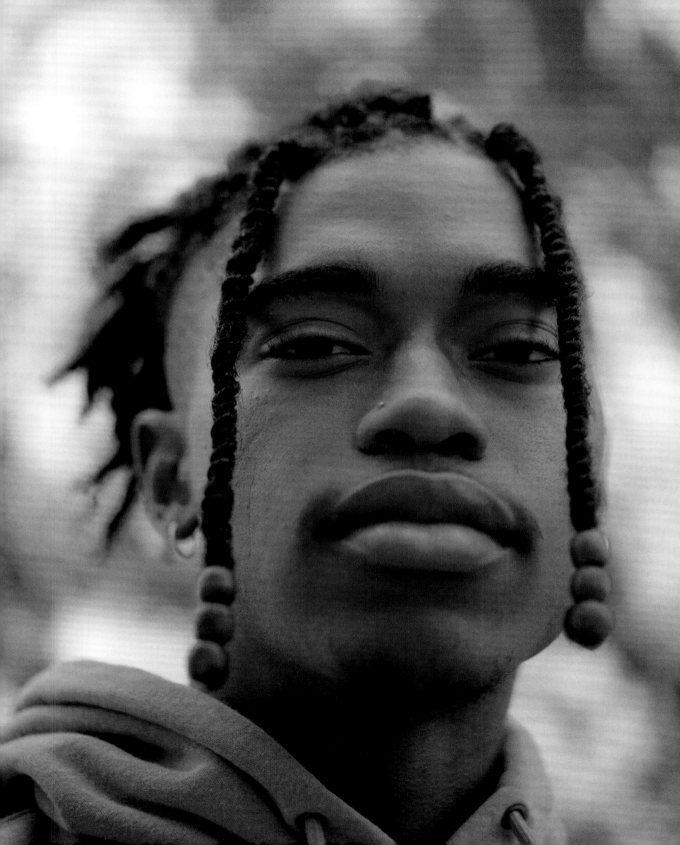

Zaveon Emerson

P. 144
FAMU

P. 164
HOWARD

P. 172
SPELMAN

P. 190
MOREHOUSE

P. 204
PVAMU

The Black
Yearbook

Afterword

> "Guilt is not a response to anger; it is a response to one's own actions or lack of action. If it leads to change then it can be useful, since it is then no longer guilt but the beginning of knowledge. Yet all too often, guilt is just another name for impotence, for defensiveness destructive of communication; it becomes a device to protect ignorance and the continuation of things the way they are, the ultimate protection for changelessness."
>
> —Audre Lorde, *Sister Outsider*

After the release of the self-published *The Black Yearbook* in 2020, there was this misunderstanding that I hated UT and my time there. Am I frustrated? Yes. Am I never going to support the institution again? *No*. My anger stems from being let down as a young adult seeking more from my university. It stems from student leaders doing what administrators were getting paid full-time salaries (and probably three to four times the living wage in Austin) to do. It was the subpar anti-hate statements and the fear of threats from representatives if they explicitly supported Black students. It was the unwillingness to do anything at all.

Being on the road for about five months and sharing a safe space with dozens of students across the country affirmed a shared collective experience. Many of these students face a similar indifference and resistance to change within their respective institutions when voicing their needs. College campuses have historically been controversial landmines for discourse on whether Black bodies deserve to *be*. Many of these students spend their time defending their

worth, and for others they spend it learning to assimilate. Neither is wrong or time better spent than the other, but it's unfortunate that most of them don't feel comfortable enough in these spaces to just *be*. Be *themselves,* be *queer,* be *unique,* be *Black.*

The most transformative part of being able to go to school for me was the act of leaving home. Everyone and everything you encounter along the way passes through you and you through them. It's a beautifully altering exchange of memory that allows us to learn from one another. Had I not left Waco, I'm not sure what person I would have become, but I'm sure I would not be who I am today. I would not be nearly as loved and nurtured by the communities of Black people I met on my journey of understanding. It would have taken me years to understand how to better love my fellow queer "siblings" and myself for that matter. I would have never stopped hating myself in this world that can feel cruel and dark at times. I would have never had the chance to *be*.

In a 2015 lecture at the University of Chicago, author Ta-Nehisi Coates talks about the power of being able to learn and grow in private at HBCUs. When graduating high school in 2016, I couldn't imagine myself there because I didn't have the money or someone to show me *how*. These Black Utopias felt out of reach. In all my learning at UT Austin, I felt so naked and ashamed of my ignorance. After all, no one has the patience for young Black boys at white institutions. There is a fixation on testing Black people, an unbalancing to be sure that we know "our place"—even though our place is right there in that room. My shame faded over time as I found other Black students that I could be vulnerable with. This is when I found art and literature from artists who opened my mind to the possibilities of *me*, my growing Black self. The oppressing buildings at the center of campus didn't feel so tall, so able anymore. This is how and where I found love. Many of the students I spoke to at HBCUs, regardless of indifference or negative experiences, have carved out a space for themselves to feel and know this same type of love while learning.

College can harden people, and life can rob them of experiences they never had. I always imagine what a life Oluwatoyin Salau, Trayvon Martin, and Emmett Till might have lived if they were still here. Not everyone experiences change. Not everyone has the opportunity or desire. In this gamified and elitist system, it can sometimes feel like we are passengers in the car called life. But in the wake of carving space for student voices here, I am reminded of those who didn't get the chance to harden, soften, or change at all. Who would they have exchanged ideas with? Who would they love? With blank pages in their books, we move on and on.

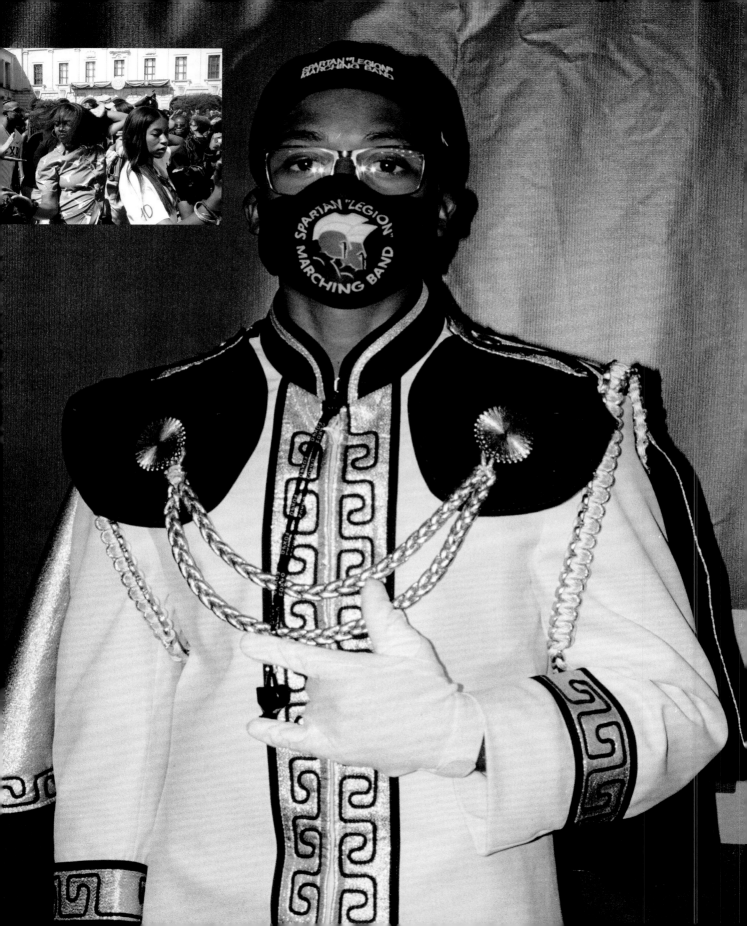

Acknowledgments

We're often told the work of great artists is made up by one individual, mystifying how artists do what we do. *The Black Yearbook* is possible by way of community.

Four years ago I would be introduced to someone who would help me to change my life and instill a sense of confidence in me to go further. My journey may not have reached this point without the guidance of Ruth Ajayi. I started making this work prior to the unfortunate events that transpired in 2020, and following the death of many Black individuals and the COVID-19 pandemic it put what I was doing under a magnifying glass. I was receiving queries from all over, and I was overwhelmed. I'm deeply appreciative of people like Ruth who took the time to advise me through such confusing times. Thank you Moyo Oyelola for introducing me to Ruth. Thank you Zach Head, Ali Brown, and Geoff Edwards for your guidance. Thank you to my agent Kirsten Neuhaus and Ulta Literary for your support. Thank you Ahmed Zifzaf for encouraging me to keep going through uncertainty. Thank you to my peers and collaborators on *The Black Yearbook* for believing in the power of image making and storytelling. Katia Osorio and Ananya Murthy, thank you for letting me crash on your couches! Southern hospitality is like no other.

Fear is the enemy of creativity, and friendship is its ally. Simona Harry, Rian Pettit, Dayjah Harris, Brandon Pegram, Sarah Ogun, Michael Johnston, Jun Tan, were some of my earliest confidants throughout my travels. Thank y'all for letting me ramble on the phone for hours trying to make sense of my thoughts. Their candor and humor kept my spirits high while I was on the road. A lot of fears were overcome thanks to them. Daniel Stroik, Anuj Mocherla, Kaela Thomas, Natalie Berry, Stasha Keivanzadeh, Jada Fraser, Leland Ellis, Tiffany Zhang, and Pratyush Singh, thank you for lending your perspectives in the editing stage.

A book like this requires unwavering belief. My editor, Kimmy Tejasindhu, was integral in helping bring this book to the finish line and supporting my artistic aspirations for the text. I'm grateful for the support of the Penguin Random House, Ten Speed Press, and 4 Color Books team for seeing the vision. Bryant Terry and Amanda Yee have been champions from the start. Our ephemeral design system would not be possible without my early collaborator and friend Huệ Minh Cao. Creating with you is a spectacle. Thank you Betsy Stromberg for making space for us to push the limits of design and break rules.

Every student seen and heard here contributed something special to the Black student experience that can not be unwritten or obscured. Things that are real have no fear of time. This is real and unthreatened by time. It's been a pleasure to understand the many ways of being through the lens of Black students across America. Thank you for being you.

About the Author

Adraint Khadafhi Bereal (b. 1998) is an art director, image maker, and author from Waco, Texas, based in New York and Texas.

He is a graduate of the University of Texas class of 2020. His work has been displayed in the George Washington Carver Museum in Austin, and the *New York Times*, *Vice*, *The Atlantic*, CNN, and the *Washington Post* have covered him. He now shoots campaigns for major clients such as Calvin Klein, Outdoor Voices, and AirBnB.

Bereal's personal work explores themes of rerooting identity, ritual, shame, and heritage. His upbringing in the South supports these themes, having been raised between Mississippi and Texas.

Typefaces: Linotype's Neue Helvetica and IBM Corp's IBM Plex Mono

Library of Congress Cataloging-in-Publication Data

Names: Bereal, Adraint, author.
Title: The Black yearbook / Adraint Bereal.
Description: First Edition. | California : Ten Speed Press, [2024]
Identifiers: LCCN 2022047034 (print) | LCCN 2022047035 (ebook) | ISBN
 9781984861405 (Hardcover) | ISBN 9781984861412 (eBook)
Subjects: LCSH: College choice--Social aspects--United States. | African
 American college students--Social conditions. | African American college
 students--Attitudes. | African American college students--Interviews. |
 Black people--Race identity. | College yearbooks--United States.
Classification: LCC LB2350.5 .B464 2024 (print) | LCC LB2350.5 (ebook) |
 DDC 378.1/982996073--dc23/eng/20230126
LC record available at https://lccn.loc.gov/2022047034
LC ebook record available at https://lccn.loc.gov/2022047035

Hardcover ISBN: 978-1-9848-6140-5
eBook ISBN: 978-1-9848-6141-2

Printed in China

Acquiring editor: Kelly Snowden | Project editor: Kimmy Tejasindhu |
Production editor: Leigh Saffold | Designer: Huệ Minh Cao |
Design manager: Betsy Stromberg | Production designer: Mari Gill |
Production manager: Jane Chinn | Prepress manager: Nick Patton |
Copyeditor: Janina Lawrence | Proofreaders: Adaobi Obi Tulton and
Carol Burrell | Publicist: Natalie Yera | Marketer: Joey Lozada

Illustrations by Adraint Bereal: 2, 142–143, 172, 217; Huệ Minh Cao: 8, 22–23,
28–29, 85–6, 136, 172, 186, 206; Jeb Milling: 150–151, 166–167, 174–175, 201,
212–213, 216, 217; Pete Sharp: 219.

Cover art credits
Other Half Creative production: Dustin Grant and Cara Scott |
Production assistant: Leah Kebrom | Photographer assistant: Christean Kareem
Studio: Please Respect Our Neighbors | Stylist: Kaela Thomas |
Stylist assistant: Keyana Wilson | HMU: Meron Weyante | Talent: Tashanna Allen
Casting: Neo Noir Agency

10 9 8 7 6 5 4 3 2 1

First Edition